LADY BUTLER
BATTLE ARTIST
1846–1933

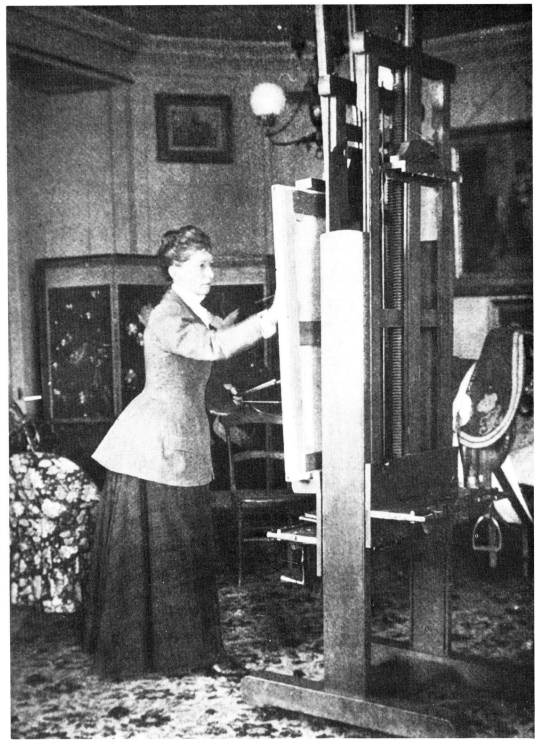

Fig. 1. Lady Butler painting at Dover Castle, 1898. *The Magnificat* is just visible on the wall, upper right. Photograph from Wilfrid Meynell's monograph, 1898. *National Army Museum*

LADY BUTLER
BATTLE ARTIST
1846–1933

PAUL USHERWOOD
Senior Lecturer in Art History, Newcastle-upon-Tyne Polytechnic
and
JENNY SPENCER-SMITH
Keeper of Fine Art, National Army Museum

Published for the exhibition
Lady Butler – Battle Artist (1846–1933)
held at the National Army Museum, London,
14 May – 26 September 1987,
the Durham Light Infantry Museum & Arts Centre
10 October – 8 November 1987
and Leeds City Art Gallery
25 November 1987 – 14 February 1988

Alan Sutton
National Army Museum
1987

ALAN SUTTON PUBLISHING LIMITED
BRUNSWICK ROAD · GLOUCESTER

First published 1987

Edited by Alan J Guy
Additional research by Michael Ball
Photography by Robert Goodall ISM and Ian Jones

British Library Cataloguing in Publication Data

Usherwood, Paul
Lady Butler, Battle artist, 1846–1933.
1. Butler, *Lady* Elizabeth—
Criticism and interpretation
I. Title II. Spencer-Smith, Jenny
759.2 ND497.B85

ISBN 0-86299-355-5

SU/135/1140–1008/R/230387/3750

Cover picture: detail from *Scotland for Ever!*
Leeds City Art Galleries

Typesetting and origination by
Alan Sutton Publishing Limited.
Printed in Great Britain by
Redwood Burn Limited.

CONTENTS

FOREWORD

William Reid, Director, National Army Museum

It is with pride and satisfaction that the National Army Museum presents the first major retrospective exhibition of the work of Britain's foremost battle painter of the 19th century. Indeed the exhibition described in this catalogue is the first devoted entirely to Lady Butler's paintings since her death in 1933. Dr Germaine Greer has written of Elizabeth Butler 'Many modern painters would envy her success; she is perhaps the last European painter to capture the imagination of the masses.' Lady Butler was not only extremely unusual in being a woman artist working in the highly masculine field of military art but she was also an innovator, particularly in her sensitive and humane depiction of the ordinary soldier. When she came on the scene, battle painting had been in decline and it is to her that a resurgence of that particularly dramatic art form should be credited. Although she has been largely overlooked in terms of artistic appreciation for a century or so, some of the paintings, especially *Scotland for Ever*! and *The Roll Call* have never ceased to be popular. In bringing together for the first time most of her major works as well as sketchbooks and watercolours made on her travels as a young artist and later as the wife of a successful Army officer, the museum aims to reaffirm her place as a military painter working in the mainstream of British art.

Her Majesty the Queen has graciously agreed to lend Lady Butler's most important painting, *The Roll Call*, and three other works. We are also grateful to the many lenders, including public galleries, regiments and private owners, who have so generously parted with their treasured pictures for the period of the exhibition. Especial thanks must go to the descendants of the artist without whose support and enthusiasm the project would be infinitely less fruitful.

It gives me deep personal pleasure to praise the splendid complementary skills of the cataloguers and authors of a fascinating series of essays, Paul Usherwood, Senior Lecturer in Art History at Newcastle-upon-Tyne Polytechnic and Jenny Spencer-Smith, Keeper of Fine Art in the National Army Museum. The undoubted success of their venture has been totally dependent on an unselfish partnership. Only close collaboration could have surmounted the problems set by distance, the complexity of the task and the urgency with which their contributions were needed by the editor and the printer. Most of the organization of the exhibition has also been Jenny Spencer-Smith's responsibility. She was fortunate to have the expert advice and support of Susan Beale, Senior Restorer in the National Army Museum.

After the exhibition closes at the National Army Museum the major part of it will go on to be displayed at the Durham Light Infantry Museum & Arts Centre and at Leeds City Art Gallery. We anticipate that its appearance at these three venues will go some way to reassessing Lady Butler's contribution to military painting.

ACKNOWLEDGEMENTS

Requests to borrow paintings from private, public and regimental collections have met with a most generous response and we are indebted to the owners who have so magnanimously agreed to lend exhibits, both those whom we can acknowledge here and others who prefer to remain anonymous.

Her Majesty the Queen; Musée de l'Armée, Paris; Mrs Brigid Battiscombe; Bury Art Gallery & Museum; Mr Rupert Butler; Mrs Hester M Whitlock Blundell; Major-General J M Strawson CB OBE, Chairman, and the Board of the Cavalry and Guards Club; Mr Leo Cooper; John Dewar & Sons Ltd; Dorset County Council; Mrs A E Douglas; The Abbot of Downside and the Trustees of Downside Abbey; Mrs Catherine Eden; Mrs Hermia Eden; The Baroness Elliot of Harwood DBE; Ferens Art Gallery, Hull City Museums and Art Galleries; Mr and Mrs G W Fielding; Mr J N Fowles; The Gloucestershire Regiment; The Viscount Gormanston; Mrs Elizabeth Hawkins; Mr C Haworth-Booth; Mr D G P Heathcote; 1st Battalion Irish Guards; King's Shropshire Light Infantry Regimental Trustees; The Regimental Museum XXth The Lancashire Fusiliers; Leeds City Art Galleries; Mr N S Lersten; Manchester City Art Galleries; Mappin Art Gallery, Sheffield; Trustees of the National Museums and Galleries on Merseyside (Walker Art Gallery); Mr and Mrs Paul Mostyn; The National Portrait Gallery; Mr G K M Newark; Mr Antony Preston; The Hon Robert Preston; Regimental Trustees, The Queen's Own Highlanders; The Queen's Regiment; General Sir Robert Ford GCB CBE, Governor, and the Commissioners of the Royal Hospital Chelsea; D Company, 4th Battalion The Royal Irish Rangers; Colonel J A D Dunsmure OBE, Scots Guards; Mrs Marie Kingscote Scott; The Somerset Military Museum Trust; Mr Ninian Crichton Stuart; The Trustees of the Tate Gallery; The President of the College and University College Dublin; The Right Reverend Monsignor D P Wall; Colonel M B Haycock CBE TD DL, Chairman, and the Warwickshire Yeomanry Museum Trust; Mr Christopher Wilkinson-Latham.

We also extend our warm thanks to the following who have given generous advice in locating and documenting works by Lady Butler or their invaluable assistance in organising the loan of pictures and preparing the catalogue:

Mr K A Abel CBE DL, Dorset County Council; Professor Bo Almqvist, University College Dublin; Mr A J Ashton, Bury Art Gallery and

Museum; Mr Michael Baldwin, Sotheby's Ltd; Major Michael J Barthorp; Mrs Julia Baxter, the Royal Collection; Miss Susan Beale, National Army Museum; Mr C Billingham, Bury Art Gallery and Museum; Mr M Bishop, the Royal Collection; Mr and Mrs Brian Whitlock Blundell; Mr Anthony Brown; Miss S Buckley; Mr W Y Carman; Major J N A Crichton-Stuart, Scots Guards; Mrs Jean M Deakin; Mr Kevin Dennigan; Mr L de Pinna, the Cavalry and Guards Club; The Viscount Dunluce, the Tate Gallery; Mr Simon Dunstan; Mr Charles Elliott, National Army Museum; Mr Oliver Everett, the Royal Collection; Lt-Col A A Fairrie, The Queen's Own Highlanders; Mr Geoffrey W Fielding; Father Charles Fitzgerald-Lombard, Downside Abbey; Forbes Magazines, New York; Mr Christopher Gilbert, Leeds City Art Gallery; Lt-Col H R Gilliver MBE, the Regimental Museum of The Gloucestershire Regiment; Mr Timothy Green, the Tate Gallery; Major C B Grundy MC, the Shropshire Regimental Museum; Major J McQ Hallam, the Regimental Museum XXth The Lancashire Fusiliers; Mrs Elizabeth Hawkins; Mr Oliver Hawkins; Colonel M B Haycock CBE TD DL, Warwickshire Yeomanry Museum Trust; Major Brian Holt, 1st Battalion Irish Guards; Lt-Col J J Kelly OBE, Royal Hospital Chelsea; Mr Graham Langton, Tate Gallery Publications; Major Michael Lee; Mr Boris Mollo TD, National Army Museum; Mr Andrew McNeil; Sir Oliver Millar KCVO FBA FSA, the Royal Collection; Mr R L StC Murray, John Dewar & Sons Ltd; Dr Pamela Gerrish Nunn; Major J K Patmore, Army Staff College; Miss Viola Pemberton-Pigott, the Royal Collection; Mr Antony Preston; The Hon Robert Preston; Lt-Col R E Ratazzi, Army Staff College; Miss Elizabeth Talbot Rice TD, National Army Museum; Mr Alec Robertson, Leeds City Art Gallery; Mrs Annette Robinson, National Army Museum; Mr Stephen Shannon, Durham Light Infantry Museum & Arts Centre; Mrs Christine Leback Sitwell; Mr Peyton Skipwith, the Fine Art Society; Major R P Smith, the Regimental Museum of the South Wales Borderers & Monmouthshire Regiment; Mr David Smurthwaite, National Army Museum; Mr Timothy Stevens; Miss Margaret Stewart, National Gallery; Mr Ninian Crichton Stuart; Mr Simon Taylor, Sotheby's Ltd; Mr Julian Treuherz, Manchester City Art Gallery; Mrs Barbara Usherwood; Mr Ralph Usherwood; Mr Jeffrey A Watson, The Arts Council of Great Britain; Capt J F F Weir, D Company, 4th Battalion The Royal Irish Rangers; Mrs L M West, Ferens Art Gallery, Hull City Museums and Art Galleries; Colonel P O Willing, Musée de l'Armée; Lt-Col H R G Wilson, 1st Battalion Irish Guards; Lt-Col L M Wilson MBE, The Queen's Regimental Museum; Mr Christopher Wood; Lt-Col R G Woodhouse, the Somerset Military Museum Trust; Mr Kai Kin Yung, National Portrait Gallery.

Extracts from Edward McCourt *Remember Butler. The Story of Sir William Butler*, London 1967 appear by permission of Routledge & Kegan Paul Ltd

LADY BUTLER – BATTLE ARTIST
1846–1933

*'Thank God I never painted for the glory of war,
but to portray its pathos and heroism'*[1]

INTRODUCTION

Elizabeth Southerden Thompson, subsequently Lady Butler, was the first painter to celebrate the courage and endurance of the ordinary British soldier. In the words of her brother-in-law, Wilfrid Meynell, a champion of her work, 'Lady Butler has done for the soldier in Art what Mr Rudyard Kipling has done for him in Literature – she has taken the individual, separated him, seen him close, and let the world so see him.'[2]

Without the benefit of military connections in her family or first-hand knowledge of battle, Elizabeth Thompson addressed the experience of nineteenth-century warfare in her pictures; what it had been like to be an infantryman facing the charge of a regiment of French cavalry, or to have ridden into 'the Valley of Death' with the Light Brigade. Previously, there had been many paintings depicting panoramic views of battles and scenes of gallant officers performing heroic deeds, but few in British art which conveyed the individual soldier's experience of battle.

Yet despite her singular achievement, there has been no exhibition or detailed survey published of Lady Butler's work.[3] The essays which do find a place for her are, on the whole, those devoted solely to women artists.[4] This oversight has continued despite the current resurgence of interest in Victorian painting.

In the past, both military and art historians have been reluctant to pay

1. Obituary, *The Times* 4 October 1933
2. Wilfrid Meynell 'The Life and Work of Lady Butler' *The Art Annual*, 1898, p 31
3. The painter held exhibitions at the Leicester Galleries in 1912, 1915, 1917 and 1919. These mostly showed her recent work in watercolour and had no pretensions to being comprehensive surveys.
4. An example of the way Elizabeth Butler has been ignored in surveys of art of the period is the book *English Art 1870–1940* Clarendon Press, Oxford, 1978 by Dennis Farr which does not mention the painter at all. Those surveys of women's art which mention the painter include; Ellen C Clayton *English Female Artists* Tinsley Brothers, London, 1876; Clare Erskine Clement *Women in the Fine Arts* Cambridge Press, Massachusetts, 1904; Walter Shaw Sparrow *Women Painters from the time of Catherine Vigri, 1413–1463, to Rosa Bonheur and the Present Day* Art and Life Library, London, 1905; Elsa Honig Fine *Women and Art: Women Painters and Sculptors from the Renaissance to the 20th Century* George Prior, London, 1978; Ann Sutherland Harris and Linda Nochlin *Women Artists 1550–1950* County Museum of Art, Los Angeles, 1979; Germaine Greer *The Obstacle Race* Secker and Warburg, London, 1979; *The Women's Art Show* Castle Museum, Nottingham, 1982; Charlotte Yeldham *Women Artists in France and England* Garland, New Jersey and London, 1984.

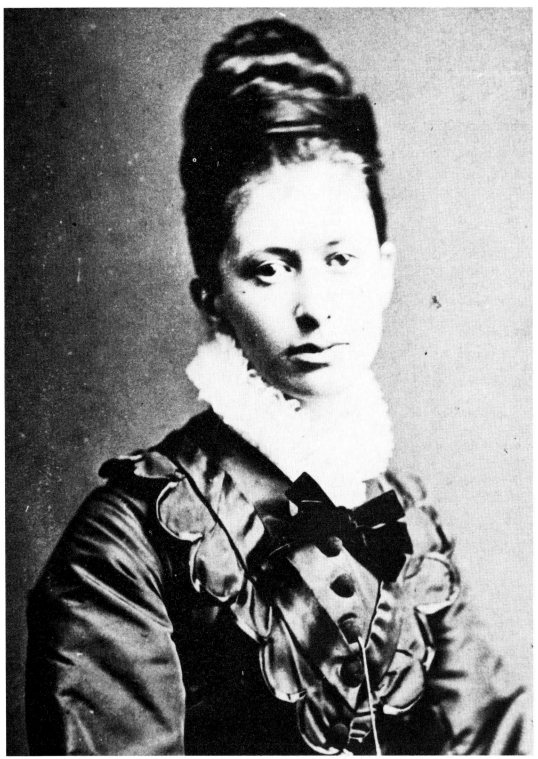

19. Elizabeth Thompson, 1874. See p 59.

much attention to battle paintings prior to the Great War, except on those occasions where they have been an important source of contemporary documentation, for example in depicting uniform. Moreover, although Elizabeth Butler's fame eclipsed that of any other British female artist in the nineteenth century, it was relatively short-lived. The period of her most popular success lasted for about seven years, from 1874 until 1881. By the early 1880s, her particular type of sombre, intimate battlefield scene had already been supplanted in public esteem by the more triumphal work of her followers and rivals, such as Richard Caton Woodville, Charles Edwin Fripp and Godfrey Douglas Giles (see below, pp 167–175). Butler was not forgotten, however. Until her death in 1933 she was always remembered as the painter of *The Roll Call*, one of the most popular exhibits at the Royal Academy in the nineteenth century.

Today the assessment of Butler's position in the genre of military art and in Victorian painting as a whole is changing. Historians are studying military painting of the last century and as a result the importance of her work in this field is beginning to be appreciated.[5] It is recognised that her early pictures, such as *The Roll Call, The 28th Regiment at Quatre Bras* and *Balaclava*, initiated a type of battle picture in Britain which was successful because it was especially attuned to the climate of opinion at the time. Her painting was patriotic, but it did not seek to glorify British victories, unlike the work of many of her successors. And, although the message of these soldiers' heroism is also idealistic, she instigated a more democratic vision of war in British art by concentrating on the experience of the ordinary soldier in battle.

Undoubtedly, Elizabeth Butler's work deserves wider recognition. Despite her sex, she was one of the leaders of her profession, a battle painter who found fame at a time when the Army and the Empire were an integral part of Victorian culture. In the words of Jean Louis Ernest Meissonier (1815–91), one of the greatest exponents of the military genre in France, '*L'Angleterre n'a guère qu'un peintre militaire; c'est une femme*' (England really has only one military painter – a woman).[6] This exhibition aims to redress the oversight of posterity by showing the range and depth of Lady Butler's *œuvre*.

5. See Matthew Paul Lalumia *Realism and Politics in Victorian Art of the Crimean War* UMI Research Press, Michigan, 1984, and by the same author; 'Lady Elizabeth Thompson Butler in the 1870s' *Woman's Art Journal*, Spring/Summer 1983; 'Realism and Anti-aristocratic Sentiment in Victorian Depictions of the Crimean War' *Victorian Studies*, Autumn 1983; Joan Hichberger 'Military Themes in British Painting 1815–1914', unpublished University of London PhD thesis, 1985; Jean M Deakin 'The Art and Life of Elizabeth, Lady Butler, Military Artist, 1846–1933', thesis for Diploma in Fine Art, Mid-Warwickshire School of Art, 1978.
6. See note on p 163.

AMAZON'S WORK

'...Amazon's work this; no doubt about it...', was Elizabeth Thompson's tribute from John Ruskin, that most influential of all nineteenth-century art critics, in 1875.[1] Like many other commentators he was surprised by the apparent incongruity of this novel phenomenon, a young woman who had achieved popular success with battle scenes. Not only was the subject matter considered to be a male preserve but it also demanded months of research, hours of labour and the ability to handle large-scale figure compositions. This required time, energy and a thorough formal training, especially in studying the human figure. Inevitably, once she became famous, there were some far-fetched speculations as to Elizabeth Thompson's past career. Her father felt obliged to write to the papers to set the record straight;

> May I, once and for all – for I have a horror of playing the part of *le père de la debutante* – beg to assure all who are placed to take an interest in my daughter that she is not, nor ever has been married; that she is not, and never has been, never could be a hospital nurse; and that any other report is inconsistent with the facts that her life has been a very uneventful one, and that she has been from her earliest days the inseparable companion of her parents – very quiet people, but proud to find the talents which they gradually developed so generally and generously recognised now.[2]

'Uneventful' the painter's upbringing may have been but it was also unconventional. Her family's interests were artistic. Her father, Thomas James Thompson (1812–1881) was a gentleman of private means, inherited from his grandfather whose money had been made in West Indian sugar plantations.[3] Since the terms of his grandfather's will stipulated that he was not to follow a profession, Thompson took to European travel and the pursuit of his own cultural interests. The painter's mother, Christiana Weller (1825–1910) shared her husband's interest in

1. E T Cook and A Wedderburn *The Works of John Ruskin* Library Edition, London, 1903–12, Vol XIV, p 138, *Academy Notes*, 1875
2. *The Times* 11 May 1874, report of a letter in *The Pall Mall Gazette*
3. Kathleen Tillotson ed *The Letters of Charles Dickens 1844–46*, Vol IV, Clarendon Press, Oxford, 1977. Thomas James Thompson had studied at Trinity College, Cambridge and stood three times for Parliament as a Liberal candidate, without success. He met Dickens in 1838.

art. In her youth, she had acquired a reputation as a talented pianist and singer and it was after one of her public piano recitals that Charles Dickens first introduced his friend Thompson to her.[4] However, as was customary, she ceased to give professional concerts after her marriage. She was also an able watercolourist, proficient enough to paint sketches for her daughter's guidance when depicting landscapes in her large oil paintings.

Elizabeth Thompson was born on 3 November 1846, in Lausanne by Lake Geneva. Her sister, later to achieve considerable fame as the poet, essayist and critic, Alice Meynell, was born a year later.[5] From 1851, the two girls spent much of their childhood on the Ligurian coast of Italy, constantly moving from place to place in pursuit of their father's interest in Italian culture. Moreover, despite his inheritance, he was not a wealthy man and the cost of living abroad was considerably less than in England.[6]

Both girls remembered their childhood as having the freedom to play as they pleased in the open air and perpetual sunshine. The winter months of most years were spent in Italy, the summer months at Edenbridge in Kent; a happy and full childhood such as few English girls of their class would have known. In 1853, in a letter to his wife, Charles Dickens described a visit to the Thompsons at Sori, near Genoa, which reveals the almost Bohemian life they led;

> I found T[hompson] with a pointed beard, smoking a great German pipe, in a pair of slippers; the two little girls very pale and faint from the climate, in a singularly untidy state – one (Heavens knows why!) without stockings, and both with their little short hair cropped in a manner never before beheld, and a little bright bow stuck on the top of it.[7]

Elizabeth, who took after her mother, was ebullient and something of a tomboy, while her sister's personality resembled that of their more reclusive father.[8]

4. Graham Storey and K J Fielding eds *The Letters of Charles Dickens 1847–49* Vol V, Clarendon Press, Oxford, 1981. Dickens described Christiana Weller as '. . .the fair forte piano player of Liverpool' in a letter of 11 July 1847. For a brief period, he had been infatuated with her but after his friend's marriage in October 1845, his view of her changed. 'Mrs Thompson disappoints me very much. She is a mere spoiled child, I think, and doesn't turn out half as well as I expected. Matrimony has improved him, and certainly has not improved her' *ibid* p 604, 17 Aug 1846.
5. *Ibid*, Vol IV p 652, note 1; Dickens gave the precise time of her birth: '13 1/2 past two in the morning', Tuesday 3 Nov, 1846. It is possible that the confusion about the date of the painter's birth (*The Times*, 4 Oct 1933) arose from the mistaken reports in 1874 that she was only 23 years old (see below, pp 36).
6. *Ibid*, Vol V, p122; Dickens lent his friend £1,000 in 1845 and the loan was renewed on 1 July 1849.
7. Quoted in June Badeni *The Slender Tree. A Life of Alice Meynell* Tabb House, Padstow, 1981, p 8. Viola Meynell *Alice Meynell. A Memoir* Jonathan Cape, London, 1929, p 20. Alice's daughter, Viola, maintained that the two girls suffered in realising how unusual their upbringing was.
8. Gertrude Sweetman TS Personal Recollections of Elizabeth Thompson (Lady Butler) p 3; Collection of Mrs Hester Whitlock Blundell. Gertrude Sweetman was a close friend of the painter from the 1890s until the painter's death in 1933.

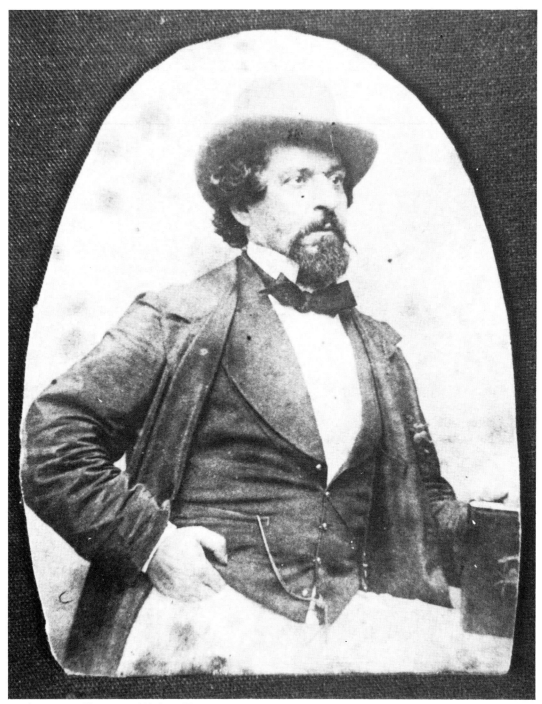

1. Thomas James Thompson c1850. See p 47.

The two girls were also fortunate in their education. Exceptionally, this was not undertaken by governesses but assumed personally by Thompson. By the standards of the day it was wide-ranging, thorough and rigorously taught. Thomas Thompson placed particular stress on 'old English history'.[9] Writing to his wife in 1851, he noted; 'The children's greatest amusement is writing History – the history of their respective Islands. Mimi [the painter] illustrates hers with portraits of the sovereigns, not without variety and character.'[10] Thompson's love of history was to be an important formative influence upon his elder daughter's choice of career.

In addition to history the girls learnt French, Italian, poetry and the Liturgy, and as was customary with girls of their class, art was encouraged. From an early age, Elizabeth showed talent in this latter field and it was recorded that '. . .everywhere the family went. . .the child's head went out of the window, watching with an insatiable interest, the changing of horses, the action of soldiers, the ever-varying humours of the roadside' which she unceasingly sketched.[11] Her early sketchbooks show a fascination with the representation of movement and character, as well as with the variety of uniforms to be seen at that time in Europe. Later, she determined to acquire a proper artistic training; one which eventually led her to realize a professional career.

In 1862, at the age of fifteen, Elizabeth Thompson began taking lessons in oil painting from W Standish in London, spending two hours a week painting his own copies of Edwin Landseer's pictures. Shortly after, she enrolled at the elementary class at the Female School of Art, South Kensington, but disliked its design-oriented regimen of copying scrolls and patterns so much that she soon left. For the next three years she received no formal training but sketched and painted while continuing to travel with the family. The Thompsons settled for a year at Bonchurch in the Isle of Wight and there, Elizabeth Thompson recorded, '. . .it became more and more borne in upon me that, if I intended to be a great artist. . .my young teens were the right time for study'.[12] She petitioned her parents and in 1866, at the age of nineteen, she returned to the Female School of Art and began attending the advanced classes. The school, which had been founded thirty years before as an adjunct to the Government Schools of Design, was primarily concerned with producing designers, teachers and 'accomplishment' artists, rather than prospective Academy exhibitors. However, at this time there was little alternative; it was still the only women's art school of any size in the country. The Academy Schools took only a very few women students and the Slade School of Art had yet to be founded.[13]

Elizabeth ensured that she received the most demanding training that the institution had to offer. At first, this entailed drawing plaster casts of

9. Elizabeth Butler *An Autobiography* Constable & Co Ltd, London, 1922, pp 1–2
10. Viola Meynell, *op cit*, p 22
11. Wilfrid Meynell 'The Life and Work of Lady Butler' *The Art Annual* 1898, p 2
12. Butler, *op cit*, p 14
13. Charlotte Yeldham *Women Artists in France and England* Garland, New Jersey and London, 1984, Vol I, pp 18–20

classical statuary for five hours a day, proceeding from fragments of figures to whole statues. After two and a half months, by special dispensation of the headmaster, Richard Burchett, she was permitted to enter the Life Class and she recorded her enthusiasm in her diary, 'Oh, joyous day! oh, white! oh, snowy Monday! or should I say *golden* Monday?'[14] For reasons of propriety, the Life Class was not allowed to draw naked subjects and the model was usually dressed as an historical figure, such as Thomas Cranmer or a Roundhead soldier in helmet and breastplate.[15] Accordingly, she supplemented her studies by attending a private, 'undraped female' life class in Bolsover Street. While she enjoyed drawing figures in historic dress, to succeed in the *genre militaire*, the type of painting on which she had determined, she needed to acquire a thorough understanding of anatomy. In 1869, she interrupted her final year at South Kensington to spend several months under the tuition of Giuseppe Bellucci at the Academy of Fine Arts in Florence. Bellucci was a stern, traditional teacher of draughtsmanship, who only allowed his pupils to paint in monochrome.

In the 1860s Elizabeth Thompson's training was exceptional both in its thoroughness and in its bias towards drawing, a partiality which had lasting effects. That she did not handle colour and paint with the same freedom and confidence as line was a point noted by John Everett Millais in referring to *The 28th Regiment at Quatre Bras* in 1875 (fig 5); '. . .she draws better than any of us, but I wish her *tone* was better'.[16] It was also her practice as a professional artist in commencing a canvas not to build up a composition in paint directly onto the surface, but rather to draw the overall design on a piece of tinted paper of the same size as the intended work with charcoal and white chalk (see Cat 36 and 56). With further preparatory studies, she would then establish the best pose for each figure in the composition, a good example of which are the sketchbook drawings for *Dawn of Waterloo* (Cat 59).

This slow and methodical way of working was also in character, for as a student Elizabeth Thompson was renowned for her dedicated, painstaking approach. Speaking of those days, she later told a friend, 'I was never ill, or rather, I never allowed myself to be ill, or to have headaches and migraines to which so many girls in those days yielded obeisance.'[17] Nor was she slow to express her views, for, in a letter to her sister she wrote, '. . .the way I have to implore, threaten and argue with the model! (I being the spokeswoman of the whole class.)'.[18] She was also keenly competitive. When a study by a fellow student, Kate Greenaway, who later achieved fame as an illustrator, was judged to be the best in class, she was chagrined. 'My study was "second best" which was no more than I

14. Butler, *op cit*, p 43
15. Germaine Greer *The Obstacle Race* Secker and Warburg, London, 1979, p 320
16. Butler, *op cit*, p 301
17. Sweetman, *op cit*, p 7
18. MS letter from the painter to her sister, 30 May 1868; Collection of Hermia Eden, Catherine Eden and Elizabeth Hawkins.

expected. Miss Greenaway is champion once more, and no wonder she bumped me seeing how hurriedly my little thing was done. . .'.[19] She also delighted in writing to her mother to describe a party she attended, eagerly recording the names of the artistic luminaries that she met and their remarks. Among them, the critic Cave Thomas was flattering enough to suggest that she could become another Rosa Bonheur, at that time the most celebrated female artist. Thompson replied that she had no intention of following the Frenchwoman to become an animal painter.[20]

In her autobiography Elizabeth related that throughout her studies she was guided by a determination to be a military painter. However, after completing her training with a final term at the Female School of Art, her first oil painting was of a religious subject, *The Magnificat* (see below, p 25). It was rejected by the Royal Academy, as was the genre painting she submitted to them the following year. There were other factors which influenced her subsequent choice of historical battle scenes. The idea was still current that 'history painting' constituted the supreme discipline, a doctrine promulgated by the first President of the Royal Academy, Sir Joshua Reynolds. There is no doubt that Thompson wished to be a great artist and that in painting military history she was setting her sights high. Her interests, influenced by her father, already lay in this direction but she also realised that the particular genre of battle painting was, in her own words, almost 'non-exploited' in Britain at that time. In the 1860s Thomas Jones Barker (1815–82) and George Jones (1786–1869) were the only painters regularly exhibiting battle pictures at the Royal Academy. Even in 1874, when *The Roll Call* (Cat 18) was exhibited at the Royal Academy, there was only one other battle picture on show, *La charge des cuirassiers français à Waterloo*, by Felix Philippoteaux (fig 17).

Although by 1870 Elizabeth was already exhibiting watercolours of military subjects, she had yet to undertake a full-scale historical painting. In July the Franco-Prussian War broke out and as she recorded in her autobiography;

> I was asked, as the war developed, if I had been inspired by it, and this caused me to turn my intention pictorially that way. Once I had begun on that line I went at a gallop, in watercolour at first, and many a subject did I send to the "Dudley Gallery" and to Manchester, all the drawings selling quickly, but I never relaxed that serious practice in oil painting which was my solid foundation.

19. M H Spielmann and G S Layard *Kate Greenaway* Adam and Charles Black, London, 1905, p 43. Thompson and Greenaway were such hard workers that they used to bribe the caretaker to lock them in the studios when the other students had left so that they could work a little longer.
20. MS letter from the painter to her mother, July 1868; Collection of Hermia Eden, Catherine Eden and Elizabeth Hawkins. The careers of Thompson and Bonheur have often been compared. Both practised what were then considered to be 'minor' genres, flourishing at a time when the traditional academic ideas in their respective countries were being challenged.

The watercolours were modestly successful, as were those she made of the British Army's manoeuvres in the New Forest in the autumn of 1872, where one of the generals, who knew of her Franco-Prussian War pictures, asked her to '. . .give the British soldiers a turn'.

Elizabeth's parents were becoming concerned at the direction their daughter's artistic career was taking. She later recalled that her father '. . .did not at all like her being so absorbed by the military element, which he considered unsuitable for so young a girl.'[21] Her sensitive mother '. . .detested war, although respecting deeply the heroism of the soldier', preferring her to espouse religious subjects.[22]

Following the success of her watercolours, Elizabeth began her first large military oil, *Missing* (fig 3) in 1872, and the next spring it was accepted by the Royal Academy. Thoroughly French in treatment as well as subject, it depicts two soldiers with one mount journeying through a desolate landscape during the Franco-Prussian War. It also derives its theme from early nineteenth-century French military painting; that of anonymous, suffering soldiers on the retreat from Moscow. In her next major work, *The Roll Call*, the French influence is even clearer, except that this owes more to the younger generation of artists who came to prominence after the defeat of 1870–71. *The Roll Call* with its sombre colours, lack of any overt emotion and its focus on an otherwise unrecorded incident in a campaign, echoes the Franco-Prussian War scenes of artists such as Edouard Detaille and Alphonse de Neuville (see below, pp 160–6).

Although Elizabeth did not mention these artists in her autobiography as an important influence upon her, she had certainly had occasion to see their work. In 1870, just before the start of the Franco-Prussian War, she visited the Paris Salon while returning to London from Italy. In the following years, there were chances to see such paintings at Goupil's or Gambart's French Gallery in London. In December 1874, after the success of *The Roll Call*, her father accompanied her to Paris where she recorded meeting 'my most admired French painters'. She visited Jean Léon Gérôme, the historical painter and sculptor, who spoke of the celebrity of her picture '*L'Appel*' and the studio of Edouard Detaille, 'my greatest admiration at the time'. At Goupil's gallery they saw Alphonse de Neuville's painting, *Combat on the roof of a house* (*Combats sur les toits-Floing, près Sedan*) and she recalled that 'I feasted my eyes on some pickings from the most celebrated artists of the Continent. . .a great treat and a great lesson'. On her return to London she reappraised her current project, *The 28th Regiment at Quatre Bras*, with a much sharper eye.

Missing constituted the painter's first *entrée* into the world of established art; she was no longer merely a modestly successful female watercolourist, but was launched as a serious artist. She received her first important commission and this determined her to have her own studio in

21. Sweetman, *op cit*, p 3
22. Butler, *op cit*, p 46

London. Despite her father's qualms, with the assistance of the family doctor, Dr Pollard, she rented rooms in Fulham and in December 1873 began work on the painting. The overwhelming public reception of *The Roll Call* at the Royal Academy exhibition the following May brought her at once to the forefront of her profession. Her work attracted many tributes, including that of John Ruskin the following year.

'Amazon', though, was hardly an appropriate accolade. Her intention was not to relish battle or to glorify war. She was by no means a pacifist, but when the London Peace Society wrote to her in 1875, after her second great success, *The 28th Regiment at Quatre Bras*, asking her to '. . .use her talents so that the false nature of the glory of war might not be stimulated', she replied that she 'heartily agreed.'[23] She made it a rule never to portray hand-to-hand combat, but her paintings demonstrate her powerful belief that in the ultimate test of war, the bravery of the individual proves the nobility of man. The clearest expression of her own attitude in painting such scenes is that;

> . . .war – that mysteriously inevitable recurrence throughout the sorrowful history of our world. . .calls forth the noblest and the basest impulses of human nature. The painter should be careful to keep himself at a distance, lest the ignoble and vile details under his eyes should blind him irretrievably to the noble things that rise beyond. To see the mountain tops we must not approach the base, where the foot-hills mask the summits.[24]

In summing up her career in 1898, Wilfrid Meynell wrote;

> It fell to the fortune of Lady Butler to be in her own Art, in this particular, a representative of her time. Paradoxical as it may sound, her Art is part of the Humanitarianism of the Century – the Humanitarianism that will lighten that century's retrospect in the day of its death; is a result of it, and is also perforce a cause. For she has exposed the horror of slaughter by simply centralising it; she has given to the victim of war the single personality that has its appeal to all others of the human family. It is no longer a marionette that is 'put to the sword', but a brother who has been done to death. [25]

23. *The Morning Post* 4 May 1875. Members of the London Peace Society disagreed amongst themselves about Thompson's pictures. Professor Leone Levi believed they were '. . .calculated to do much harm; they gave eclat to war'; Miss Beecher felt they showed the horrors of war '. . .in their true ghastliness'.
24. Butler, *op cit*, pp 46–7
25. Wilfrid Meynell, *op cit*, p 31

EARLY EXHIBITS

Although it was the appearance of *The Roll Call* (Cat 18) at the Royal Academy in 1874 which brought Elizabeth Thompson to the attention of the public, it was not the first picture which she exhibited there. *Missing* (fig 3), her painting of two French soldiers straggling after battle during the Franco-Prussian War of 1870–1871, had been accepted and shown the year before. Despite being hung in a poor position high up on the wall, it was generally liked by reviewers. *The Architect*, for instance, declared that the picture '. . .deserves a place lower down, where the capital drawing of the horse, and the honest and artistic way in which the figures of the victor and captive [*sic*] tell the tale of the name missing from the roll call, could be better appreciated.'[1]

What was more, Thompson had already exhibited several pictures at other venues. Even as a student she had shown paintings, usually watercolours, at those galleries favoured by women artists, such as the Dudley Gallery in London, which she noted that *The Times* had referred to as the 'nursery of young reputations'.[2] In 1867, as a second-year student at the Female School of Art, South Kensington, she began by showing an oil painting, *Horses in Sunshine,* at the Society of Female Artists and a watercolour, *Bavarian Artillery going into action* (Cat 8), which had been rejected by the Society of British Artists, was exhibited at the Dudley Gallery. Her father met the art critic of *The Times*, Tom Taylor, as he came from the press view at the Dudley Gallery and the latter's favourable remarks about his daughter's picture gave the artist considerable encouragement. Another watercolour of artillery, *The Crest of the Hill*, was shown to the great art critic, John Ruskin, when he visited the Thompsons at their London home on 19 March 1868. It had been refused by the Dudley Gallery but the young artist had the satisfaction of hearing Ruskin call the picture 'wonderful!' and refer to it as having 'immense power'. He was not entirely complimentary about all of her works and advised her to avoid imaginary historical subjects such as that of her drawing of Lancelot and Guinevere, which she showed him.

Other pictures which Elizabeth Thompson exhibited before her sudden

1. *The Architect* 24 May 1873
2. See Charlotte Yeldham *Women Artists in France and England* Garland, New Jersey and London, 1984, Vol I, p 69. Only watercolours were exhibited at the Dudley Gallery and in 1873 over 70 of the exhibitors were women.

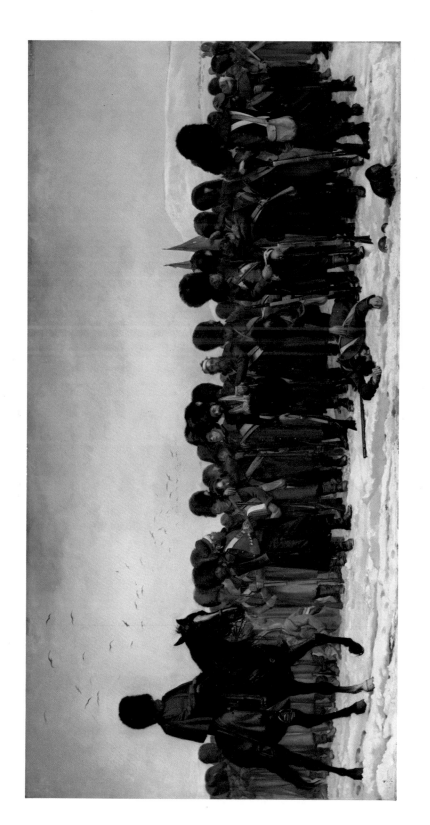

PLATE 1. Cat 18: *The Roll Call*. Reproduced by gracious permission of Her Majesty the Queen

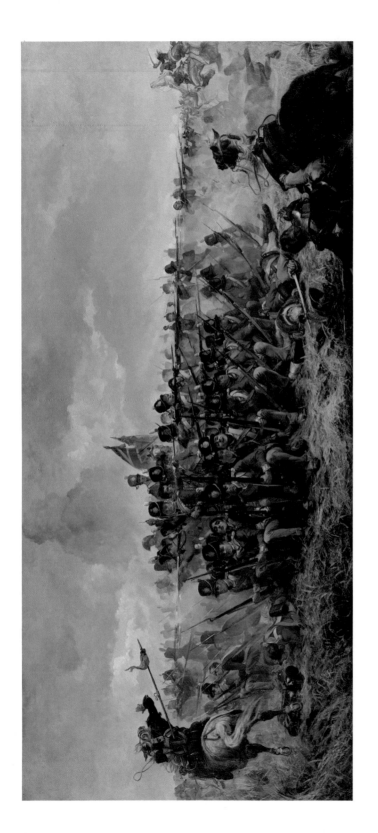

PLATE 2. Fig 5: *The 28th Regiment at Quatre Bras*. National Gallery of Victoria

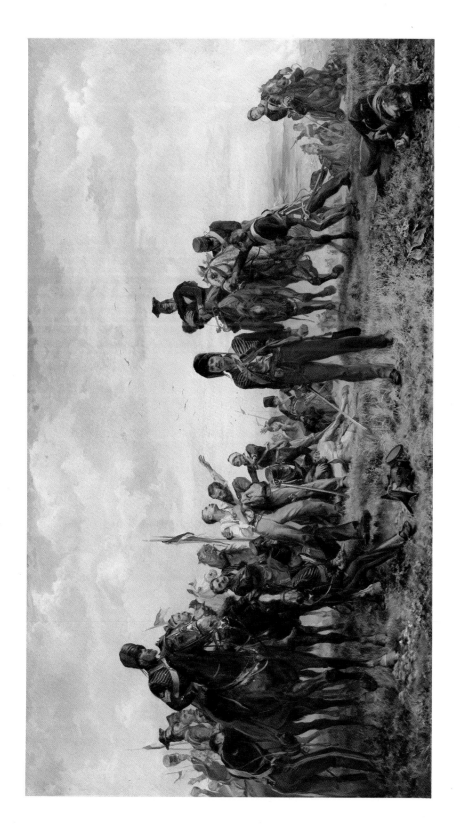

PLATE 3. Cat 25: *Balaclava*. Manchester City Art Galleries

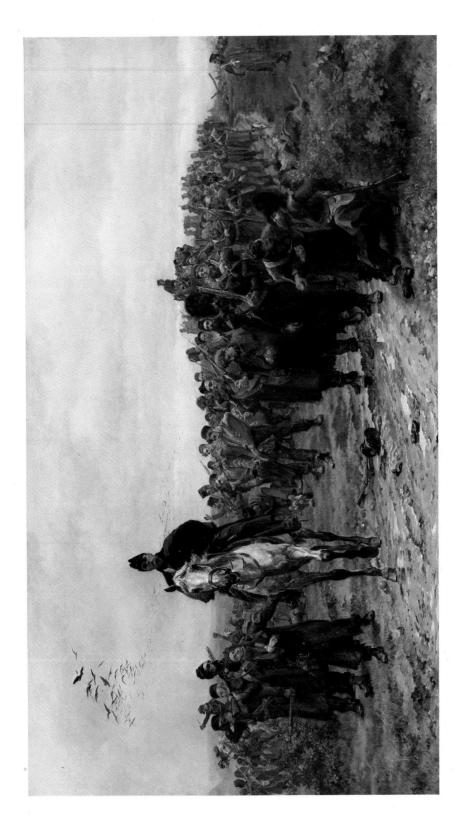

PLATE 4. Cat 26: *The Return from Inkerman*. Ferens Art Gallery

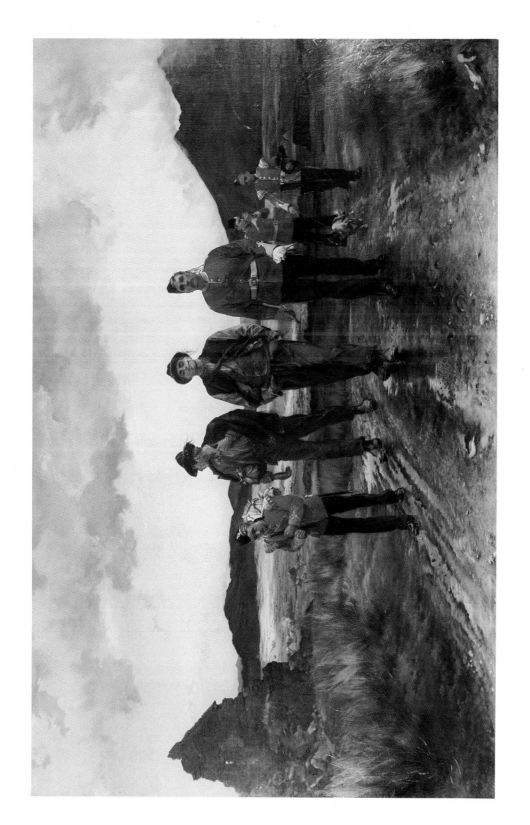

PLATE 5. Cat 30: *"Listed for the Connaught Rangers"*. Bury Art Gallery and Museum

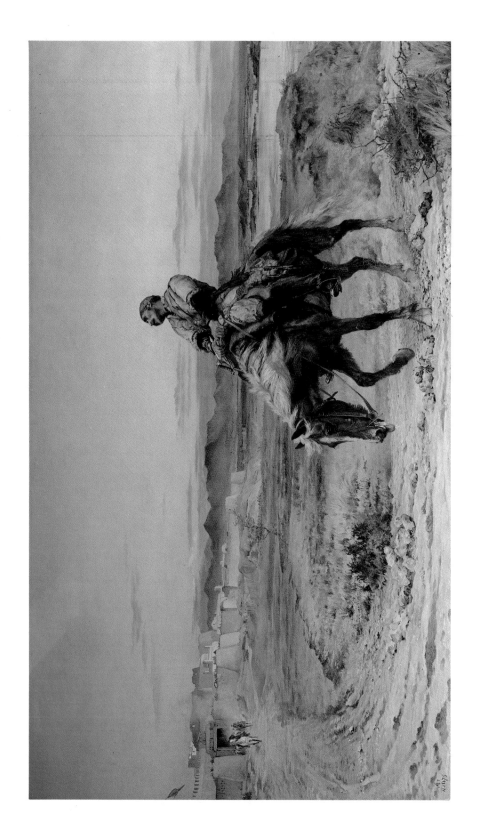

PLATE 6. Cat 31: *The remnants of an army*. The Tate Gallery, London

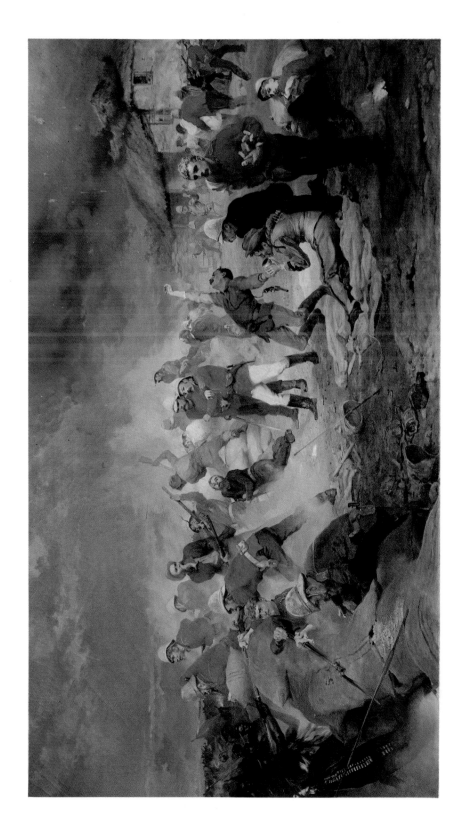

PLATE 7. Cat 33: *The defence of Rorke's Drift*. Reproduced by gracious permission of Her Majesty the Queen

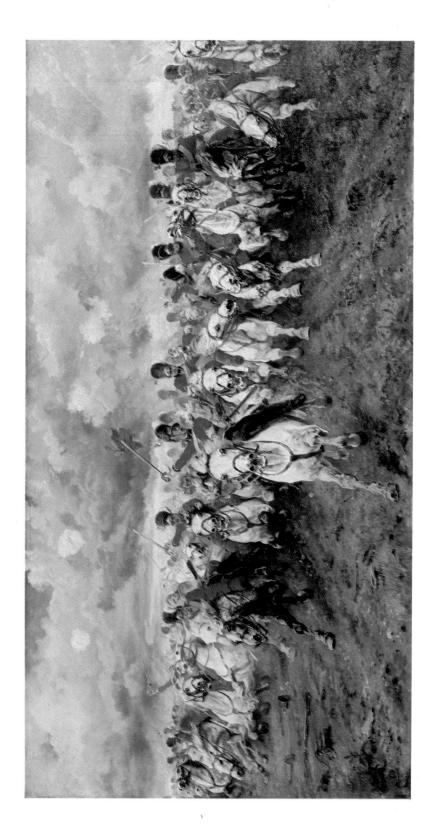

PLATE 8. Cat 36: *Scotland for Ever!* Leeds City Art Galleries

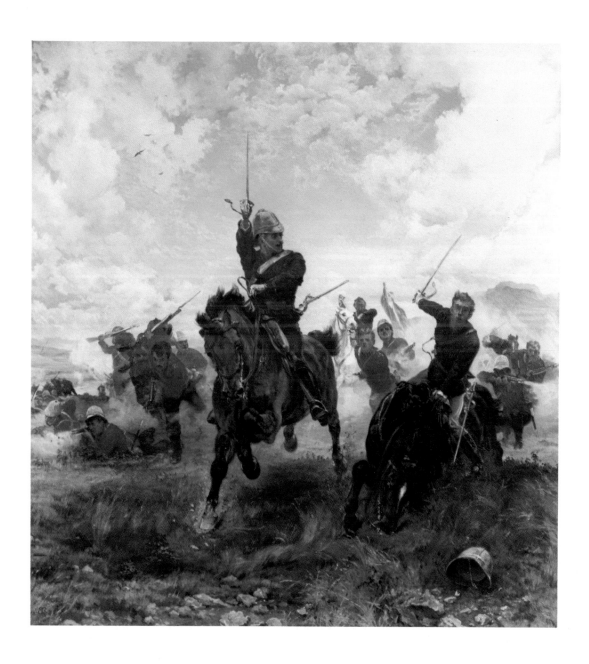

PLATE 9. Fig 8: *"Floreat Etona!"* private collection

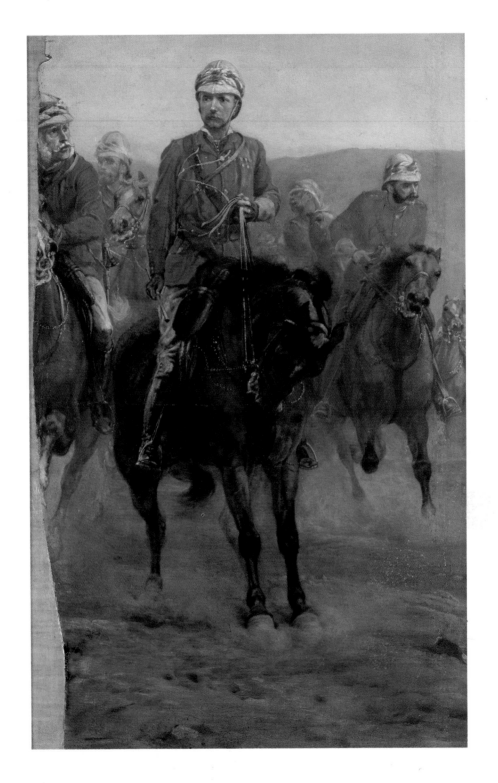

PLATE 10. Cat 41: "*After the Battle*". Mr & Mrs Geoffrey W Fielding

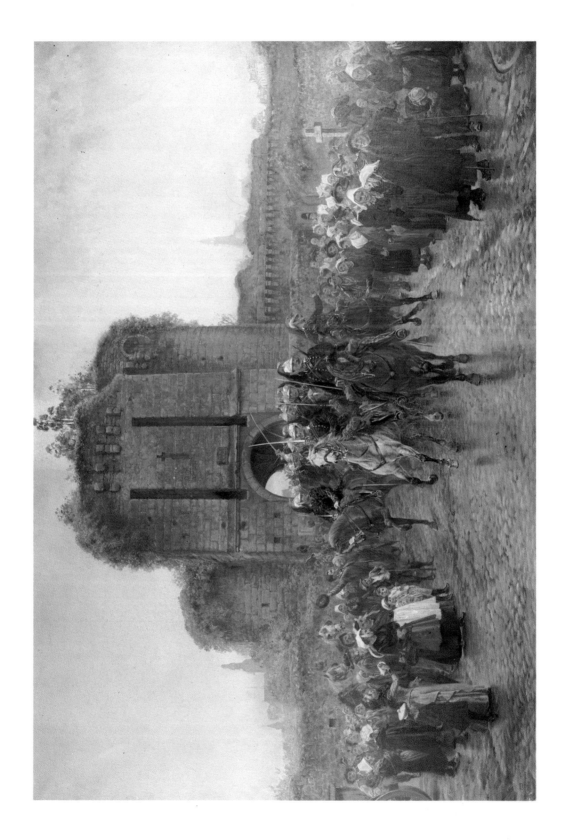

PLATE 11. Cat 45: *To the front*. The Hon Robert Preston

PLATE 12. Cat 46: *Evicted*. University College, Dublin

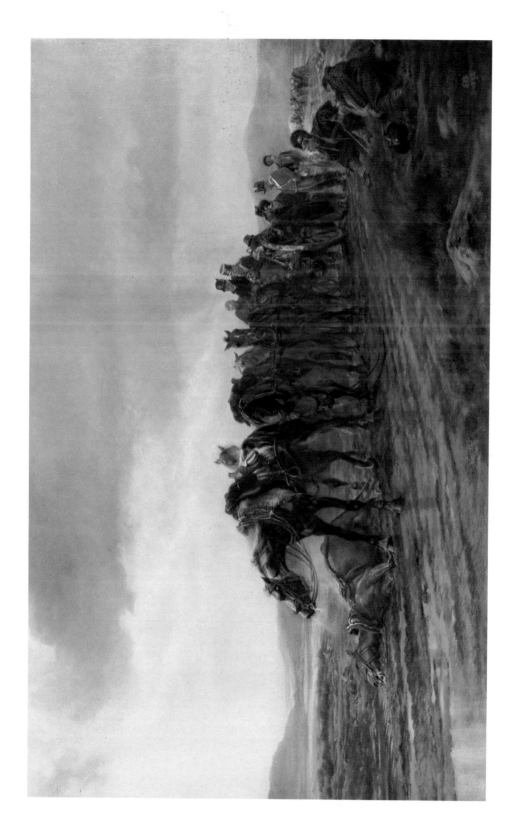

PLATE 13.　Cat 57: *Halt on a forced march: Peninsular War.* King's Shropshire Light Infantry Regimental Trustees

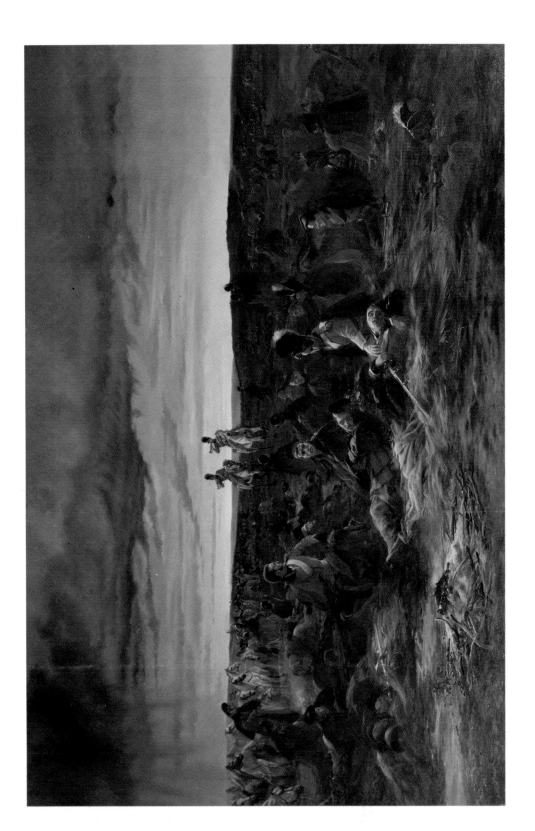

PLATE 14. Cat 60: *Dawn of Waterloo*. Executry of Major M D D Crichton-Stuart

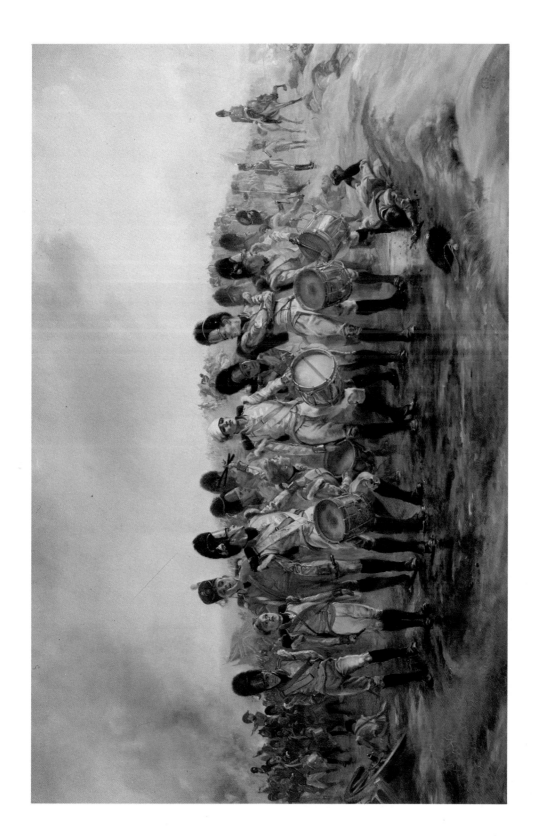

PLATE 15. Cat 61: *"Steady the drums and fifes!"* The Queen's Regiment

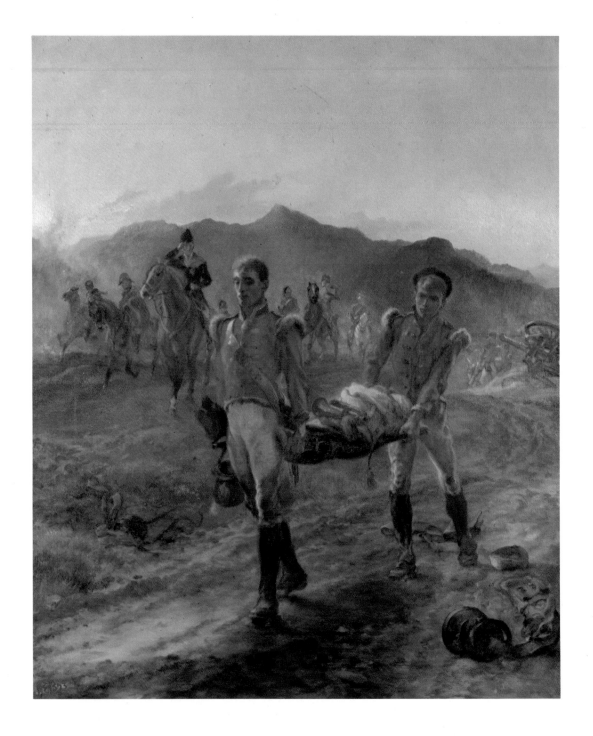

PLATE 16. Cat 62: *On the morrow of Talavera: soldiers of the 43rd bringing in the dead.*
The Hon Robert Preston

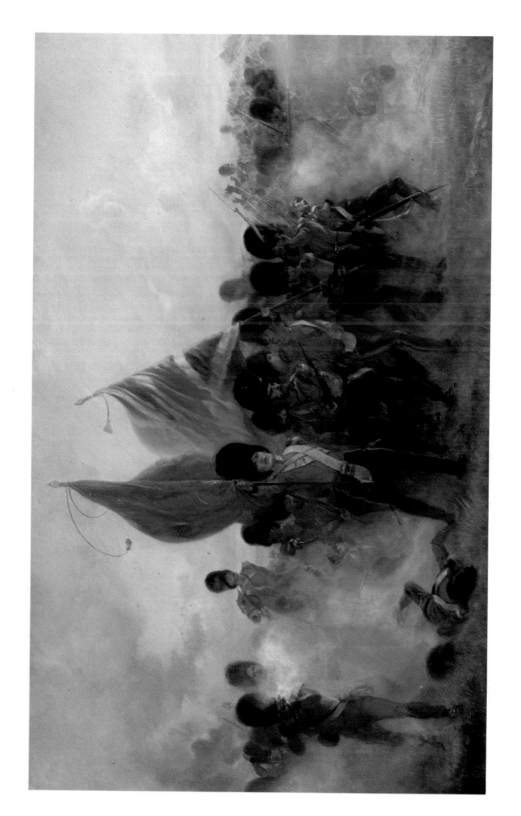

PLATE 17. Cat 64: *The Colours: advance of the Scots Guards at the Alma.* RHQ Scots Guards.

PLATE 18. Cat 87: *Yeomanry Scouts on the Veldt*. The Abbot of Downside

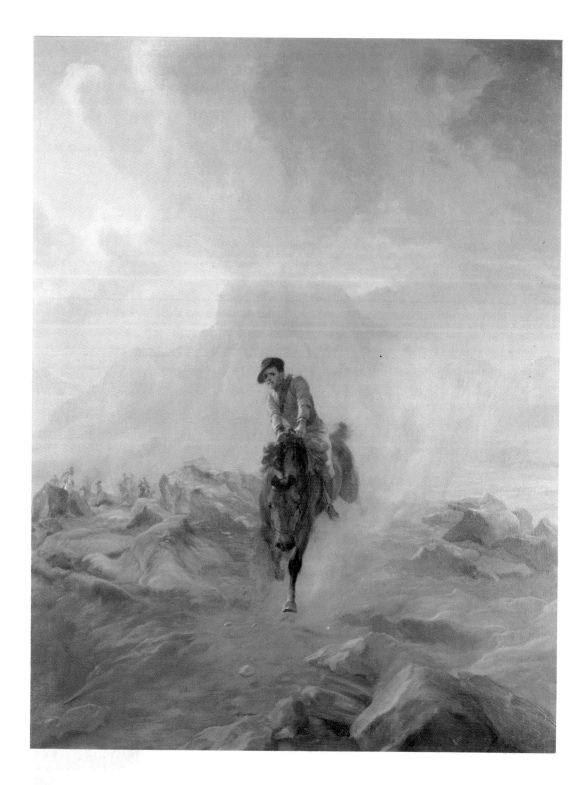

PLATE 19. Cat 88: *Within sound of the guns*. Army Staff College

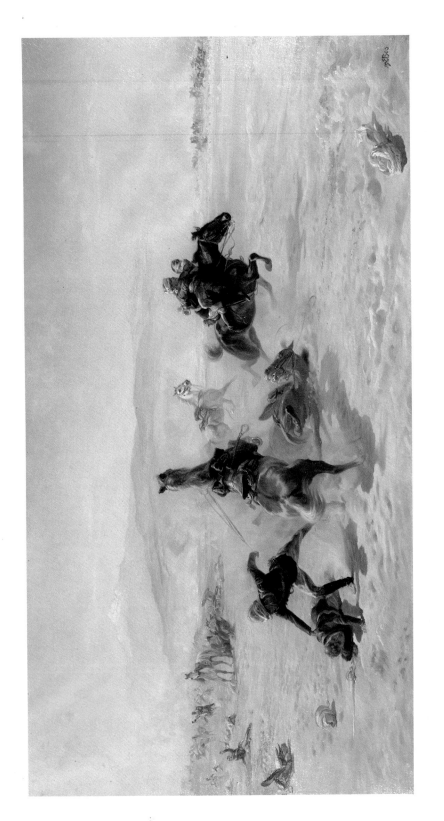

PLATE 20. Cat 90: *Rescue of wounded, Afghanistan*. Army Staff College

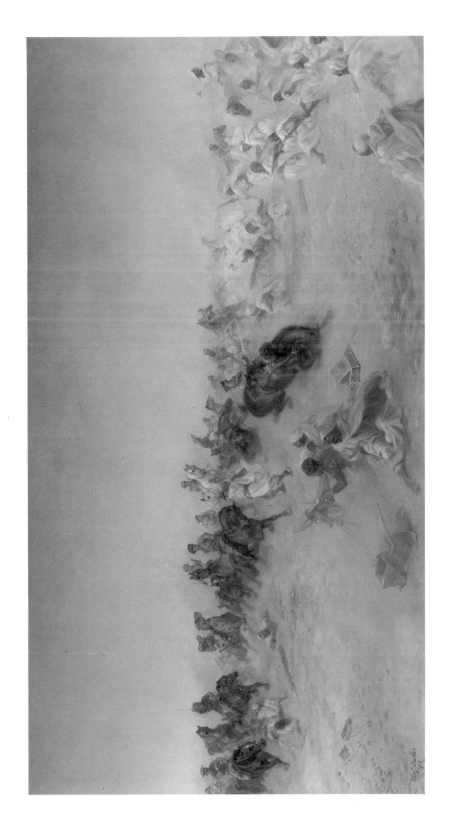

PLATE 21. Cat 108: *The Dorset Yeoman at Agagia, 26th Feb. 1916. Dorset County Council*

PLATE 22. Fig. 15: *"In the retreat from Mons: the royal horse guards"*. Durban Art Gallery

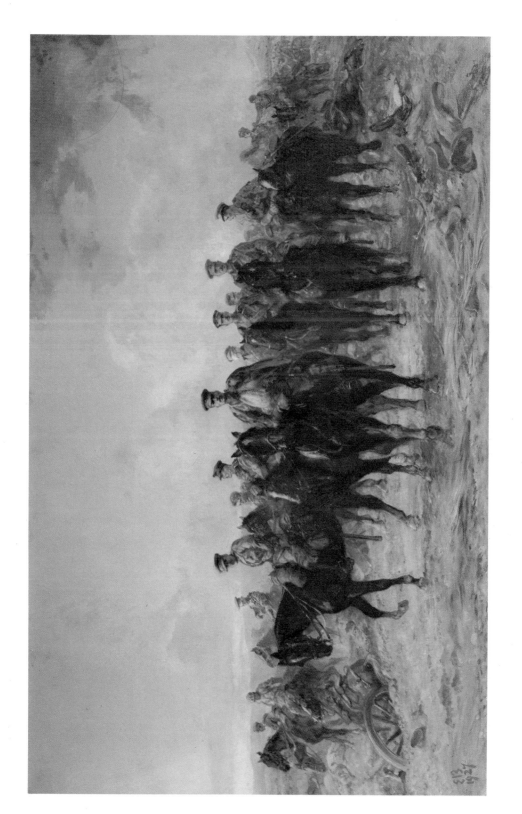

PLATE 23. Cat 114: *"In the retreat from Mons: the royal horse guards"*. Commissioners, Royal Hospital Chelsea

PLATE 24. Cat 115: *A Detachment of Cavalry in Flanders*. Mr N S Lersten

Fig. 2. *Soldiers Watering Horses*, watercolour 1872. Photograph by Sennett & Spears

rise to fame in 1874, were *Resting* and *"On the Look Out"*, two military paintings shown at the Society of Female Artists in 1868. The Society, under the patronage of the Duchess of Cambridge, exhibited a high proportion of works by amateur 'accomplishment artists' but when its name changed to the Society of Lady Artists in 1872, full membership was limited to professional artists. They were restricted to 23 in number and Thompson was one of those granted membership.[3]

In 1868 the Dudley Gallery also displayed a portrait of the artist's sister, Alice Thompson, later the famous poetess Alice Meynell, and in 1871 Thompson had two watercolours on show there, *Wounded and taken Prisoner* and *Ploughing in the Vineyards near Florence* (Cat 12). The following year the gallery exhibited four of her pictures, *Standing at Ease, Bersaglieri Recruits, Genoa; Chasseur Vedette* (Cat 16); *French Cavalry drawn up under Fire, waiting to Charge* and a work entitled *Reminiscences of Rome*. In 1873 it displayed some watercolours developed from sketches of the British Army on manoeuvres and two foreign military subjects, *Drilling the Drummers, Genoa* and *French Artillery on the March*.[4] The prices of these watercolours were usually between eight and twelve guineas each.

Although military subjects were predominant in her *œuvre* even during the early years, Thompson's first major canvas was of a religious subject, *The Magnificat*, also known as *The Visitation* (Church of St Wilfrid, Ventnor, Isle of Wight). This painting, executed in Rome during the

3. Yeldham, *op cit*, Vol I, p 92
4. Wilfrid Meynell 'The Life and Work of Lady Butler' *The Art Annual* 1898, p 32

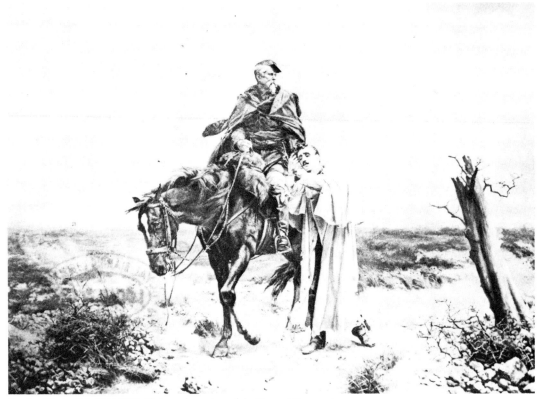

Fig. 3. *Missing* R.A. 1873 (590). Photograph courtesy of the Viscount Gormanston

winter of 1869 to 1870, and for which the artist's mother and an old woman found on the steps of the Church of Santa Trinità sat as models, was shown at an international exhibition in the city. The exhibition was held under papal patronage in the cloisters of Santa Maria degli Angeli, beside the Baths of Diocletian but, as a woman, the artist was not permitted to enter, although her father reported that the picture had been well received. It was not admired in London however, for in the spring of 1871, when she submitted it for exhibition at the Royal Academy it was rejected and returned with a large hole in it.

This venture into the field of sacred art was made at 'the earnest desire' of the painter's mother whose conversion to Roman Catholicism in the late 1860s had been followed shortly by that of both her daughters. Elizabeth Thompson had also been inspired by the paintings of the High Renaissance she had seen in Florence in 1869. She particularly admired the work of Andrea del Sarto (1486–1531) in the Churches of SS Annunziata and San Salvi and also the *Madonna with St Francis and St John* in the Uffizi.

In 1871, at Ventnor, she recorded;

There I kept my hand in by painting in oils life-sized portraits of friends and relations and some Italian ecclesiastical subjects, such as

young Franciscan monks, disciples of him who loved the birds, feeding their doves in a cloister; an old friar teaching schoolboys, *al fresco*, outside a church, as I had seen one doing in Rome. For this friar I commandeered our landlord as a model, for he had just the white beard and portly figure I required . . . Also a candlelight effect in the Church of San Pietro in Vincoli, in Rome; a large altar-piece for our little Church of St Wilfrid, and so on, a mixture of the ecclesiastical and the military.

A report in the *Art Journal* of 1876, after the overwhelming successes of *The Roll Call*, *The 28th Regiment at Quatre Bras* and *Balaclava* (Cat 18, fig 5 and Cat 25) announced that she was considering '. . .turning her attention in future to Sacred Art.'[5] In the following year the Fine Art Society made an agreement with her that they should have the first refusal of any religious pictures.[6] In later years her only major religious oil painting was *Homeward in the afterglow: a Cistercian shepherd in medieval England* (R.A. 1908, No. 959), which received no acclaim. Had it not been for the experience with her first oil painting and the subsequent overriding success of her military works, Elizabeth Thompson might well have pursued a career painting religious subjects.

In 1872, after another rejection by the Royal Academy (a watercolour of a member of the Papal Swiss Guard saluting two bishops in a Roman street), she attended the Army's autumn manoeuvres near Southampton. It proved to be a turning point for her. She sent the finished watercolours to the Dudley Gallery in 1873 and one of these, *Soldiers Watering Horses* (fig 2) was purchased by a Manchester businessman, Charles Galloway, who was so pleased with it that he commissioned an oil painting from the artist. Although *Missing* was on show at the Royal Academy that year, it was her choice of subject for Galloway, a Crimean War scene, *The Roll Call*, which was to bring her immediate success at the Royal Academy in April 1874.

5. *The Art Journal* 1876, p 190
6. Fine Art Society MS Minute Book 28 March 1877

THE RECEPTION OF
THE ROLL CALL

To the unselect many – to the general public – Miss Thompson is as new as the Albert Memorial in Kensington; and it is for that reason that we hail her appearance with this honest, manly Crimean picture, as full of genius as it is full of industry.

The Daily Telegraph 2 May 1874

I hope you will allow me to congratulate you on this excellent exhibition. When we see these walls surrounded with pictures – when we look at the Catalogue and see the names of yourself [Sir Francis Grant, P.R.A.], of Messrs. Millais, Leighton, Prinsep, Watts, Ward, Frith, Graves, Calderon, Alma-Tadema and many others I might mention, it is unnecessary to say that we have here a collection of pictures of the greatest artists this country can produce (Cheers). I am glad to take this opportunity of saying that I hope these gentlemen who have come to the Royal Academy on this occasion, have not forgotten to look at the picture in the next room which I think deserves attention. It is numbered 142 in the Catalogue, and is entitled – 'Calling the Roll after an Engagement in the Crimea'. This picture, painted by a young lady, who I am given to understand is not yet 23, is deserving of the highest admiration, and I am sure she has before her a great future as an artist (Cheers).

Extract from the Prince of Wales's speech at the Royal Academy Banquet, 2 May 1874 *The Times* 4 May 1874

A Royal dictum at the Academy dinner has, of course, been enough to collect an inconvenient crowd in the corner of the same room, where hangs Miss E. Thompson's 'Calling the roll after an engagement, Crimea.' On Monday, when we were there it was almost impossible to see it . . .

The Spectator 9 May 1874

Even before *The Roll Call* was put on display at the annual exhibition of the Royal Academy it was already beginning to cause a considerable stir among the artistic establishment and London Society. On 'Studio Sunday', 29 March 1874, two days before the picture was submitted to the Hanging Committee, when it was customary for painters and potential purchasers to make the rounds of artists' studios, an inordinate number of people came to see it. Among them was the agent for Charles Galloway,

28

the commissioner of the work. He was so delighted that he promptly advised Galloway to raise his payment for the picture from the £100 originally agreed upon to £126. After it had been accepted by the Royal Academy, the artist returned to her parents' home at Ventnor where she received various reports from friends in London that '. . .it was "the talk of the clubs" and spoken of as the "coming picture of the year".' However, it was on Varnishing Day at the Royal Academy, 28 April that the painter fully realised the extent of the *The Roll Call*'s popular appeal. She recorded in her diary, 'I soon espied my dark battalion . . . *on the line*, with a knot of artists before it. Then began my ovation . . . I never expected anything so perfectly satisfactory and so like the realisation of a castle in the air as the events of this day.' There followed, on 1 May, '. . . the-to-me-glorious private view', when it was the turn of London Society to give its verdict. Again the picture was highly acclaimed. Finally came the true test, the first public day. The artist records that on Opening Day there was '. . . a dense crowd before my grenadiers . . . I awoke and found myself famous'. Indeed such was the throng that within a few days a policeman was stationed in front of the picture in order to protect both it and its unfortunate neighbours, two small pictures by Frederic, Lord Leighton and one by Edouard Frère. Previously such precautions had only ever been taken for two paintings in the history of the Royal Academy; David Wilkie's *Chelsea Pensioners receiving the London Gazette Extraordinary of Thursday June 22, 1815, announcing the Battle of Waterloo* in 1822 and William Powell Frith's *Derby Day* in 1858. Appropriately at the Royal Academy Banquet, the principal guest speakers, the Prince of Wales and the Duke of Cambridge, Commander-in-Chief of the Army, singled the picture out for praise.

One result of this almost unprecedented attention was that Galloway soon found himself showered with offers for the picture. The Prince of Wales wanted it. Another collector offered him £1,000. The dealers Thomas and William Agnew said that they would pay whatever sum he cared to ask for it. Colonel Lloyd Lindsay VC, whose own valour at the battle of the Alma Butler was later to commemorate (Cat 64), was '. . . wild to have it'. Galloway refused them all. However, when the Queen wished to acquire the picture, he ceded it to her after protracted deliberations. As part of the agreement he insisted that he should be allowed to purchase the painter's next major work with its copyright for the same fee, £126. In the event she received an additional £1,000 for *The 28th Regiment at Quatre Bras* (fig 5). In addition, Galloway retained *The Roll Call*'s copyright which he subsequently sold to the publishers, J Dickinson & Co for £1,200, a huge sum for the time (see below, pp 41–3).

When the Royal Academy exhibition ended, *The Roll Call* toured the country to overwhelming public acclaim. In Newcastle-upon-Tyne, it was advertised by men with sandwich-boards which simply read '*The Roll Call* is Coming!'. Such was its reputation that no further information was needed. In Liverpool, 20,000 people saw the picture in three weeks, an immense number at that time. A quarter of a million carte-de-visite

PUNCH'S ESSENCE OF PARLIAMENT.

CORONAT opus. — Everything indicates the beginning of the end. London is oozing out of town; and the Parliamentary crew can hardly be got to stick to the ship. A Saturday's sitting (*July* 25), for the purpose of clearing the decks, coiling down the loose ropes, fishing the damaged spars, and heaving the dead overboard; and yet there has been no battle. But the ship is in as great a mess as if there had been, and all her own officers' doing! Thirty expiring Acts were continued, by the united efforts of less than thirty all but expiring Members. Vehement complaint from Mr. Martin, swelled by a chorus of Home-Rulers, against the Government for "sandwiching three Irish Coercion Acts between thirty expiring statutes"—a feat only possible, we should

20. *Punch* 8 August 1874. See p 60.

photographs of the artist, now referred to by the press as 'Roll Call Thompson' and looking as she thought '. . . a rather harrassed and coerced young woman', were sold by J Dickinson & Co (Cat 19).

The extraordinary popularity of *The Roll Call* in May 1874 took the art critics and newspaper reviewers by suprise. The picture is neither very large nor especially dramatic. The colour range is narrow; grey greatcoats under a leaden grey sky, black bearskins, brilliant white snow and occasional glimpses of red tunics and blood. The composition could hardly be simpler, a frieze of figures set at a slight angle to the picture plane, relieved only by a mounted officer and a fallen man lying head-down in the snow. Indeed, the picture could almost be described as dull, except that this is no parade; these are soldiers newly returned from battle and so the picture's restrained, sober treatment only serves to emphasize the intense human interest of the scene. This was described in *The Illustrated London News*;

> . . . one poor fellow has fallen dead even at the muster; a comrade feels in vain for the beating of his heart; another wounded man sickens at the sight; one near him stares out vacantly, frenzied by a wound in the head; another binds up his bleeding hand: the hardy veteran and the new recruit, the sickly and the strong, the insensible and the impressionable . . . [1]

The picture's success with the public was not affected by the opinions of the reviewers and for some of them this was a source of irritation. *The Spectator* and *The Daily Telegraph*, for example, chose to deride '. . . the inconvenient crowd' in the corner of Room II, '. . . the dense mob of ardent admirers, who go into ecstasies over the painted bearskins and the grey gaberdines of the grenadiers'. It was commonly imagined by reviewers that the picture would prove to be an isolated success. For example, the critic of *The Academy* suggested that Elizabeth Thompson would probably be '. . . a single-speech orator'.[2] Sometimes the writers asserted themselves more subtly by making a show of their superior knowledge of the painter and their awareness of *The Roll Call*'s links with French military painting. They also made it their business to warn her of the supposed dangers of premature celebrity, never failing to note that she was a young woman and therefore impressionable. None of them, however, failed to acknowledge the extraordinary power and realism of *The Roll Call*. The review in *The Times* is typical; '. . . a picture of the battlefield, neither ridiculous, nor offensive, nor improbable, nor exaggerated, in which there is neither swagger, nor sentimentalism, but plain, manly, pathetic, heroic truth, and this the work of a young woman . . .'.

But *The Spectator*'s critic was not the only one to attribute the popularity of the picture to the compliments paid to the artist by the Prince of Wales in his speech at the Royal Academy Banquet, when he

1. *The Illustrated London News* 9 May 1874
2. *The Academy* 1874, p 584

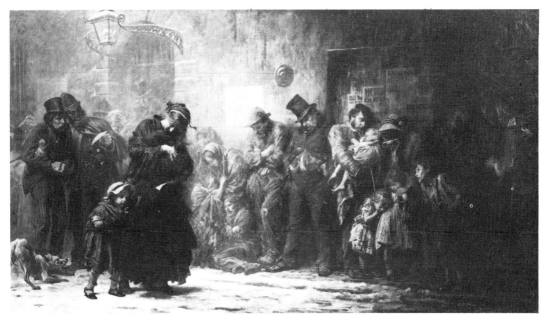

Fig. 4. SAMUEL LUKE FILDES (1844–1927) *Applicants for admission to a casual ward* R.A. 1874 (504) 142.3 × 247.7. In the collection at Royal Holloway and Bedford New College, University of London

prophesied 'a great future' for her. In addition to the reviews there was helpful publicity from disputes about the unfairness of the picture being protected by a guard rail and a policeman or of its being borrowed by the Queen during the exhibition. A debate ran for several days in the letters page of *The Times* as to the anatomical accuracy of the horse's gait.[3] In the words of Henry Stacy Marks R.A.;

> The controversies in the Press
> Contribute to the great success
> And widely advertise, I guess
> The picture of Miss Thompson.[4]

However, as even the reviewers must have realised, there had to be additional reasons to account for its 'dense mob of ardent admirers'.[5] The picture was entirely novel on several counts. *The Roll Call*'s bleak manner of portraying battle, borrowed from French military painting of the time, had no precedent in Britain. The unusual composition of the line of men across the picture plane was a departure from the standard triangular formats of academic history painting. It also made a powerful appeal to patriotic sentiment; the stalwart guardsmen seemed the embodiment of all that was best in British manhood, '. . . a row of our noble fellows'.[6]

The immediate popularity of *The Roll Call* should also be seen in the

3. *The Times* 2, 12, 15, 16 & 18 May 1874
4. H S Marks *Pen and Pencil Sketches* Chatto and Windus, London, 1894, Vol I, p 126
5. *The Academy* 2 May 1874
6. *The Queen* 9 May 1874

context of the burgeoning social conscience of the 1870s. It was no coincidence that the other hugely successful exhibit at the Royal Academy in 1874 was Luke Fildes's *Applicants for admission to a casual ward* (fig 4), a large sombre picture of the homeless and hungry queueing outside a workhouse.[7] In the social reformist climate of the time the public responded to its muster of outcasts as easily and in very much the same terms as they did to *The Roll Call*. In fact there is a striking similarity in the reviews which the two pictures received. Fildes was praised for sticking to his task undeterred by his 'wretched troop' of the destitute, whilst Thompson was praised for not shying away from 'the terrible havoc of war'.[8]

Equally significant was the way in which the subject of the painting echoed the general preoccupation with improving the efficiency of various institutions of British life and it was evident that the Army, a bastion of privilege and archaic custom, was sorely in need of change.[9] In 1870, radical reforms were instituted by Edward, Viscount Cardwell, the Secretary of State for War in Gladstone's first administration of 1868–74. They included an increase in expenditure, a new regimental system and a complete reorganisation of the terms and conditions of soldiers' service. These improvements were intended to encourage the enlistment of a better calibre of man, although even by 1874 it was apparent that the aims had not been fully realised.[10] Most controversial of all the reforms was the abolition of the purchase and sale of officers' commissions and promotions.[11]

In this context, it was singularly apt that Elizabeth Thompson's picture should commemorate a Crimean War scene. Not only had that campaign been the last full-scale war which the British Army had fought on European soil , but it had also made both the authorities and the public aware of the need for change, and the military reforms of the 1870s were accompanied by an upsurge of interest in the Crimean War of two decades

7. Matthew Paul Lalumia *Realism and Politics in Victorian Art of the Crimean War* UMI Research Press, Michigan, 1984
8. *The Art Journal* 1874, p 164; *ILN* 9 May 1874
9. Matthew Paul Lalumia 'Lady Elizabeth Thompson Butler in the 1870s' *Woman's Art Journal* Spring/Summer 1983; Ian Bradley *The Optimists: Themes and Personalities in Victorian Liberalism* Faber, London, 1980
10. *The Pall Mall Gazette* 22 May 1875. The Cardwell reforms brought improvements in the pay, food and living conditions of the other ranks. Flogging as a punishment was abolished in peacetime and the standard period of service with the colours was reduced. Nevertheless, the Army still failed to attract recruits of the right calibre; Allan Ramsay Skelley *The Victorian Army at Home* Croom Helm, London, 1977, *passim*. In 1874 16.37% of recruits were under five feet six inches in height.
11. For example, *The Times* 2 May 1874 said that in the mounted officer '. . . the true sternness of command [struggles] with the concern of a good soldier'. Differing views on what should be looked for in an officer were advanced by the nation's top soldiers in their speeches at Royal Academy Banquets. The Commander-in Chief, the Duke of Cambridge, spoke of '. . . those high feelings of honour and character' which are the birthright of an English gentleman (*The Times* 1 May 1871); Sir Garnet Wolseley emphasized the need for officers to receive '. . . a scientific education' (*The Times* 8 May 1874).

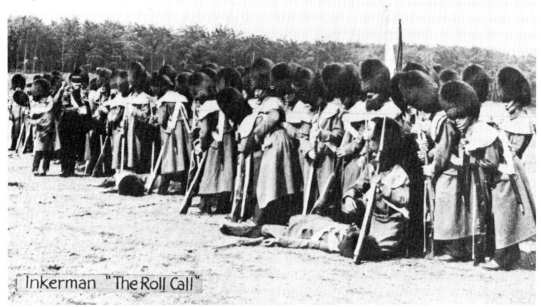

Inkerman "The Roll Call"

120. A re-enactment of *The Roll Call* in 1909. See p 156.

earlier.[12] For example, it was not until 1875 that the first major Balaclava reunion for veterans of the Light and Heavy Brigade charges was held at Alexandra Palace (see Cat 25) and two years later the Balaclava Commemoration Society was formed.

No Crimean War scene could have been more compelling than the *The Roll Call*'s exhausted guardsmen standing in the snow. It epitomised the exceptional courage with which ordinary British soldiers had endured appalling and often unnecessary hardships. 'It is impossible to overpraise the disciplined silence of men under privations which in a few weeks reduced one battalion from nearly 1,000 effectives to a strength of thirty Rank and File' wrote one survivor, General Sir Evelyn Wood; '. . . there is nothing in history grander than the enduring courage and discipline of the British soldier as shown in the winter of 1854–5.'[13]

Hitherto, acknowledgement of both the suffering and stoicism of these soldiers had not appeared in oil paintings. Indeed, the only previous Crimean painting *The Morning Post*'s reviewer could think of was John Dalbiac Luard's intimate, almost Pre-Raphaelite treatment of the interior of an officer's hut, *A Welcome Arrival* (National Army Museum

12. Two articles which reflected this renewed interest in the military lessons of the Crimean War were 'The British Army during the last twenty years' *The Standard* 2 May 1874 (printed opposite a review of *The Roll Call*), and Sir Garnet Wolseley's 'England as a Military Power in 1854 and 1878' *The Nineteenth Century* 1878, pp 433–54.
13. General Sir Evelyn Wood *The Crimea in 1854 and 1894* Chapman and Hall, London, 1895, pp 212–3. So terrible were the ravages of cold and disease that at one point in January 1855 only 11,000 British troops were able to remain in the trenches; 23,000 were listed as sick or wounded.

5808–18), exhibited in 1857. As the paper noted in its review of *The Roll Call*, it was the despatches of William Howard Russell for *The Times*, the accounts in *The Illustrated London News*, A W Kinglake's history of the war and the memoirs of veterans which had acquainted the public with the ordeal of the soldiers in the Crimea.[14] Many images of the war had been produced at the time and the public was familiar with the posed photographs, the stylised prints and the crude engravings of the illustrated newspapers, but *The Roll Call* went far beyond these by providing an atmospheric, realistic and humane view of the conflict which enabled the public to identify with the suffering of the men caught up in it. It was the first time that such a vital image of the soldier's own experience of war had appeared in Britain.

Indeed such was the authority of *The Roll Call* that when it appeared in 1874 there was no concern to establish the precise subject of the picture. In the accounts of the succeeding years it was sometimes asserted that the scene shows the aftermath of the battle of Inkerman, even though the battle was fought in the autumn of 1854 before any snow had fallen.[15] For example, a postcard photograph of a re-enactment of Thompson's picture by guardsmen at the Aldershot Military Tattoo of 1909 bears the title, *Inkerman "The Roll Call"* (Cat 120). This was an understandable attribution however, for it was at Inkerman, the 'soldier's battle' fought on 5 November 1854, that the day was won, as the Queen herself noted, by the '. . . persevering valour and chivalrous devotion' of the British rank and file.[16] The artist herself never referred to the question of an exact historical context for the painting; her concern was to show the condition of the soldiers. The painting is thus intended to be understood as an archetypal image of the Crimean War.

There was also considerable amazement at the sex of the painter of *The Roll Call* and it was expressed, albeit with admiration, by the Duke of Cambridge in his speech at the Academy Banquet; '. . . it is astonishing to me how any young lady should have been able to grasp the speciality of soldiers under the circumstances delineated in that picture.'[17] The reviewers, who were almost exclusively men, also praised Thompson for managing to succeed in a traditionally male field. However, because she was a woman, they treated her in a superficially chivalrous though in fact derogatory manner. In their articles they invariably wrote of the accomplishments of *The Roll Call* as though they were inherently masculine virtues. 'The truth', according to the *The Morning Post*, 'is told in this work as it seldom is by woman's hand, and rarely by feminine tongue. No pain has been spared.'[18] 'There is no sign of a woman's weakness' said

14. *The Morning Post* 7 May 1874; see also, Matthew Paul Lalumia 'Realism and Anti-Aristocratic Sentiment in Victorian Depictions of the Crimean War' *Victorian Studies* Autumn 1983, pp 25–51
15. For example; Frederick Goodall *Reminiscences of George Frederick Goodall* Walter Scott, London and Newcastle-upon-Tyne, 1902, p 368
16. Wood, *op cit*, p 157
17. Wilfrid Meynell 'The Life and Work of Lady Butler' *The Art Annual* 1898, p 6
18. *The Morning Post* 7 May 1874

The Times[19] while *The Spectator* commented '. . . a thoroughly manly point of view'.[20] The painter herself, however, was always presented as shy, young and in need of protection, although the only dangers they could think might face her were from 'injudicious flatterers and equally injudicious advisors' or 'premature competency'.[21] In this respect it is revealing that the Prince of Wales in his speech at the Academy Banquet of 1874 referred to the painter as being 'not yet 23' when in fact she was 27.

The critics did not perceive any contradiction in presenting the painter of what was evidently an elaborate and bold undertaking as a shy young maiden who did not flinch before the horrors of war. It is possible this notion was based on a universally known and cherished model, that of Florence Nightingale, an angel of mercy who ventured forth from the safe domestic domain in order to minister to the casualties of the Crimea. For a time after the first appearance of *The Roll Call*, it was widely assumed that the painter had gained her understanding of war while serving as a Red Cross nurse either in the Franco-Prussian War or, more improbably, in the Crimea, a belief that was fostered by the red cross in her monogram.[22]

The picture did not prove to be the isolated success some of the reviewers imagined because Elizabeth Thompson's next two major works, *The 28th Regiment at Quatre Bras* (1875, fig 5) and *Balaclava* (1876, Cat 25) were almost equally popular. *The Roll Call* continued to be a favourite with the public for many years. In 1907 the picture was shown at the Irish International Exhibition in Dublin and, according to the painter, it still proved very popular.[23] Even in 1912 it had not lost its capacity to move audiences. It appeared that year as the centrepiece in an exhibition of the artist's watercolours at the Leicester Galleries in London. 'If we admit', said *The Times*[24], 'with Rembrandt and Velasquez, that great and emotional scenes of human experience, like a battle or a surrender, are fit subjects for art, no fault can be found with the subject of "*The Roll Call*".' In William Holman Hunt's words, '. . . it touched the nation's heart as few pictures have ever done'.[25]

19. *The Times* 2 May 1874
20. *The Spectator* 9 May 1874
21. *The Daily Telegraph* 2 May 1874; *Academy* 2 May 1874. *The Spectator* 9 May 1874 went so far as to speak of Thompson arriving at a '. . . dangerous crisis in her career as an artist . . . If her head is not turned by fashionable applause, her best energies will now be directed to a continued course of severe technical training . . .'.
22. Elizabeth Butler *An Autobiography* Constable & Co, London, 1922, p 47; *Saturday Review* 16 May 1874
23. MS letter from Elizabeth Thompson to her mother, 13 May 1907; Collection of Hermia Eden, Catherine Eden and Elizabeth Hawkins.
24. *The Times* 13 June 1912
25. William Holman Hunt *Pre-Raphaelitism and the Pre-Raphaelite Brotherhood* Macmillan and Co, London 1905, Vol II, p 305

THE ACADEMY ELECTION

Following the successes of *The Roll Call* (Cat 18) and *The 28th Regiment at Quatre Bras* (fig 5) at the Royal Academy in 1874 and 1875, Elizabeth Butler, as the painter had become upon her marriage, did not exhibit there again until 1879. In that year she displayed two canvasses, "*Listed for the Connaught Rangers*" (Cat 30) and the more popular picture of the First Afghan War, *The remnants of an army* (Cat 31). In June she was nominated for election as an Associate of the Academy.

At the time this was greeted as a considerable achievement because no woman had ever been elected, although Angelica Kauffmann and Mary Moser had been two of the founders of the institution in 1768. During the nineteenth century a succession of women stood for election and in 1874 three women artists were nominated, one of whom, Mrs E M Ward, had a considerable reputation as an historical painter. None had been successful.[1]

Nevertheless, the climate of opinion favoured Elizabeth Butler's chances, for along with other British institutions, the Royal Academy itself was regarded by many as overdue for reform. Not only were women excluded from membership but standards at the annual exhibition were low.[2] There was discrimination against certain types of painting, particularly landscape[3] and the Academicians customarily awarded themselves all the best positions on the walls.[4] In this atmosphere the success of her paintings in 1874 and 1875 could also be seen as an affront to the Academy, a point made by a *Punch* cartoon (26 June 1875, Cat 22) which portrays the Academicians drawn up in square as in Elizabeth Thompson's exhibit of that year, *The 28th Regiment at Quatre Bras*, stolidly resisting the onslaught of the 'outsiders' amongst whom she appears.

Some reviewers had seen *The Roll Call*'s position 'on the line' (i.e. at

1. Charlotte Yeldham *Women Artists in France and England* Garland, New Jersey and London, 1984
2. *The Illustrated London News* 1 May 1874; *The Daily News* 18 May 1874
3. *The Pall Mall Gazette* 18 May 1874
4. *The Athenaeum* 12 & 27 June 1875. In the next couple of years the demands for reform grew more insistent. On his retirement from the presidency of the Royal Academy, Sir Francis Grant was criticised for having missed opportunities for change (*The Art Journal* 1875, p 285) and in 1876 Sir Charles Dilke argued in the House of Commons that the time had come for government intervention in the Academy's affairs (*The Athenaeum* 13 May 1876).

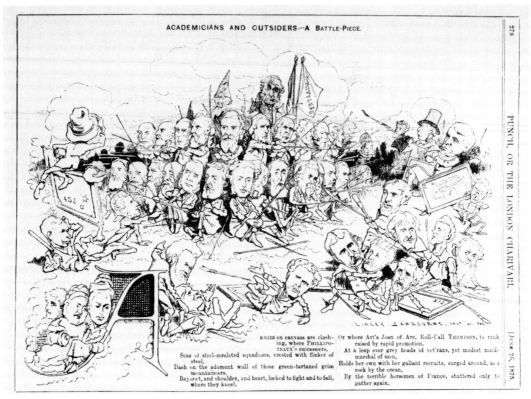

ACADEMICIANS AND OUTSIDERS.—A BATTLE-PIECE.

PUNCH, OR THE LONDON CHARIVARI.

[JUNE 26, 1875.

RMIES on canvass are clash-
ing, where PHILLIPO-
TEAUX's cuirassiers,
Seas of steel-corseleted squadrons, crested with flicker of
steel,
Dash on the adamant wall of those green-tartaned grim
mountaineers,
Bayonet, and shoulder, and heart, locked to fight and to fall,
where they kneel.

Or where Art's Joan of Arc, Roll-Call Thompson, to rank
raised by rapid promotion.
At a leap over grey heads of vet'rans, yet modest maid-
marshal of men,
Holds her own with her gallant recruits, surged around, as a
rock by the ocean,
By the terrible horsemen of France, shattered only to
gather again.

22. *Punch* 26 June 1875. See p 62.

eye level) in Gallery II at the Royal Academy as proof '. . .that real genius has no insurmountable obstacles to encounter from "The Forty"' (the full Academicians)[5]; others also saw its popular and critical success as an argument for women becoming Academicians. John Everett Millais R.A. had suggested to Thompson the possibility of her election at the first showing of *The Roll Call*, if she sent '. . .only as good a picture next year'. Sir Henry Cole, one of the designers of the Great Exhibitions of 1851 and 1862, mentioned the possibility in his Academy Banquet speech in 1875 and so too did the influential painter, William Powell Frith, the following year.[6]

The undoubted success of *The Roll Call* in May 1874 caused the issue of women as painters to be debated in the press. Some of the opinions which were expressed took the view that women were to be encouraged in this field, while stopping short of endorsing a fully professional status which membership of the Royal Academy would have given them.[7] George Augustus Sala in his *Daily Telegraph* review of the picture spoke of it as;

5. *The Daily Telegraph* 2 May 1874
6. Elizabeth Butler *An Autobiography* Constable & Co, London, 1922, p139
7. This was not a novel idea. Since the 1850s it had been common to suggest that one answer to those questions of women's rights and the debate concerning appropriate

. . .a good and wholesome sign – as clear and strong evidence that women have no reason to write about the rights which the best of them do not want, and would not accept, or to hanker after a participation in the dirty drudgery which pertains to men, when they can sit down at their desks and easels to write books and paint good pictures. We say this sign is a wholesome one; because in every work of art-excellence executed by a woman and commanding public acceptance and applause, we see a manacle knocked off a woman's wrist and a shackle hacked off her ankle. We see her freed from the degrading and soul-numbing bondage of the needle, and the weari-some servitude of governessing among the stuck-up classes or grinding texts, and droning hymns, with charity children. We see her endowed with a vocation which can be cultivated within her own home, and in the very utmost privacy, without the risk of submission to any galling tyranny or more galling patronage. We see her enabled to earn, by the exercise of her intellect and her ingenuity, a different stipend from that which she earns now, which may be defined as a stipend slightly exceeding the wages of a nurserymaid, but failing to approach those of a professed cook.[8]

However, not all subscribed to this view and many saw the success of *The Roll Call* as ensuring Thompson's membership.[9] Indeed, so probable did her election seem that the Academy decided to consider the implications of such an event with care. The Council of the Academy checked the existing rules to see if there was any objection to women members and decided there was none, although several thought that women would need to be excused some of the duties of membership, such as teaching in the Schools and attending Council meetings.[10]

George Dunlop Leslie R.A. recalled some of the questions Academicians were asking themselves at this time. If one solitary lady attended the Academy Banquet;

Would she have to be escorted into dinner? And if so, by whom? The President has to escort the highest personage that attends the banquet. Would the Royal personage himself escort the lady? Would ladies be eligible to serve on the Council – or to serve as Visitors? Might we not some day even have a female President? And if not, why not?[11]

occupations for middle class ladies which Sala mentions was for women to practise as professional artists, and in the 1870s the idea was widely promulgated. An article in *The Art Journal* of 1872, recommending more opportunities for women to train as painters, makes many of the same points as Sala's review of *The Roll Call*; Anthea Callen *The Angel in the Studio: Women in the Arts and Crafts 1870–1914* Astragal Books, London, 1979, pp 25–6.

8. *The Daily Telegraph* 2 May 1874
9. For example, the view of George Shepherd *A Short History of British Painting* Sampson Low, London, 1880, pp 131–2
10. Charlotte Yeldham, *op cit*, Vol I, p 75
11. George Dunlop Leslie R.A. *The Inner Life of the Royal Academy* John Murray, London, 1914, pp 222–3

The forty full members of the Royal Academy were selected from among the Associate Members when a vacancy occurred in their number. The method of electing the associates was by a three-stage system of ballots. In the first ballot Elizabeth Butler won 12 votes out of the possible 52, the highest number and two more than her rival, Hubert von Herkomer. However, in the second ballot which included those who had received more than 4 votes in the first round, Herkomer won with 18 votes; Elizabeth received 16 votes and Frank Dicksee 8. The final contest was between the two highest scorers in the second ballot and Herkomer emerged the victor with 27 votes to her 25.[12]

In the event she was never again nominated as a candidate. Her only verdict on the subject, was 'Since then I think the door has been closed, and wisely'.[13] Possibly her natural conservatism in professional matters dissuaded her from reapplying and becoming the inevitable instrument of a major reform, or she may have been more realistic about her chances of success. In 1880 she failed to have her royal commission, *The defence of Rorke's Drift* (Cat 33), ready in time for the exhibition and thus had nothing on show. As successful elections tended to follow in the wake of successful exhibits this must have damaged her chances. In addition, there were certainly those who would not have forgotten that in 1876 and 1877 she had chosen to exhibit with a private gallery, the Fine Art Society in Bond Street, rather than at the Royal Academy (see below, pp 41–3). In 1876 a cartoon in *Punch* expressed this resentment. A visitor to the Royal Academy says, 'I have been looking everywhere for Miss Thompson's picture. Where is it?' To which the reply is, 'Oh, not here at all. The lady is above exhibiting here'.[14]

Besides, in the late 1870s the question of the emancipation of women had ceased to stir people in the way it had earlier. Similarly, the debate concerning the reform of the Academy subsided.[15] By the 1880s Butler's reputation began to decline so there was no longer any question of her reapplying for election. Nevertheless, in coming within a couple of votes in 1879, she had the satisfaction of knowing that she had come closer to being a Royal Academician than any other woman in the nineteenth century. Indeed it was not until 1922 that Annie Swynnerton became an Associate Member and the first woman Academician, Laura Knight, was elected in 1936.

12. Wilfrid Meynell 'The Life and Work of Lady Butler' *The Art Annual* 1898, p 11
13. Elizabeth Butler, *op cit*, p 153
14. *Punch* 13 May 1876
15. Anthea Callen, *op cit*, pp 214–21

THE PAINTER AND THE FINE ART SOCIETY

The firm of J Dickinson & Co, which changed its name to the Fine Art Society in 1875, was responsible for publishing all the engravings of Elizabeth Butler's paintings during her most popular period from 1874 to 1881. The Society's manuscript Minute Book provides a record of the transactions which proved to be most lucrative to the firm, although the artist herself only had the benefit of selling one picture and its copyright to them, albeit for a comparatively large sum. However there is no doubt that Butler's reputation and popularity were enhanced by the widespread sale of reproductions of her work.

Although by the standards of the day the asking prices for the engravings were relatively high, from four guineas for the cheapest print to 15 guineas for a special artist's proof, the print of *The Roll Call* sold very well with a run of 1,150 in the first edition published on 13 July 1874.[1] It adorned homes throughout the country and eventually all over the world. The painter later recalled coming across a copy by chance in the house of a wine merchant at Funchal in the Canary Islands on her journey out to the Cape in February 1899.[2]

The engraving of *The Roll Call* and its successors proved so successful that it would be no exaggeration to attribute the financial stability of the Society in its early days to these prints. The gross profits recorded on 31 December 1876 for subscriptions to the engravings of *The Roll Call, The 28th Regiment at Quatre Bras* and *Balaclava* totalled £34,232. By the next year, with the addition of a print of Elizabeth Thompson's new picture, *The Return from Inkerman*, the figure had risen to £51,061.

Inevitably, the firm had to make certain outlays in producing the engravings and a considerable proportion of its total expenditure was invested in reproducing Thompson's work, although the sums involved were relatively insignificant compared to the eventual profits. For example, the engraver W T Davey received a fee of £100 for an outline of *The Return from Inkerman* in October 1877 and in 1881 W T Hulland was paid £150 for an engraving of *The Roll Call*. It was also quite costly to borrow a picture whilst it was being engraved; the Society was obliged to

1. G W Friend *An Alphabetical List of Engravings Declared at the Printseller's Association, London since. . .1847 to. . .1885* Printseller's Association, London, c 1886
2. Elizabeth Butler *From Sketch-Book and Diary* Adam and Charles Black, Burns and Oates, London, 1909, p 96

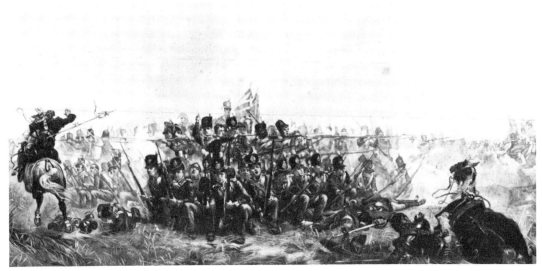

122. *Quatre Bras*, engraving by F Stacpoole, published by the Fine Art Society, 1876 & 1879.

pay £180 for a year's loan of *The 28th Regiment at Quatre Bras* for this purpose. However the greatest expense was the purchase of copyrights which could cost several thousand pounds each. The manuscript Minute Book reveals that to pay for that of *The Return from Inkerman* and another popular picture by Edwin Long, *Egyptian Feast* (R.A. 1877, No 83), it was necessary to raise capital by issuing a special share edition.

In 1874 J Dickinson & Co bought the engraving rights of *The Roll Call* from Charles J Galloway, the commissioner of the picture, for £1,200. By commissioning a painting the owner normally held the copyright and was entitled to any fee from the sale of engraving rights, but the artist, mentioning the fee she received for the oil in her autobiography, adds the bald statement 'The copyright was mine'. Whatever the original understanding had been, when Galloway ceded the picture to Queen Victoria he felt that he retained the copyright and was prepared to take the painter to court to prove it. Thompson was forced to concede and Galloway even secured an agreement whereby the Queen herself signed the first six copies of the artist's proofs when the engraving was published.

It seems unlikely that, even before marriage, Elizabeth Thompson needed to earn her living by taking commissions for her work, since her father was a man of some means who appears to have been extremely supportive of his daughters. But the artist was concerned to be more than a talented lady amateur and strove, in her sister's words, '. . .to enter into that equal competition with other professors of her art which can never be attained by amateur aloofness'.[3] The implication is that she undertook commissions in order to be seen to be a professional artist.

She was glad, even delighted at first, to receive £126 for *The Roll Call*

3. *The Magazine of Art* 1879, p 260

42

from Galloway when her asking price had been £100, but it was the success of the picture and the recognition it brought which gave her greatest satisfaction. The conditions which Galloway subsequently imposed on ceding the painting to the Queen not only forced the artist to relinquish its copyright to him, but it also bound her to paint for him her next major oil, *The 28th Regiment at Quatre Bras,* for a fee of £1,126 including the copyright. He then sold the copyright of both pictures to the Fine Art Society for £1,200 and £2,000 respectively, making a profit of almost £2,000 on the purchase price of the two paintings. The artist's views on the subject are not recorded, but three years later in 1877, mindful of this and the fact that the Society had paid *Balaclava*'s owner £3,000 for its copyright, her initial asking price for *The Return from Inkerman* was £6,000 for both painting and copyright. In fact she eventually settled with the Society for half that sum, receiving '£3,000 + 90% of all that the picture [engravings] sold for over £1,500 provided the picture [is] delivered to the Society for Exhibition not later than 20th April.'[4]

This was still an enormous sum in comparison with the fees of other artists, such as the £1,200 which the Society had paid to Felix Philippoteaux for his large canvas of the battle of Balaclava the previous year. The Society tried to protect its purchase by extracting certain assurances from Thompson and in March 1877 she agreed not to paint any battle pictures over a certain size for the next two years or to exhibit her new picture, *The Return from Inkerman,* at the Royal Academy, conditions which ultimately may have cost her membership of that august institution. If she did not keep the agreement the price of *Balaclava* was to be reduced to £2,500. These conditions may also explain why the subjects of her next two Academy exhibits, although military, were not of battlefield scenes.

The Return from Inkerman proved to be the last picture by the artist that the Society exhibited and her next two major canvasses, "*Listed for the Connaught Rangers*" and *The remnants of an army* were exhibited at the Royal Academy in 1879. The moment of parting came in March 1881 when arrangements were being made to exhibit *Scotland for Ever!* at the Fine Art Society's premises. The Society's Minutes show that they considered that the artist, now Elizabeth Butler, had broken an agreement either about this picture's showing or about the engraving to be made from it and they took out an injunction against her, eventually accepting an out-of-court payment of £500. The painting was exhibited by another fine art publisher, S Hildesheimer & Co, at the Egyptian Hall in Piccadilly. Unfortunately the full story of the disagreement is not known, but what is certain is that in March 1881 an association which had been of benefit to the painter as well as to the firm came to an abrupt end. The Society published further prints of her pictures of which they already owned the copyrights, but after 1881 such dealings as she had with print publishers were with other firms such as Henry Graves & Co, and Goupil & Co.

4. Fine Art Society, MS Minute Book, 12 March 1881

THE CATALOGUE

Editorial Note

Before her marriage to William Butler the artist customarily signed her works with her initials, either 'E.S.T.' for Elizabeth Southerden Thompson, or simply 'E.T.'. From about the year 1867 until 1880, two years after she became Mrs Butler, she added the monogram of a capital 'C' containing a cross within it, a device which symbolised the 'Red Cross Society'. The 'society' was a group formed by the artist and a few of her fellow students at the South Kensington School of Art who aimed to give each other mutual support and to perform good deeds. The monogram is indicated in the inscription details by the abbreviation 'mon'.

Those oil paintings which were exhibited at the Royal Academy and other galleries are referred to by the titles with which they appeared at these institutions. It will be noticed that these often encorporate eccentric use of capital letters and punctuation. Measurements are in centimetres, height by width. Details of provenance are given where available. Literary references listed are to reviews of exhibitions during the painter's lifetime and all other sources are indicated in footnotes. All unattributed quotations in the text are taken from Elizabeth Butler *An Autobiography* Constable & Co Ltd, London, 1922.

1. Early Works and 'Roll Call Thompson'

1. Photograph of Thomas James Thompson (1812–81), the artist's father, c1850.

The Viscount Gormanston

2. Sketchbook c1859–60

87 pages (missing some pages and some cut-out sections of pages), 21.3 × 15.6

Insc on second page: *E Thompson/aet 13 & 14*

Prov: By direct descent

The Viscount Gormanston

Elizabeth Thompson's earliest surviving sketchbook contains a variety of lively drawings in pen-and-ink and in pencil. In addition to studies of people, horses, Alpine landscapes and medieval figures there are a number of small vignettes of scenes of contemporary European soldiers.

2–1. Studies of *Garibaldini*
Pencil

Giuseppe Garibaldi was the Italian adventurer whose Sicilian campaign of 1860 precipitated the unification of Italy. In her autobiography, the artist recalled '. . . we, like all the children about us, became highly exalted *Garibaldians*. I saw the Liberator the day before he sailed from Quarto for his historical landing in Sicily [5 May 1860], at the Villa Spinosa, in the grounds of which we were, on a visit at the English consul's.' These vignettes of Garibaldi's volunteer corps bivouacking appear to have been sketched from life at this time, while the Thompsons were living at Genoa. They demonstrate the young artist's strong sense of movement and grasp of the shape and cut of uniform.

3. Sketchbook 1860 No 2

98 pages (including 6 loose pages), 21.9 × 16.5

2–1

Insc on flyleaf: *Mimmie Thompson/Aged 14/Casa Quartara [?]/Albano/ November 29 1860*
on backboard: *Ended August 12 – 1861 Mimmie Thompson*

Prov: Lt-Col P R Butler, the artist's son. Presented to the National Army Museum in 1963

National Army Museum 6311-193-5

'Mimi' was Elizabeth Thompson's nickname within her immediate family. This sketchbook, executed at Albaro near Genoa from the end of 1860 to the spring of 1861 and in London and Hastings thereafter, contains small pen-and-ink studies of Italian troops; *bersaglieri, carabinieri* and *garibaldini* as

Wimbledon

"Bayonet Back!"

The Yankee Volunteers

The British Ditto

3–1

48

well as of peasants, boatmen, priests, horsemen and carnival scenes. There are several caricature drawings comparing the armed forces of England, France and Piedmont. The decorative tailpiece pursues this theme with comparisons of the cliffs of Dover and Mount Vesuvius, British and Piedmont flags, Kentish hops and Italian vines.

In addition there are studies of people in a café in Genoa, visitors to Hastings and two pencil drawings of a woman playing the piano who may have been the painter's mother, a talented pianist and singer much admired by Charles Dickens.

3–1. Four drawings of British and 'Yankee' Volunteers

Pen-and-ink

Insc: *Wimbledon, "Down South", The Yankee Volunteers, The British Ditto*

In these four vignettes Elizabeth Thompson drew her own amused interpretations of the differences in the accoutrements and the standards of discipline of American volunteers and the British rifle volunteer units who were training on Wimbledon Common. She was enthusiastic about the British citizen soldiers and resented the mocking attitude expressed in the caricatures of the magazine *Punch*. Her grandfather, John Hamilton Thompson, was appointed Adjutant of the 11th Middlesex (St.George's) Rifle Volunteer Corps in May 1860 and he '. . . went through storm and rain and sun in several sham fights' which the young artist may have witnessed.

4. Sketchbook 1861 No 4

34 pages, 12.7 × 17.8

Insc on flyleaf: *Sketches of Costumes and Uniforms – E S Thompson*
on cover: *1861 No 4*

Prov: By descent to the present owner, the artist's grandson

The Hon Robert Preston

This sketchbook appears to have been kept during the same period as *No 2* (Cat 3), for it contains many drawings which must have been executed in Italy, before the Thompsons moved to England in the spring where they remained for the rest of the year. Like the earlier sketchbooks, it includes studies of *garibaldini*, Piedmontese and French soldiers, as well as some of British soldiers of the line and Genoese peasants. However, these are mostly executed in watercolour and are designed as decorative vignettes.

4–1

4–1. English Guardsmen

Watercolour over pencil

Insc: *English Guardsmen./M.T. Sep.21*

This watercolour of two guardsmen defending their colours represents an early interpretation of the heroic theme that the artist was to paint in oils many years later as *The Colours: advance of the Scots Guards at the Alma* (Cat 64). It does not appear to be derived from any images of the subject then in existence but may be an example of the exercises in drawing historical themes which Thomas Thompson took to giving his daughter at this time.

5. Sketchbook 1862

21 pages (missing several torn out pages), 12.5 × 17.5

Insc on flyleaf: *1862*

Prov: Lt-Col P R Butler. Presented to the National Army Museum in 1963

National Army Museum 6310-353-2

This sketchbook contains small pen-and-ink studies similar to those in the earlier books. These are often comic in nature, depicting French, British and Indian military 'types', scenes in Genoa and *garibaldini* in battle as well as drawings of individual figures and animals.

5–1. Military Types

Pen-and-ink

Insc: *ET/British Soldier Italian Austrian French Russian Egyptian American*

This drawing reveals that at the age of fifteen or sixteen Elizabeth Thompson already had considerable ability in draughtsmanship as well as a sense of humour. The soldiers are increasingly caricatured as the line progresses from left to right, a possible indication of the artist's prejudices. Although they lack accuracy in detail, she has captured the essential differences in the infantry uniforms of these nations.

6. Sketchbook 1865 No 2

36 pages, 9.1 × 12.1

Insc: *1865 No 2/Pictorial Notes on Land &/Water./E.Southerden Thompson*

Prov: By direct descent

The Hon Robert Preston

This sketchbook was kept during the Thompson family's summer and autumn tour of the Continent in 1865 and contains pen and ink, watercolour and pencil drawings of British military 'types', buildings in Calais and Bruges, studies of clouds and the people of Belgium and Germany. A page of vignettes from the sketchbook is reproduced opposite page 19 of the artist's autobiography entitled *Flying*

shots in Belgium and Rhineland in /65 and depicts various slightly caricatured figures of soldiers and peasants. The Thompsons' tour culminated in a visit to the battlefield of Waterloo on the artist's nineteenth birthday, where the family accepted the services of an old soldier as a battlefield guide. Sergeant-Major Mundy, in 1865 an old man with a long white beard, had been 27 when he fought at Waterloo with the 7th Hussars. The anecdotes and accounts of the battle which he related as they travelled the field fascinated and appalled the young artist who returned to Brussels '. . . a wiser and a sadder girl'.

6–1. Sketches of Prussian people

Pen-and-ink

Insc: *A Düppel hero (!)/Prussian Hussar/ Officer/Smart-Uniformed!*

The sketchy and almost caricatured treatment of Prussian soldiery, with the caustic comment 'Smart Uniformed!', reflects the artist's reaction to the arrogance of those she encountered and whom she described as being '. . . so blatantly proud of having beaten the Danes and getting Schleswig-Holstein' after the successful siege of Düppel in 1864.

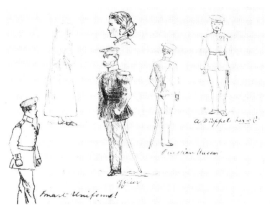

7. Sketchbook 1867 No 1

22 pages, 20.7 × 27

Insc on first page: *1867/No.1/Elizabeth Thompson/aetat. 20*

Prov: Lt-Col P R Butler. Presented to the National Army Museum in 1963

National Army Museum 6311-193-4

In her autobiography the painter mentions that she gave sketches to her fellow students at the Female School of Art, South Kensington, of '. . . fights

round standards, cavalry charges, thundering guns' which probably would have been finished drawings worked up from the pencil and pen-and-ink studies in this sketchbook. It includes several heroic military vignettes of cavalry, handsome young officers and furious battle scenes, mainly of French soldiers of the Napoleonic Wars, as well as a number of sketches of men in armour.

In March 1868, while she was still a student, Elizabeth Thompson had the opportunity of showing the art critic, John Ruskin, her 'imaginative drawings' including one of Lancelot and Guinevere. 'That greatest of living minds', as she referred to him, thought that she had not studied from nature sufficiently and told her to avoid 'sensational' subjects for the time being. He further advised her, 'Do fewer of these things, but what you do do right and never mind the subject.' Thompson privately disagreed with him; '. . . my great idea is that an artist should choose a worthy subject and concentrate his attention on a chief point.' However, she was delighted by his admiration of some of her watercolours and his judgement that she was '. . . destined to do great things'.

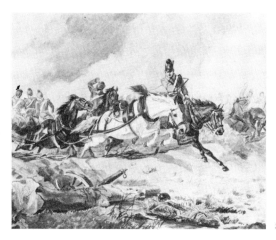

8

8. Bavarian Artillery going into action

Watercolour over pencil 28 × 32.8 1867

Insc (label verso): *No 2/Bavarian Artillery Advancing/by/Miss E.Southerden Thompson/Care of E.W.Pollard Esq/No 1 Brompton Square S.W.*

Mr D G P Heathcote

Although the exhibitor's label on the reverse of this watercolour bears a different title, Elizabeth Thompson referred to this picture in her autobiography as *Bavarian Artillery going into action*. It was the first watercolour which she exhibited at a commercial gallery while still a student, and when the influential critic of *The Times*, Tom Taylor, mentioned the work to the artist's father, she exclaimed, 'I had begun!'

The subject of the picture is taken from the 'Seven Weeks' Austro–Prussian War of the summer of 1866. Bavarian gunners gallop forward with their superior rifled field guns to check the Prussian assault at the battle of Sadowa (Königgrätz), the final engagement of the war fought on 3 July. The Austrians and their allies the Bavarians were dealt a crushing defeat, mainly because their infantry were equipped with outdated muzzle-loading rifles. The young artist's sympathies clearly lay with the vanquished Bavarians.

Exhib: Dudley Gallery 1867

7–1

7–1. Female students at the South Kensington School of Art

Pencil

Insc: *1867/No.1/Elizabeth Thompson/aetat. 20*

This page of drawings shows that the artist often sketched whatever presented itself to her eye. As well as the studies of a foot in the Life Class, architecture and foliage, she also captured the informal attitudes of her fellow students as they sketched and painted around her.

51

9. A Mercenary in period armour

Oil on canvas, 10⅛ × 12 in, 25.5 × 30.5 cm 1867

Insc: *18 ETS 67*

Prov: By direct descent

Private collection

On entering the South Kensington School of Art in 1866 Elizabeth Thompson was delighted to find she was allowed to join the Life School after preliminary work 'in the Antique', thus being able to work from a real model rather than drawing plaster copies of classical statuary. She recorded in her diary, 'I have chosen for subject a freebooter in a morion and cloak upon a bony horse, watching the plain below him as night comes on, with his blunderbuss ready cocked. Wind is blowing, and makes the horse's mane and tail to stream out.'

9

The subject is purely imaginary, a romantic notion of an 'historical' figure which constituted an exercise in developing a composition from a life study. In the class a thin, nervous model posed in armour and a morion (helmet) for the preliminary drawings and when the oil was finished Thompson received praise from the headmaster, Richard Burchett, for her unaided treatment of the subject.

10. Self-Portrait

Pencil 24 × 33.5 1868

Insc: *E S T*
verso: *Elizabeth Thompson 1868*

Prov: By descent from the artist to the present owner, the artist's great grand-daughter

Mrs Marie Kingscote Scott

This drawing, executed during the artist's final year as a student at the South Kensington School of Art,

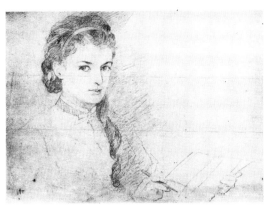

10

is thought to be the earliest existing self portrait. In comparison with the drawings in the Sketchbooks of 1865 and 1867 (Cats 6 and 7) it shows an increased fluency in handling line, the result of the continual sketching exercises of 'time' and 'memory' which the students were set.

11. Mimi Thompson

Oil on card 19.7 × 15.5 1869

Insc: *Mimi Thompson 1869*
Verso, by Mrs Barbara Wall: *Mimi Thomson, [sic]/painted by herself/ (afterwards Lady Butler)/& presented to our aunt/ Miss Dalilla Novello/Valeria Gigliucci.*

Prov: Purchased in 1980 from Mrs Wall, grand-daughter of Alice Meynell, the artist's sister

National Portrait Gallery, London

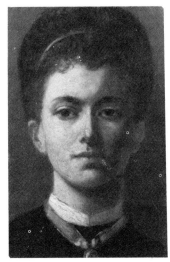

11

This self-portrait may have been painted in Florence as an independent exercise while the artist was the pupil of 'a very fine academic draughtsman', Giuseppe Bellucci, who did not allow his students to paint with colours.

12. Ploughing in the Vineyards near Florence

Watercolour 15⅛ × 26½ in, 38.4 × 67.5 cm 1869

Insc: *E.S.T./18*(mon)*69/Florence*

Prov: By direct descent

Private collection

During the summer of 1869 while Elizabeth Thompson was studying with Giuseppe Bellucci in Florence, the master persuaded his student to take a month's rest from the boiling atmosphere of his studio. The Thompson family had taken a house just outside the city, within sight of the *Duomo*, and the artist recorded painting this watercolour of white oxen ploughing in the field there.

A later version of the watercolour appears as Plate 24 of *From Sketch-Book and Diary* (1909), the artist's book of travel reminiscences. Although that hot summer of 1869 is recalled in the text, the illustration is dated 1904, but the disposition of the peasant, the oxen and the vines in the foreground all appear to have been based on this early watercolour, a much fresher and more pleasing picture. It demonstrates the artist's practice in later years of copying and redefining her earlier works, not always to advantage.

Exhib: Dudley Gallery 1871 (224)

Fig 2. Soldiers Watering Horses

Watercolour 1872 (photograph by Sennett & Spears), see p 25

Insc: *(mon)/E.S.T./1872* [?]

Prov: Purchased by Charles J Galloway in 1872

Private collection

In 1872 Thomas Thompson took his daughter to see the autumn manoeuvres near Southampton where, as noted in her diary, she saw '... the British soldier as I never had the opportunity of seeing him before'. It was to be of great significance to her career. A general who was an umpire at the manoeuvres asked her to '... give the British soldiers a turn', referring to her previous pictures of foreign military subjects such as *Bavarian Artillery going into action* (Cat 8). 'Subjects for watercolour drawings appeared in abundance to my delighted observation', she recalled and the resulting pictures were sent to Manchester and the Dudley Gallery in London. However, it was this particular watercolour, exhibited at the latter venue, which led to her recognition as an artist.

The painting shows soldiers of an unidentified mounted rifle volunteer unit watering their horses at a trough under the watchful eye of a monocled officer of the 100th (Prince of Wales's Royal Canadian) Regiment. The artist has chosen to depict her favourite subjects, soldiers and horses, in a delightfully informal setting. They are presented in the frieze-like composition which she later used to such effect in her oil paintings, notably *The Roll Call* (Cat 18) and *Scotland for Ever!* (Cat 36).

The watercolour was purchased from the Dudley

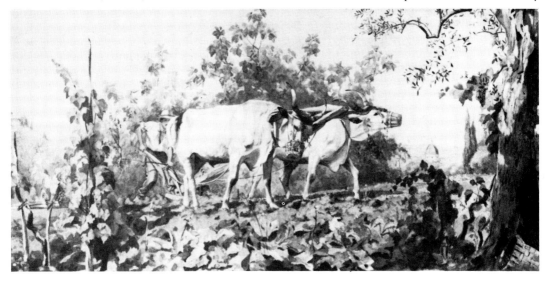

12

by a Manchester businessman, Charles J Galloway, who then commissioned Thompson to paint him a picture in oils. Although in the spring of 1873 *Missing* (fig 3), her first painting to be accepted by the Royal Academy, was mentioned in the Press and sold, it was Galloway's commission, *The Roll Call*, which brought her instant fame at the Academy the following year.

The painting remains untraced, but was known to be in a private collection in 1978. A small watercolour sketch (16.7 × 29), signed and dated as above, may be a preliminary study made on the spot (private collection).

Exhib: Dudley Gallery 1873 (84), *Drivers Watering their Horses – Infantry Camp, Autumn Manoeuvres, 1872*

Fig 3. Missing

Oil on canvas 1873 (photograph courtesy of the Viscount Gormanston), see p 26

This is the only known photograph of Elizabeth Thompson's first major military painting and first exhibit at the Royal Academy; the original oil painting as yet remains untraced.

Missing depicts two French soldiers, a wounded officer riding a spent horse who supports a cloaked cuirassier as they wearily make their way through desolate countryside. These two have become separated from their comrades after defeat in an action during the Franco–Prussian War. *Missing* marks the first appearance of a key theme in Elizabeth Thompson's work, that of wounded and exhausted soldiers returning from a scene of conflict bearing the mark of their experiences; the true horrors of war which can only be hinted at on canvas. It is a sombre and heroic painting but it is also melo-dramatic in its bleakness. The incident is imaginary and lacks the 'realism' of Thompson's subsequent interpretations of this theme, such as *Balaclava* (Cat 25) and *The Return from Inkerman* (Cat 26).

Early in the summer of 1870, the artist returned from Italy to complete her studies at the South Kensington School of Art. In July, the Franco–Prussian War broke out and, at the outset, popular opinion favoured the German cause until swayed by a series of French defeats culminating in the siege of Paris. Graphic tales of those beleaguered within its walls, appearing in the British Press, based on reports despatched by all means possible including pigeon post and hot-air balloon, gripped the public imagination and created a considerable demand for pictures of the war. Thompson recorded in her autobiography that she had sent 'many a subject' inspired by the war to the Dudley

Gallery and to Manchester and that her work had sold quickly, but that she ' . . . never relaxed that serious practice in oil painting which was my solid foundation'.

In treatment *Missing* is indebted to French military painting; both to the melodramatic pictures of suffering soldiery in the Napoleonic Wars and to the more dour scenes of the Franco–Prussian War by artists such as Edouard Detaille and Alphonse de Neuville. This was Thompson's first large canvas on a military subject, for which her father and a young Irish officer were the models. Although it was accepted by the Royal Academy it was poorly placed, being hung very high on the wall or 'skied' in the jargon of the time. Despite this it received favourable notices in the press and was sold. With its moderate success there was none of the fuss concerning the artist's sex and choice of subject matter which attended the debut of *The Roll Call* (Cat 18) in the following year. If there had been any doubt in Thompson's mind as to which of the several types of subject matter that she had been painting hitherto she should now seriously pursue, the acceptance of *Missing* and the popularity of her watercolours of the Franco–Prussian War and the British Army's autumn manoeuvres of 1872 must have convinced her that she should concentrate her talents upon the military genre.

Exhib: R.A.1873 (590 original oil)

Refs: *The Architect* 24 May 1873; *The Times* 26 June 1873

Engraved for *The Magazine of Art* 1879

13. 10th Bengal Lancers tent-pegging

Watercolour 47.5 × 85 1873

Insc: (mon)/*Eliz:th Thompson 1873*

Prov: Presented to the Indian Army Museum by the regiment in 1956

National Army Museum 5602-595

When she painted this watercolour Thompson had not actually seen tent-pegging and relied on a description given her by an officer of the regiment. The subject entirely suited her interest in drawing men and horses in movement and she painted it on a number of occasions, exhibiting an oil with the same title at the Royal Academy in 1902 and another entitled *Rivals. Bengal Lancers tent-pegging* in 1911. A watercolour of the figure of the sowar on the left, who has missed his tent-peg and is pulling up his galloping horse, was exhibited at the 1874 Winter Exhibition of the Royal Institute of Painters in Water Colour and was purchased by *The Graphic*. It was reproduced as the Christmas

13

supplement print of that paper in 1875 (Cat 117).

The triumphant figure on the right, waving his lance with its impaled peg in the air, was painted again by the artist in 1906 (private collection).

> Exhib: Society of Lady Artists 1874 (247),
> *Tenth Bengal Lancers at "Tent Pegging"
> Sealcote, 1871*

14. Sketchbook 1873

67 pages, 9 × 16

Insc on flyleaf: *Feb 23 1873*

Prov: Lt-Col P R Butler. Presented to the National Army Museum in 1963

National Army Museum 6311-193-2

This sketchbook consists mainly of pencil sketches of the 79th Regiment, the Queen's Own Cameron Highlanders, made while they were stationed in the Isle of Wight in 1873. There are two studies of a lancer helping a wounded comrade which appear to be preliminary drawings for the composition of the painter's first Royal Academy exhibit, *Missing* (fig 3), shown that year. The book also contains an elaborate study in pencil heightened with red chalk of one of the cavalry charges at Balaclava which suggests that the artist was already developing ideas for a painting on the subject of this battle. The final picture, *Balaclava* (Cat 25), showing the return of some of the troopers from the fateful Charge of the Light Brigade, was commissioned by the Manchester businessman, J Whitehead, who had previously purchased *Missing*.

In addition, there are a number of studies of horses, children and individual soldiers, two ladies having a picnic who may be the painter and her sister, sketches of heathland scenery and a religious composition, *The Road to Emmaus*. The sketchbook also contains copious notes and memoranda by the artist. A note of an appointment written across the top of a page, 'Graphic 12 o'clock', may refer to the painter's arrangement with the illustrated weekly paper, *The Graphic*, to send pen and ink sketches for publication of the Bishop of Salford's pilgrimage to Paray-le-Monial in France. At the time there was considerable public interest in the first pilgrimage to be made abroad by English Catholics since the Reformation.

14–1. Study for Waiting for the Colonel

Pencil

Insc: *piper sergeant/bays/drum/sticks/small/
drums/On Parade Drummers of the 79th/A
Sketch at Parkhurst*

Sketched from life, this group of bandsmen formed the basis for the watercolour entitled *Waiting for the Colonel*, (Cat 15).

14–1

55

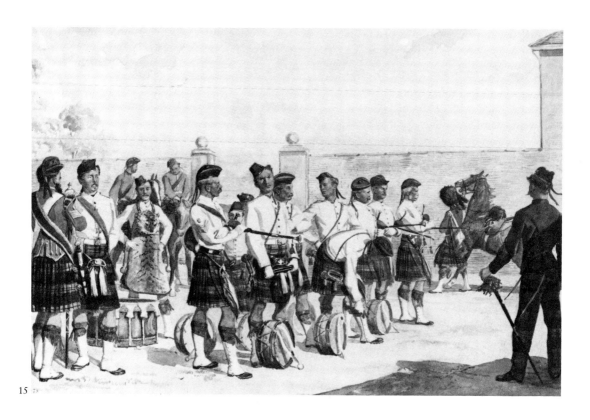

15

15. Waiting for the Colonel

Watercolour 24.3 × 35.6 1873

Insc: *18*(mon)*73/E.S.T.*

Private collection

This watercolour of the Band of the 79th Regiment, the Queen's Own Cameron Highlanders is based directly on one of several pencil sketches (Cat 14–1) that the painter made in 1873 of the regiment while it was quartered at Parkhurst, Isle of Wight, about twelve miles from Ventnor where the Thompsons were living. She admired Highland uniform and described the men as '... splendid troops, so essentially pictorial', painting them on several occasions during her career.

16

16. Chasseur Vedette

Oil on paper on panel 19.6 × 22.2 1873

Insc: *E*(mon)*T/1873*

Mr Leo Cooper

This small painting shows a French light cavalry trooper on picket duty as night begins to fall. French military artists often used the theme of the vedette in depicting a single soldier and Thompson's treatment of the subject may well have derived from Jean Louis Ernest Meissonier's *Vedette au Hussards* which was exhibited in 1872 at Gambart's French Gallery in Piccadilly (reproduced in *The Graphic* 1872, p322).

Exhib: Dudley Gallery 1872 (?)

56

17. Study of a Wounded Guardsman

Oil on panel 22 × 13.4 c1874

Prov: Lt-Col P R Butler, presented to the National Army Museum

National Army Museum 6311-194-1

This portrait of a guardsman with a head wound is a preliminary study for the key figure standing in the centre of the line in *The Roll Call* (Cat 18). A pen-and-ink version of the study is reproduced on page 103 of the artist's autobiography, in the chapter devoted to *The Roll Call*, entitled *Crimean Ideas* (Cat 132). In the final oil painting the figure differs considerably from both of these studies in features and expression, as well as the size of the beard, and presents a more stoical attitude than this anxious, drawn face. Although Thompson wanted to convey the effect that the experience of battle must have had upon the guardsmen, this alteration suggests that she was careful not to be over-

dramatic. The heroic figure of the soldier who keeps in line despite a wound to the head recurs as a type throughout late nineteenth-century battle painting, for example in Robert Gibb's *The Thin Red Line* (Cat 136), Charles Edwin Fripp's *Isandhlwana* (Cat 138) and William Barnes Wollen's *The last stand of the 44th Foot at Gundamuck* (Cat 140).

On the reverse of the panel are two studies of a sailor and a Highlander in a glengarry which were possibly painted at a later date. There is also a faint pencil outline of of a head.

18. Calling the roll after an engagement, Crimea. (The Roll Call)

Oil on canvas, 91 × 182.9 1874

Insc: (mon)/*Eliz:th Thompson/1874*

Prov: Commissioned by Mr Charles J Galloway of Manchester and Knutsford, for £126; ceded to Queen Victoria in May 1874

By gracious permission of Her Majesty the Queen

Exhibited at the National Army Museum only

Elizabeth Thompson's name has always been particularly associated with this sombre picture of Grenadier Guards mustering in the cold grey light after an engagement during the Crimean War of 1854–56. Although the artist never linked the subject with a particular action it has sometimes been assumed to refer to the battle of Inkerman, 5 November 1854, even though Inkerman was fought in rain and fog, not snow as seen in Thompson's picture. As part of the Guards Brigade, the 3rd Battalion Grenadier Guards had defended the two-gun Sandbag Battery against heavy odds, at one point being completely surrounded, but after three hours of fierce, mainly hand-to-hand, combat the Russians retreated behind Sevastopol's defences having lost approximately 12,000 men. The Grenadier Guards battalion lost 104 officers and men killed, with another 130 wounded,[1] and their adjutant, Captain George Higginson, recalled that barely 200 men responded at roll call.[2] According to Higginson's obituary upon his death in 1926 at the age of 100, he was the mounted officer in the painting.[3]

However, the fact that the battle was not identified by the artist indicates that it was intended to be an archetypal picture of the Crimea; its depiction of the condition of the soldiers in the aftermath of battle being more important than its

17

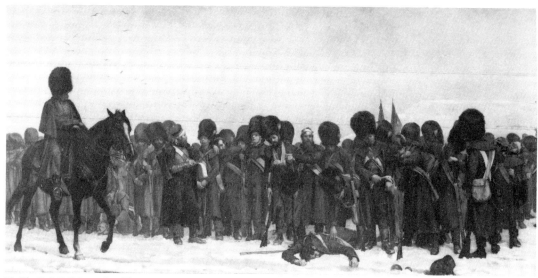

18. *The Roll Call.* Reproduced by gracious permission of Her Majesty the Queen

exact historical context. The scene contains several motifs indicating that the Guards have been victorious; the upright standards, the fleeing enemy soldiers on the distant hillside and the single Russian helmet lying in the blood-spattered snow in the foreground. Nevertheless, it is the condition of the surviving guardsmen, testifying to the arduous fight they have had, which is the focus of attention. The men struggle to respond to the roll call but several can hardly stand, while others seem almost overcome by the agony of their wounds or are dazed by memories of their horrifying experience. One man has fallen head-down in the snow and one of his comrades feels for the beating of his heart. Another hides his head in his arms, the only overt expression of emotion in the picture. *The Roll Call*, as the picture came to be known almost immediately, is an image not of British victory but of the courage and sacrifice of the anonymous British soldier.

The Roll Call was commissioned by a Manchester industrialist, Charles Galloway, after he had bought a watercolour by the painter, *Soldiers Watering Horses* (fig 2), at the Dudley Gallery in 1872. The artist may have conceived the idea of a Crimean roll call in the spring of 1873 as her sketchbook for this period (Cat 14) includes a drawing of an officer and a private of the 79th Regiment, the Queen's Own Cameron Highlanders entitled *reading roll*. Thompson began work on the project in earnest during the autumn of 1873 when she persuaded her father to let her take a London studio and she moved to 76 Fulham Road. Richard Burchett, the headmaster of the South Kensington School of Art, still took an interest in his ex-pupil

and helped her by finding suitable models, mostly ex-soldiers, and one of these, the model for the sergeant calling the roll, was found an invaluable help as he had seen service in the Crimea. Dr Pollard, the Thompson family doctor, helped her to track down uniforms and accoutrements, many being discovered in ' . . . a dingy little pawnshop in a hideous Chelsea slum'. As Thompson acknowledged in her autobiography she was obsessive in her attempts to ensure that the picture was historically accurate in every detail. Unfortunately, the veterans whom she consulted could not always agree amongst themselves about the correct details, even as to the markings on their haversacks. The autobiography reproduces a pen-and-ink drawing entitled *Crimean Ideas* (see Cat 132) which includes a study for the figure with the bandage round his head. Another version of this guardsman was painted in oils on a small panel (Cat 17), although the final figure in the painting is substantially different from both studies.

On 13 December 1873, four months before she had to send the picture to the Royal Academy, Thompson began work on the canvas itself. Although this was rather late, she had prepared well, methodically making watercolour sketches of the attitudes of each of the 30 or so guardsmen on view. She recorded her technique in transferring them to canvas;

Each figure was drawn in first without the great coat, my models posing in a tight 'shell jacket,' so as to get the figure well drawn first. How easily then could the thick, less shapely great coat be painted on the well-

secured foundation. No matter how its heavy folds, the cross-belts, haversacks, water-bottles and everything else broke the lines, they were there, safe and sound, underneath.

The picture was entirely novel in the context of British military painting at that date. The simple but strikingly effective 'head-on' composition gives it a dramatic immediacy which satisfied a public need to understand the experience of the war at a time when, with military reforms in the air, there was a revival of interest in the Crimea. Its general manner, the sombre colours, understated emotion and its treatment of an unusual aspect of campaigning, is certainly indebted to French military painting (see below pp 160–6 and above pp 31). The iconography of the soldiers themselves may well be derived from figures in prints and the illustrated newspapers published during the Crimean War, or from the statues of the three guardsmen leaning on their muskets at the foot of John Bell's Guards' Memorial in Waterloo Place, London (1860). However, although during its progress the Crimean War was extensively documented pictorially by photographs, coloured prints and illustrations in newspapers, there had previously been no paintings portraying it with this kind of realism.

The Roll Call captured the imagination of the general public and London Society alike, immediately becoming 'the hit of the season'. Moreover, it won the approval of the many Crimean veterans who saw it. So well was the picture received by the public that, throughout her career the painter repeatedly made use of one or other of its features such as the rutted road in the foreground, the arc of birds in the sky or the line of stout-hearted rank and file. The status of battle painting in Britain was considerably enhanced and thereafter, the concept of the manly soldier, valiantly bearing the marks of recent conflict, became an essential feature of the genre.

Exhib: R.A. 1874 (142); Newcastle-upon-Tyne, Leeds, Birmingham, Liverpool and Oxford 1874–5 Fine Art Society 1877;
'City Art Gallery Inaugural Exibition', Leeds 1888; Guildhall 1897 (11);
International Exhibition, Dublin 1907;
Franco-British Exhibition 1908 (259); Leicester Galleries 1912 (7);
Arts Council 'Great Victorian Pictures', Leeds, Leicester, Bristol and Royal Academy 1978
Refs: *The Academy* 23 May 1874; *The Art Journal* 1874, pp 163–4; *The Athenaeum* 16 May 1874; *The Birmingham Daily Post* 6 Nov 1874; *The Birmingham Morning News* 5 Nov 1874; *The Daily Telegraph*

2 May 1874; *The Graphic* 9 May 1874; *The Illustrated London News* 9 May 1874; *The Liverpool Mercury* 7 May 1874; *The London Figaro* 16 May 1874; *The Morning Post* 2 May 1874; *The Newcastle Daily Journal* 2 May 1874; *The News of the World* 10 May 1874; *The Pictorial World* 2 May 1874; *The Pall Mall Gazette* 2 June 1874; *Punch* 16 May & 8 Aug 1874; *Queen* 2 May 1874; *The Saturday Review* 16 May 1874; *The Spectator* 9 May 1874; *The Tablet* 8 Aug 1874; *The Times* 2 May 1874 (for further references see above, pp 28–36); *The Daily News* 4 May 1875
Engr: Line and stipple engraving by F Stacpoole, 63.5 × 101.6, published by J Dickinson & Co 13 July 1874; mixed method engraving by W T Hulland, 38.1 × 76.2 published by the Fine Art Society (Ltd), 7 November 1882

1. Lt-Gen Sir F W Hamilton *The Origin and History of the First or Grenadier Guards* John Murray, London, 1874
2. General Sir George Higginson *Seventy-One Years of a Guardsman's Life* John Murray, London, 1916
3. *The Sunday Chronicle* 20 June 1926

18A. Copy of The Roll Call

attributed to Princess Louise, Duchess of Argyll

Oil on canvas 88.9 × 180.3 c1895

Prov: Presented to the Guards Club by the Fine Art Society, 1937

Cavalry and Guards Club

Exhibited at Durham and Leeds only

The authorship and date of this full-size copy of *The Roll Call* have not been firmly established and Thompson herself does not mention her picture being copied. However, Wilfrid Meynell, the artist's brother-in-law, noted in 1898 that '"*The Roll Call*" now hangs at Osborne, and it may be of interest to add that a copy of it has lately been made in oils by the Princess Louise'.[1] The Princess was an able painter who exhibited at a number of London galleries. Several of her works depict Crimean War subjects.

1. Wilfrid Meynell 'The Life and Work of Lady Butler' *The Art Annual* 1898, p 7

19. Carte-de-visite photograph of Elizabeth Thompson, 1874, looking, she thought, '. . . a rather harrassed and coerced young

woman'. Thousands of copies of this photograph were sold after the artist's sudden rise to fame. See p 14.

Collection of Hermia Eden, Catherine Eden and Elizabeth Hawkins

20. Punch's Essence of Parliament

Engraving, published in *Punch* 8 August 1874, see p 30.

In summarising the topics of the 1874 'season', Edward Lindley Sambourne's caricature gives Elizabeth Thompson and *The Roll Call* pride of place.

21. Sketchbook 1874–75

22 pages 18 × 25

Prov: Lt-Col P R Butler. Presented to the National Army Museum in 1963

National Army Museum 6311-193-3

Elizabeth Thompson's sketchbook of 1874 to 1875 is mainly composed of studies for the artist's third Academy painting, *The 28th Regiment at Quatre Bras* (fig 5). Many of these were made at Chatham in July 1874 where Colonel J F M Browne, Royal Engineers, Deputy Adjutant-General, drew out a large number of his men to demonstrate field exercises for her. There are also pencil drawings of French cavalry being repulsed by a volley from a British square, soldiers kneeling in line and a number of careful watercolours of grass overlaid with purple shadows for the foreground of the picture *The 28th Regiment at Quatre Bras*. In her autobiography the painter records that her mother helped her to make studies of a field of rye at Henley-on-Thames, '... two regular "Pre-Raphaelite Brethren" ... bending over a patch of trampled rye'. It was in such a field that the 28th (North Gloucestershire) Regiment were reported to have formed square to receive the enemy's cavalry.

A large pen-and-ink and pencil study for the fallen horse which appears on the right of the final picture was made at the riding school of the Royal Horse Guards in Knightsbridge.

Various inscriptions reveal the care with which the artist sought to achieve accuracy in her paintings. The fly-leaf is annotated with the following questions and her answers: 'Do men in square ever lean forward while firing? A little', 'Would kneeling man in excitement raise his musket from ground to parry a thust before enemy came up to him? No'. Other remarks concern the effect of gunsmoke; 'Where smoke is thin and blue it should be like a film or veil with scarcely any variety or thickness ... men look all one colour through smoke no matter what they have on – shakos tall or little ...'. There is also a list of the figures she had still to complete on the canvas, setting herself to paint about one a day.

In addition, the sketchbook contains two pencil studies of a 'draped' female figure in a Life Class and a double-page drawing of the Royal Horse Artillery on exercise at Aldershot.

21–1

21–1. Studies for the front rank of the square in Quatre Bras

Pencil

Inscribed with notes of the artist's appointments, 26 October – 4 November 1874

After watching 300 of Colonel Browne's sappers exercising for her benefit the artist was allowed to select eight men to model in her studio. Unfortunately, she was told that three of the eight were 'unsuitable' characters, but the others were detailed to pose for her, possibly in the period uniform which Colonel Browne had ordered from the Army Clothing Factory in Pimlico. These figures, sketched from life, show that the artist had already decided upon their final arrangement for the oil painting.

Fig 5. The 28th Regiment at Quatre Bras

Oil on canvas 97.2 × 216.2 1875
(photograph only)

Insc: *E/(Mon)T/1875*

Prov: Purchased by Charles J Galloway for
£1,126 with the copyright (by the terms of
The Roll Call agreement, 1874). The
copyright was sold to J Dickinson & Co in
July, 1874 for £2,000. Christie's, 28 May
1881; bought in at £75.10/-. Purchased by
the National Gallery of Victoria,
Melbourne, in 1884 (£1,500)

Reproduced by permission of the National
Gallery of Victoria, Melbourne, Australia

I wished to show what an English square
looks like viewed quite close at the end of
two hours' action, when about to receive a
last charge. A cool speech, seeing I have
never seen the thing! And yet I seem to have
seen it – the hot, blackened faces, the set
teeth or gasping mouths, the bloodshot eyes
and the mocking laughter, the stern, cool,
calculating look here and there; the unim-
pressionable, dogged stare!

This was Elizabeth Thompson's stated aim in
choosing the subject of the 28th (North Gloucester-
shire) Regiment at the battle of Quatre Bras, 16
June 1815, as it formed square to receive the last
charge of Marshal Ney's cuirassiers and Polish
Lancers.

Since *The 28th Regiment at Quatre Bras* was the
successor to *The Roll Call* the artist took great
pains with it. As always she made certain that she
knew the historical background, reading contem-
porary accounts such as Capt W Siborne's *History
of the War in France and Belgium in 1815*[1] before
embarking on the project. The 28th had formed
square in a field of 'particularly tall rye', so in
mid-July 1874 she visited Henley-on-Thames to
make sketches for the foreground of the pictures
with the assistance of her mother. In order to do
this to her own satisfaction she first bought part of
a field of rye grass, trampling it herself with the aid
of some local children. No doubt she was aware of
the similar depiction of long grass in Meissonier's
painting *1807: Friedland*. She also visited Sanger's
circus, where two horses were made to lie down
and flounder while she made studies of them for the
horse lying in the right foreground of the picture.
Since the success of *The Roll Call* Elizabeth
Thompson was quite a celebrity and she appears to
have enjoyed the assistance of the Army from this
time. With the permission of the Royal Horse
Guards she went to the riding school at Knights-
bridge to make further sketches of one of their
black chargers. 'The riding master' she recorded,
'strapped up one of the furious animal's forelegs
and then let him go. What a commotion before he
fell!' The drawings and notes that she made at this
time are contained in the Sketchbook of 1875 (Cat
21).

For the soldiers themselves she used all sorts of
models; policemen were particularly useful as,
unlike most men of the 1870s, they did not wear
moustaches. Colonel James Browne, Royal Engi-
neers, Deputy Adjutant General, helped her by
having a Waterloo-style uniform made up at the
Army Clothing Factory at Pimlico. He also invited
her down to Chatham to make studies of a large
number of men and 300 were put through appro-
priate exercises in full dress carrying knapsacks for
her benefit. The artist's notes in the front of the
sketchbook suggest that she was able to use this
extraordinary opportunity to find the answers to a
number of pictorial problems. Colonel Browne

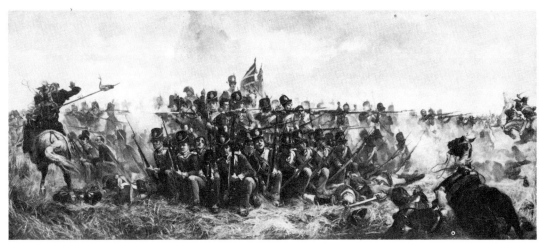

Fig 5

then allowed her to pick eight men with suitably beardless faces for use as models in her Brompton studio. While she was painting the canvas she was visited by the Duke of Cambridge, Commander-in-Chief of the Army who, she remembered '. . . gave each soldier in my square a long scrutiny and showed how well he understood the points'.

At the Royal Academy Thompson's efforts were rewarded. When she visited the exhibition she saw 'A dense, surging multitude before my picture. The whole place was crowded so that before "Quatre Bras" the jammed people numbered in dozens and the picture was most completely and satisfactorily rendered invisible.' Reviewers could not fault the historical accuracy of *The 28th Regiment at Quatre Bras*, save only for the soldiers' clean faces and uniforms. They were less happy about some rather hastily painted areas of the picture and the colour, the attempt to 'keep down' the soldiers' red coats by introducing a flourish of red smoke in the centre. Nevertheless, for the most part they were impressed by the 'Hogarthian' (sometimes 'Shakespearean') variety of character, the calm heroism of the officers, the fixed determination of the veterans, the defiant, jeering levity of the young men. Again, the picture was novel in its representation of battle, not least in its close-to, head-on scrutiny of the infantry square in action, as opposed to the more traditional, 'off the ground' over-view. This was noted by the reviewers who considered it so much more telling than the '. . . clashing of swords and muscular energy of a hand-to-hand struggle' in Felix Philippoteaux's more conventional *La charge des cuirassiers français à Waterloo* (fig 17) hanging in an adjoining room.

Despite its being poorly hung in the 'Black Hole' of the Lecture Room *The 28th Regiment at Quatre Bras* was generally admitted to be one of the highlights of the 1875 exhibition, along with Hubert von Herkomer's *Last Muster* and Edwin Long's *Babylonian Marriage Market*. Even John Ruskin, in his *Academy Notes* paid tribute to it. He had not previously publicly commented on her work, but now he declared;

I never approached a picture with more iniquitous prejudice against it than I did Miss Thompson's; partly because I have always said that no woman could paint; and secondly, because I thought what the public made such a fuss about must be good for nothing. But it is amazon's work this; no doubt about it, and the first fine Pre-Raphaelite picture of battle we have had . . . it remains only for me to make this tardy genuflexion . . . before this Pallas of Pall Mall . . .[2]

The central theme of the picture, that of a group of men staunchly facing the enemy, was frequently used by the battle painters who succeeded Thompson, for example by Charles Edwin Fripp in *Isandhlwana* (Cat 138) and William Barnes Wollen in *The last stand of the 44th Foot at Gundamuck* (Cat 140). Indeed, the last stand of the regiment was a common subject of late nineteenth-century British battle painting. The picture itself was copied by Edward Linley Sambourne in a *Punch* cartoon (26 June 1875), *Academicians and Outsiders. – A Battlepiece* (Cat 22), satirising the conservatism of members of the Royal Academy. Individual artists and the critic, John Ruskin, are portrayed forming square to resist the attack of other painters who were demanding a reform of the institution at the time. Elizabeth Thompson herself, who was never admitted to membership because the issue of accepting women was still too controversial, is depicted frowning in one corner.

Exhib: R.A.1875 (853); Manchester, Newcastle-upon-Tyne, Leeds, Nottingham and Leicester 1875–76; Fine Art Society 1877; Guildhall 1900 (16)

Refs: *The Architect* 22 May 1875; *The Art Journal* 1875, p220; *The Athenaeum* 1 May 1875;*The Graphic* 15 May 1875; *The Illustrated London News* 1 May 1875; *Punch* 26 June 1875; J Ruskin *Academy Notes* London 1875; *The Spectator* 8 May 1875; *The Times* 1 May 1875; *The Tablet* 5 Aug 1876

Engr: Mixed method engraving by F Stacpoole, 63.5 × 101.6, published by the Fine Art Society (Ltd), 30 Oct 1876; mixed method engraving by Richard Josey, 38 × 76, published by the Fine Art Society (Ltd), 24 April 1888

1. Capt W Siborne *History of the War in France and Belgium in 1815, containing minute details of the Battles of Quatre Bras, Ligny, Wavre and Waterloo* T & W Boone, London, 1844, 2 Vols.
2. E T Cook and A Wedderburn *The Works of John Ruskin* Library Edition, 1903–12, London, Vol XIV, p 308

22. Academicians and Outsiders

Engraving, published in *Punch* 26 June 1875, see p 38.

Using the composition of Elizabeth Thompson's Royal Academy painting of 1875, *The 28th Regiment at Quatre Bras*, *Punch* depicts some of the 40 full Academicians defending themselves against the reforming zeal of some of the other exhibitors, while Thompson and two other female colleagues wait in the wings.

23. A Quiet Canter in the Long Valley, Aldershot

Watercolour 51 × 87.5 c1875

Insc: *E.*(mon)*T.*

Prov: By descent to the present owner, the artist's great-grandaughter

Mrs Brigid Battiscombe

In Wilfrid Meynell's monograph on his sister-in-law's career, this watercolour is reproduced with the title, *A Quiet Canter in the Long Valley* but the author omits to mention the date.[1] It may also be the picture which he refers to as *Scots Greys Advancing*, which was exhibited at the New Watercolour Society in 1876. It is known, however, that Elizabeth Thompson attended the Aldershot manoeuvres for several days in July 1875 where she witnessed the sights that would have provided the basis for this painting. By then a celebrity, the Army afforded her every assistance and she and her father travelled to Aldershot on the special train which also carried the Prince of Wales, the Duke of Cambridge and many other high-ranking guests.

She was delighted with the parade in the Long Valley, and recalled that '... the most splendid military spectacle was given us, some 22,000 being paraded in the glorious sunshine and effective cloud shadows in one of the most striking landscapes I have seen in England ... Their very faces seemed different; clean, open and good looking'. Meynell noted that even in her minor compositions such as

this, the painter '... has taken the individual, separated him, seen him close, and let the world so see him'. The 2nd Royal North British Dragoons (Scots Greys), part of the impressive spectacle on that day, were to inspire the artist on many subsequent occasions, especially as the subject of her most dramatic painting, *Scotland for Ever!* (Cat 36).

1. Meynell, *op cit*, p 31

24. Italian Boy

Watercolour with bodycolour over pencil 34 × 24 1875

Insc: *Castagnolo/Sept 1875/Elizabeth Thompson*

Prov: By descent from the painter to the present owner, through his aunt Mrs Kingscote, the painter's elder daughter

Mr Antony Preston

In September 1875 the artist and her sister Alice Thompson travelled to Tuscany, staying at the Villa Castagnolo just outside Florence as guests of Mrs Janet Ross and the Marchese della Stufa during the celebrations of the four-hundredth anniversary of the birth of Michelangelo. During the grape harvest at the villa she '... sketched hard every day in the garden, the vineyards, and the old courtyard where the most picturesque vintage incidents occurred, with the white oxen, the wine pressing, and the

24

661 of Britain's finest cavalry was reduced to a mounted strength of 195 in just twenty minutes.[2] Alfred, Lord Tennyson's famous lines were quoted in the catalogue of the exhibition which launched the painting;

> Stormed at with shot and shell
> While horse and hero fell
> They that had fought so well
> Came through the jaws of Death,
> Back from the mouth of Hell,
> All that was left of them,
> Left of six hundred.

Balaclava was a popular subject for military painters and the Royal Academy exhibition of 1876 included two pictures of the battle, Felix Philippoteaux's *Charge of the Heavy Brigade* and Thomas Jones Barker's *The Return through 'The Valley of Death – Lord George Paget bringing out of action the remnant of the 11th Hussars and 4th Light Dragoons.* However, Elizabeth Thompson's treatment of the subject was original in that not only is the action itself omitted but so too are all of the officers who took part. Once again, as in *The Roll Call* and *The 28th Regiment at Quatre Bras*, the painter's concern was with the suffering and courage of ordinary soldiers.

According to Elizabeth Thompson's autobiography the picture was well in hand by 17 July 1875 when she was engaged in checking details of the action with survivors and finding suitable models. Again, the accounts given to her by veterans of the campaign varied considerably and at one point a 'Col.C.', avowing that no dress caps were worn during the charge, rubbed out part of a preliminary charcoal sketch and coolly substituted his own drawing, putting '. . . mean little forage caps on all the heads (on the wrong side too!)'. An old sergeant of the 17th Lancers heartened the painter by saying 'Well, miss, all I can tell you is that my dress cap went into the charge and my dress cap came out of it!' He had also kept his uniform all those years and kindly lent it to the artist. Sub-Lieutenant Edward Inman of the 10th (Prince of Wales's) Royal Hussars brought her his bay horse to model for the animal on the left of the picture and Major George L Smith, an officer of the 107th Foot (Bengal Infantry), sat for the figure of the bearded troop sergeant riding it.[3] The actor, W H Pennington, posed for the central figure in the picture. He had seen service in the Crimea as a trooper of the 11th (Prince Albert's Own) Hussars, one of the five regiments that took part in the charge. The design of the mounted groups to the right of the Pennington figure may have originated in 1873 when the painter was working out the composition of *Missing* (see Cat 14).

bare-legged merry *contadini*, all in the atmosphere scented with the fermenting grapes.'

This drawing shows one of these *contadini* (peasants) engaged for the vintage which provided such an idyllic holiday for the two sisters. However, the necessity to begin work on Thompson's next canvas, *Balaclava* (Cat 25) forced them to return to London in early October.

25. Balaclava

Oil on canvas 103.4 × 187.5 1876

Insc: *18 ET 76*(mon)/*E.T.*

Prov: Purchased by John Whitehead in 1876 and presented by his son, Robert Whitehead in memory of his father, John, to the City of Manchester in 1898.

Manchester City Art Galleries

'That glorious blunder of which Englishmen are justifiably proud'[1]

Elizabeth Thompson's second Crimean picture depicts the remnants of the Light Brigade returning from the disastrous charge during the battle of Balaclava, 24 October 1854. As a result of a misinterpretation of orders, a force estimated at

In August 1875 Elizabeth sketched the grassy slopes of the South Downs in Sussex which resembled the scenery of the North Valley where the charge occurred. Then in late summer she went to Italy which for a while deferred further work on the picture. On returning to London in late September, she restarted the project and, on 19 October, she was in a position to begin a large preparatory charcoal sketch.

Despite the problems of foreshortening caused by having figures advancing directly from the picture plane, particularly with the group centre right, *Balaclava* follows its predecessors *The Roll Call* and *The 28th Regiment at Quatre Bras* in presenting a head-on, eye-level view of the men, allowing the spectator to study each soldier in turn. As with her previous works, reviewers hailed what *The Manchester Critic* called the painter's '. . . special faculty for individualisation'. Indeed reviewers on the whole praised the picture, with the exception of one figure, the hussar in the centre modelled by Pennington. *The Manchester Critic* went as far as to say 'We think it would have been as well if you, Mr Pennington, had never come back from the charge. You are theatrical – not dramatic – simply ruinously obtrusive and unreal'. Not merely did he seem to lack the restraint that audiences had come to expect of Thompson's figures, but it was thought that he also bore disturbing signs of having suffered some kind of mental derangement in the fray, a level of realism in the portrayal of war that was still unacceptable. Deaf to the calls of his comrades, '. . . dazed and drunk with the wine of battle', in the

words of *The Sunday Times*, he marches on clenching his bloodied sword. However, some of the other figures in the painting, such as those gesturing with outstretched arms, could be seen as being more 'theatrical' and it seems probable that this charge was levelled at the figure because of Pennington's own reputation as an actor. In fact, in the summer of 1876, Pennington appeared in a *tableau vivant* based on the figure which the painter arranged herself and she records her irritation at his performance, 'We didn't want a representation of Mr. So-and-so in the becoming uniform of a hussar, but my battered trooper. The thing fell very flat.' On 25 October he was also employed to recite Tennyson's lines at the banquet for survivors of the charge held at Alexandra Palace.[4]

A further criticism concerned the painter's decision to exhibit the picture at a private gallery, the Fine Art Society in Bond Sreet. The magazine *Fun* suggested that she had foresaken the Royal Academy for financial reasons, by publishing a cartoon which showed the Academy walls crowded as ever with pictures except for a space where Thompson's picture should have been, with a note on it saying: 'The Charge of Balaclava 1/- extra see advertisements of Miss Thompson's Great Picture.' In her autobiography, the painter implicitly dismissed such allegations, claiming that interruptions and unavoidable delays made it impossible for her to complete the picture in time for the Academy. William Powell Frith warned her that if she did not send a picture to the Academy she would lose the chance of election to membership.

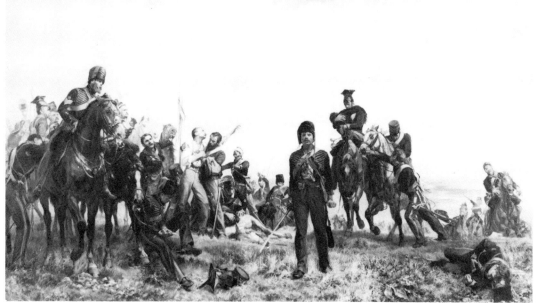

25

Whatever the reason for her change of venue, there is no doubt that the Fine Art Society was delighted to have the opportunity to show *Balaclava* first. From the Minute Book, it is evident that the Society had staked its future on the picture, by paying £3,000 for the copyright alone, a record sum according to advertisements that appeared later in the year in a Huddersfield newspaper.

None of these criticisms affected the popularity of *Balaclava*. It toured the country and everywhere it was shown crowds flocked to view it. 50,000 visitors were reported at the Fine Art Society in London[5] and by the time it arrived in Liverpool in January 1877 over 100,000 people had seen the picture.

> Exhib: Fine Art Society April 1876;
> Newcastle-upon-Tyne Aug 1876;
> Scarborough Sept 1876; 'The Balaclava
> Banquet', Alexandra Palace, London Oct
> 1876; Birmingham Oct 1876;
> Leeds Nov 1876; Huddersfield Dec 1876;
> Liverpool Jan 1877; Manchester Feb 1877;
> Fine Art Society April 1877; The
> Infirmary, Bolton 1881;
> Manchester Royal Jubilee Exhibition 1887
> (10); 'Works by Naval and Military
> Artists', Guildhall 1915 (229); 'Le Salon
> Imaginaire', Akademie Der Kunst, Berlin
> 1968; 'The Brilliant Year: Queen
> Victoria's Jubilee 1887', Royal Academy
> 1978 (143).

> Refs: *The Academy* 5 May 1876; *The Daily
> Telegraph* 22 April 1876; *The Graphic* 20
> May 1876; *L'Indépendance* (Belgium) 11
> June 1876; *The Literary World* 26 June
> 1876; *The Observer* 23 April 1876; *Punch*
> 13 May 1876; *The Sporting Gazette* 6
> May 1876; *The Standard* 18 May 1876;
> *The Sunday Times* 30 April 1876; *The
> Tablet* 5 August 1876; *The Times* 17 May
> 1876; *The World* 26 April 1876; *The Art
> Journal* 1877, p190.
> In addition, a scrapbook compiled by T E
> Weller, the painter's maternal grandfather,
> contains over forty review articles from
> newspapers in Newcastle-upon-Tyne,
> Sunderland, Liverpool, Hexham,
> Huddersfield, Birmingham, Leeds,
> Scarborough, York, Salford and
> Manchester; Collection of Hermia Eden,
> Catherine Eden and Elizabeth Hawkins.

> Engr: Mixed method engraving by
> F Stacpoole, 63.5 × 101.6, published by
> the Fine Art Society, 20 April 1876

1. *The Yorkshire Post* 10 Nov 1876
2. Lord Cardigan, the Brigade commander, mustered 195 men immediately after the action, though many more survivors turned up later. Casualty figures for the Brigade have been computed at 245, 37% of those engaged. 118 men had been killed and 127 wounded; the Marquess of Anglesey *A History of the British Cavalry* Vol II, Leo Cooper, London 1975, p 103.
3. Letter lodged at Manchester City Art Gallery
4. W H Pennington *Sea, Camp and Stage*, J W Arrowsmith, Bristol, 1908
5. *The Illustrated London News* 30 Oct 1876

26. The Return from Inkerman

Oil on canvas 104.4 × 185.6 1877

Insc: *E T(mon)/1877*
> Printed on frame: *23rd 33rd It was a
> glorious day for British arms 88th 30th /
> Grenadiers Coldstreams Scots Fusiliers
> Inkerman Nov. 5th 1854 1st Royals
> Marines Rifles*

Prov: Purchased by the Fine Art Society
> April 1877 ; sold Christies 17 May 1884
> to Mclean for £682.10; purchased by the
> Ferens Art Gallery in 1913 from the sale
> of George McCulloch's collection for
> £892.10/-

Ferens Art Gallery, Hull City Museums and
Art Galleries

Elizabeth Thompson's third picture of the Crimean War depicts a ragged column of exhausted and wounded men, mostly of the Coldstream Guards and the 20th (East Devonshire) Regiment, as they trudge back to camp from the heights of Inkerman on the evening of 5 November 1854. By the mid-1870s, Thompson had established a reputation as a painter of the soldier's experience of battle and Inkerman was therefore an obvious subject to choose. Rain and fog had often made it impossible for the British commanders to issue effective orders and 'the Soldiers' Battle' had been won largely by the courage and determination of the men through hours of chaotic fighting.

Wilfrid Meynell described the painting, knowing the painter's intentions;

> Two stretchers with wounded officers are being carried. Beside one, rides a staff-officer on his pony. Some Grenadier and Coldstream Guards are moving off on the right, beyond the French ambulance; and farther afield, in the gathering mist of that November day, are the ruins of Inkerman and the heights from which, early in the morning, the Russian guns played on the artillery of the 2nd Division as it struggled up to the ridge over which the troops are now

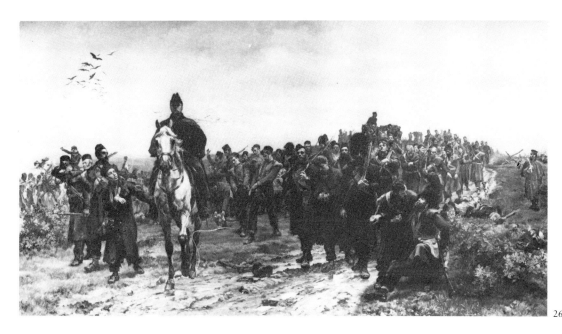

passing, and on the brow of which was the fierce fight around Pennefather's guns. The dead belong to the British; no Russian soldier passed during that day beyond the crest of the ridge.[1]

As in Thompson's previous pictures of the Crimea the men are shown bearing the physical and emotional marks of the conflict, albeit with the matter-of-fact stoicism which Thompson saw as the unsung heroism of the ordinary soldier. The debris of battle, spent shot, pieces of leather and the blood-stained shako on the road in the foreground, echo the terrible cost of the fighting while the low rain clouds and the line of black birds following the column add a sombre, symbolic intensity.

As always, the painter's preparations for the picture were meticulous. In the summer of 1876 she read everything she could find on the battle, especially William Howard Russsell's accounts in *The Times*, and consulted veterans of the action at Aldershot. She went to Sussex again to make studies for the vegetation in the foreground. By the end of August she was in a position to make a cartoon, following her usual procedure of 'fixing' the composition in sepia on a sheet of paper of the same size as the projected picture. Then in the autumn, during her annual visit to Italy, she made further studies, sketching the oak bush shown in the foreground on a rare rainy day.

By the following spring the picture was complete, although once again the painter had been delayed, this time with a cold which she recalled '... retarded my picture so much that, to my deep disappointment, I had again to miss the Academy'. In April 1877, after several weeks of negotiations, *The Return from Inkerman* was sold to the Fine Art Society. It commanded the huge sum of 3,000 guineas, although this was only half the amount the painter, or rather her father who conducted such negotiations for her, had hoped for.[2] It was then promptly put on exhibition for four weeks at the Society's premises at 148 Bond Street together with *The Roll Call*, *The 28th Regiment at Quatre Bras* and *Balaclava*, with *Missing* hanging in an upstairs room. This time, however, Thompson's new painting attracted little attention from the press. This may have been partly because the exhibition at the Fine Art Society coincided with the opening of the Royal Academy show, the main artistic event in London, although reviewers had certainly not ignored *Balaclava* when it was shown at the same gallery the year before. However, it seems more likely that the essential features of the picture, the return of weary soldiers after a battle, their advance along a rutted road towards the spectator, the composition, viewpoint and the emotional tenor of the whole painting had already been used to telling effect, both in *The Roll Call* and *Balaclava*. By now the formula no longer had any novelty.

The Graphic, which did review *The Return from Inkerman*, noted how close in design and mood the picture is to the grey, rain-soaked Franco-Prussian War scenes of Thompson's contemporaries in France, Edouard Detaille and Alphonse de Neuville (see below, pp 160–6).

Exhib: Fine Art Society April 1877;
Exposition Universelle, Paris 1878 (30);
Loan Exhibition, Royal Academy 1909.

Refs: *The Art Journal* 1877 p 190; *The Graphic* 28 April 1877

Engr: Mixed method engraving by W T
Davey, 50.8 × 101.6, published by the
Fine Art Society (Ltd), 8 April 1878

1. Meynell, *op cit*, p 8
2. Fine Art Society MS Minute Book 7 March 1877

27. Carte-de-visite case

Insc: *Presented to Pn.Sergt.J.Dodds by Miss
E.Thompson/ Painter of the ROLL CALL
1877*

Mr G K M Newark

27

The date of the inscription inside the case together
with the regiment of the recipient of this gift from
the artist suggest that Pioneer Sergeant John Dodds
may have been a model for one of the figures in *The
Return from Inkerman* (Cat 26). Unfortunately
Elizabeth Thompson devotes very little space in her
autobiography to the subject of her research for the
picture and fails to mention any of the men who
modelled for her.

John Dodds was born in Darlington in 1840 and
at the age of seventeen, after an apprenticeship in
plastering, he enlisted as a private in the
Coldstream Guards. By 1866 he had reached the
rank of sergeant, but four years later he was
court-martialled for dereliction of duty and reduced
to the rank of private. However, he soon rose
through the ranks again and in 1876 he was finally
promoted to pioneer sergeant. He was discharged
on completion of his second term of limited engage-
ment on 25 March 1879.[1]

It is possible that Dodds was the model for the
figure of the bearded Coldstream guardsman who
appears in the centre right of *The Return from
Inkerman*, carrying a rifle over both shoulders. As a
pioneer sergeant he may have worn a beard and so
would have made an excellent subject for one of the
bearded troops of the Crimean War.

1. Public Record Office, WO12/1770 and WO97/2674

*Presented to Pn.Sergt J.Dodds by Miss E.Thompson
Painter of the ROLL CALL 1877*

27. Detail

2. Marriage and Colonial Wars
1877–1890

Elizabeth Thompson's marriage to Major William Butler of the 69th Regiment on 11 June 1877 was widely regarded as being a good match. John Ruskin wrote to Butler to congratulate him, 'I am profoundly thankful for the blessing of power that is now united in your wife and you. What may you not do for England, the two of you'.[1]

William Francis Butler (1838–1910), a Catholic Irishman from an impoverished family, had made his way in the Army entirely through force of personality, intelligence and a readiness for active service anywhere in the world. By 1877, he had already served in Burma, India, Canada and West Africa. He was also a gifted and prolific writer who, by this time, had published accounts of his experiences in Canada in *The Great Lone Land* and *The Wild North Land*, and during the Ashanti War of 1873 in *Akim-Foo. The Story of a Failure*, as well as a history of his own regiment.[2] Marriage to such a man might have furthered the painter's career for, at this point, she had exhausted the Crimean War as a source of subject-matter and Butler's knowledge of the contemporary colonial wars was a ready store of new material.

From this period Elizabeth Butler did turn to contemporary imperial themes, but within a few years her career began to founder. After 1881 she sold few of her paintings and the scant reviews which she received were almost entirely unsympathetic. Competition from a growing number of battle painters had helped to undermine her pre-eminence (see below, pp 167–174). However, the decline in her popularity can also be attributed to the change of circumstance brought about by her marriage. Both the public and reviewers took time to adjust to her change of name; until 1880 she signed her canvasses with the monogram and initials of her maiden days as well as with 'EB' for Elizabeth Butler. As an officer's wife, she was required to live an unsettled life, following her husband in his postings around Britain and abroad. Furthermore, she had to reconcile her career with the task of bringing up a family of five children. Consequently

1. Quoted in MS letter from Elizabeth Butler to Alice Meynell, December, 1880; Collection of Hermia Eden, Catherine Eden and Elizabeth Hawkins. Also, Edward McCourt *Remember Butler. The Story of Sir William Butler* Routledge and Kegan Paul, London, 1967, p 130
2. William Butler's written works include essays on various topics, accounts of campaigns and travels, biographies of famous soldiers and a boy's adventure story. There is a list of his works in McCourt, *op cit*, p 267

in the 1880s she produced fewer pictures than previously. After *Scotland for Ever!* appeared in 1881, it was four years before she exhibited another large painting; too long a period to keep her name in the forefront of popularity. While her earnings must have far outstripped those of her husband who, in 1881 as a lieutenant-colonel and senior staff officer at Devonport had an annual salary of £600,[3] she no longer practised her art as if it was her main source of income. In effect, she relinquished her professional status within the art world and only pursued her work as and when domestic duties permitted. As an indication of the importance which the Butlers attached to their respective careers, Elizabeth's autobiography constantly mentions 'Will's' doings, but in the 455 pages of the general's memoirs, his wife is not even mentioned once.

A further consequence of her marriage was that it brought the painter within the sphere of her husband's unorthodox political opinions. William Butler was a ' . . . champion of lost causes and a seeker of impossible goals'.[4] In his autobiography, he wrote of the lasting effect that the horrors of the Irish famine, 'the black '46', had had upon him as a boy. He became a strong supporter of the cause of Home Rule for Ireland and an admirer of Charles Stewart Parnell. Although an able, ambitious officer and a protégé of Sir Garnet Wolseley, he persistently spoke out against any policy of enlarging the British Empire, which he saw as 'the mania for acquisition'. Repeatedly, and often at some risk to his career, he made it his business to present the case of those who resisted Britain's imperial policies, whether it was the Boers, Zulus, Arabs, Afghans or Ashanti. In Wolseley's view;

> Had he lived in mediaeval times, he would have been the knight errant of everyone in distress. Sympathy for all human, indeed for all animal suffering, was in him an actual living force, always striving to help the poor in body, and to comfort the weak-hearted. A loyal subject of the Crown, he yet always entertained a heart-felt sympathy for those whom he believed to be a down-trodden race, and a lost cause appealed to his deepest feeling.[5]

These liberal attitudes were combined with an army officer's distrust of city-dwellers, politicians and those whom he once described as the 'permanent government' of England; that is, the Establishment.[6] He also loathed the world of finance. 'It is a misfortune of the first magnitude in the lives of soldiers of to-day,' he wrote in his autobiography, 'that the majority of our recent wars have their origins in purely financial interests or sordid Stock Exchange ambitions.'[7] In fact, only one of the many campaigns in which he participated seemed to him entirely worthy, the

3. Lt-Gen The Rt Hon Sir W F Butler GCB *An Autobiography* Constable and Co Ltd, London, 1911, p 215
4. McCourt, *op cit*, p xi
5. Shane Leslie *Salutation to Five* Hollis and Carter, London, 1951, p 97
6. McCourt, *op cit*, p 203
7. William Butler *An Autobiography*, p349

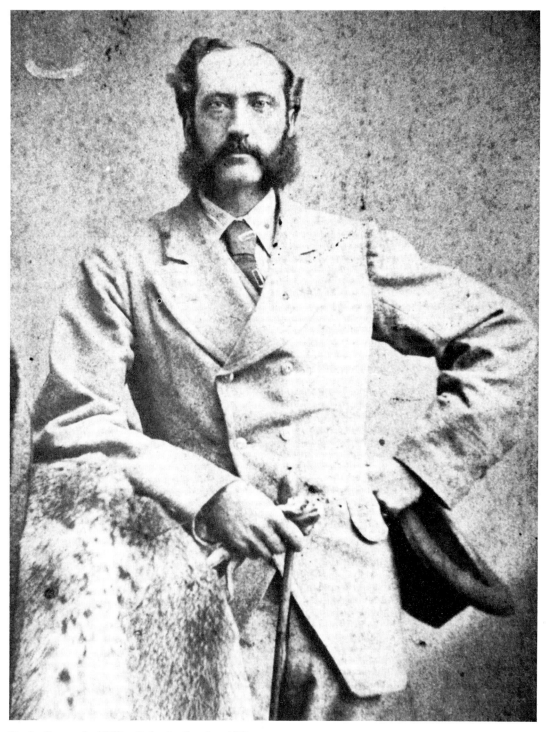

Fig. 6. Photograph of William Butler, San Francisco, 1873.
Two years after the Red River Campaign of 1870, Butler returned to Canada and travelled through the north-west territories, and finally down the Pacific Coast to San Francisco. He returned to England to join Sir Garnet Wolseley's expedition to Ashanti. The Viscount Gormanston

Gordon Relief Expedition of 1884. In Charles Gordon, the charismatic and romantic individualist, he recognised a kindred spirit.[8]

Such reservations concerning 'the imperial mission' were inevitably at odds with the prevailing enthusiasm for an aggressively expansionist imperial policy. The popular mood was clearly demonstrated by the noisy celebrations in the streets of London after Wolseley's victory at Tel-el-Kebir in 1882.[9] In so far as Elizabeth Butler's pictures hinted at her husband's heterodox views, this could only be disadvantageous to her career.

Initially, even those pictures which were influenced by William Butler's views received acclaim. Both *The remnants of an army* (Cat 31) and *"Listed for the Connaught Rangers"* (Cat 30), the paintings which the artist exhibited at the Royal Academy in 1879, were well received, although they were close in spirit to her husband's essays criticising Government foreign policy. *The remnants of an army*, in depicting one of the worst moments of the First Afghan War, reflected his exasperation with the decision to invade Afghanistan for the second time, and in *"Listed for the Connaught Rangers"* there is an expression of his concern at the insensitive treatment of the Irish peasantry.[10] Yet, possibly because the implications of both paintings were not fully appreciated and the pictures appeared to concur with the optimistic climate of opinion in May 1879, they were successful.

By 1882, Elizabeth Butler's artistic fortunes had changed. In turning to contemporary subjects, she chose to depict the disastrous charge at Laing's Nek in the Transvaal War of 1880–81, (*"Floreat Etona!"*, fig 8); the aftermath of the Gordon Relief Expedition (*A Desert Grave*, see Cat 44) and an exposure of the suffering caused by British policy in Ireland (*Evicted*, Cat 46). Repeatedly, while her rivals exulted in conquest, she represented soldierly courage in the face of adversity. Even the picture *"After the Battle"* (Cat 41), commemorating Wolseley's spectacular victory at Tel-el-Kebir in 1882, is not whole-hearted in celebrating the triumph and, by the time it was exhibited in 1885, it was no longer topical. Butler, who was present at the battle as a staff officer and is portrayed in the scene, was greatly concerned that the victory over Arabi Pasha's nationalist rebellion had cost the lives of as many as ten thousand

8. William Butler *The Campaign of the Cataracts* Sampson Low, London, 1887, p 84. In one of his more extravagant passages the author muses on the death of Gordon in Khartoum and compares the martyr hero to the Sphinx. 'So, as I think over the solitary figure of the great Celtic soldier, standing out in the desert, awaiting the end, it seems to me that he, too, has been set there to mark for ever the real height he had held among the children of his day. Better that thus it should have been, than that, brought back by our little hands, he should have been lost to us again in the babble of our streets.'; McCourt, *op cit*, pp 202–3.

9. *The Graphic* 25 Nov 1882 reported that there were hundreds of thousands of people in St James's Park watching the royal review of Wolseley's men. 'We may not be a war-like nation, but we love nevertheless the tap of drums and the blare of trumpets.'

10. William Butler 'The Afghans and Afghanistan' and 'A Plea for the Peasant' in *Far out: Rovings Retold* Wm Isbister, London, 1880

72

fellaheen, or Egyptian peasant soldiers. It is thought to have been at his insistence that the canvas was eventually cut up.[11]

Although before her marriage the painter had shown such determination to pursue a full professional career, it would have been exceptional at that time for any wife to sustain such an ambition. Furthermore, William Butler was a stern, authoritarian husband and father. Eileen, their younger daughter, testified to this fact;

> What is surprising is that one who, in public life, invariably championed the under-dog should, in his own home, have been a complete autocrat. No-one there ever dared dispute my father's will – least of all my mother, in whom loyalty was an outstanding quality, who detested rows, and who, fortunately for herself, had her studio into which to retreat and there find tranquility.[12]

There is no evidence to suggest that Elizabeth resented his domination or strove for greater consideration of her artistic aspirations. She had already achieved success and, as with many women of her time and class, she accepted what were considered to be the duties of marriage. She did not subscribe to the campaign for the political rights of women and was alarmed, for instance, to learn that her sister, Alice, was to take the platform at a Suffragette meeting in 1912;

> I am curious to learn how the great suffragist meeting next Sunday in Hyde Park will go off. Massed bands, playing the 'Women's March', led by the composer, Ethel Smythe, in a 'Cap of Liberty', the papers say all the marchers will wear 'Caps of Liberty'. I hope there will be some exceptions if you are one of the marchers.[13]

As her daughter implied, there was great resilience of character in Elizabeth Butler. As her paintings showed, she was sympathetic to the sufferings of mankind, but valued fortitude above all. The single female protagonist of her *œuvre*, the Irish peasant woman in *Evicted* (R.A. 1890), who stands before the smouldering ruin of her home, epitomises that quality of individual courage. At a personal level, the artist took an equally stoical view of the impact of marriage upon her career.

11. The destruction of the picture is mentioned in McCourt, *op cit*, p 157. A note on the back of the remaining portion of the canvas, written by the artist's son, Lt-Col P R Butler, indicates that *A Desert Grave* (R.A.1887) suffered a similar fate. (Information courtesy of Mr G W Fielding)
12. Eileen Gormanston *A Little Kept* Sheed and Ward, London, 1953, p 133
13. June Badeni *The Slender Tree: The Life of Alice Meynell* Tabb House, Padstow, 1981, p 210; MS letter from the painter to Alice Meynell, July 1912

Marriage and Colonial Wars 1877–1890

28. Copy of the Butlers' Marriage Certificate, 11 July 1877

Not illustrated

The Viscount Gormanston

Elizabeth Thompson and William Butler were married by Cardinal Manning in the Church of the Servite Fathers in London. The artist's sister, Alice Meynell and the Thompsons' family doctor, Edward Pollard were the two witnessess.

29. Sketchbook 1877

33 pages 13 × 18

Insc: Aldershot & Chobham 1877

Prov: Lt-Col P R Butler. Presented to the National Army Museum in 1963

National Army Museum 6310-353-3

The artist was excited by the rich colouring of the Kerry landscape and *"Listed for the Connaught Rangers"* gave her the opportunity to show its varied hues and the way in which these were affected by passing cloud formations. Some of the preliminary drawings in this sketchbook include colour notes on these effects. In addition, there are a number of studies of the 17th Lancers, regiments of hussars and the Life Guards exercising at Aldershot, as well as the Royal Engineers at Chatham. A pencil drawing of a charge of the Life Guards may have provided the basis for Elizabeth Butler's most ambitious and dramatic composition, *Scotland for Ever!* (Cat 36). There are drawings of some of the people encountered on board ship, in Calais and the Pyrenees where the Butlers made a brief European tour in the summer of 1878.

29–1. Study for "Listed for the Connaught Rangers"

Pencil

The studies for *"Listed for the Connaught Rangers"* (Cat 30) made in June 1877 at Glencar,

29–1

Co. Kerry, show how the painter worked to find a satisfactory arrangement for the figures. This tentative grouping gives greatest prominence to the central figure of one of the two recruits and its composition is not as harmonious as in the final work. The artist had yet to arrive at an adequate balance showing the six figures marching down the road towards the spectator as an interactive group, while at the same time conveying their individual characters.

30. "Listed for the Connaught Rangers": recruiting in Ireland

Oil on canvas 107 × 169.5 1878

Insc: *ET*(mon)/*18 EB 78*

Prov: Commissioned by John Whitehead for £2,000; donated by his son, Robert, to Bury Art Gallery in memory of his father

Bury Art Gallery and Museum

The painting depicts two Irish peasants in traditional dress being marched out of a Kerry glen by a recruiting party of a sergeant, private and two drummer boys of the 88th (Connaught Rangers) in the 1870s. It represents a departure from the battle scenes that had made Butler's reputation, but which were beginning to lose their novelty with the art-viewing public. In both this and *The remnants of an*

74

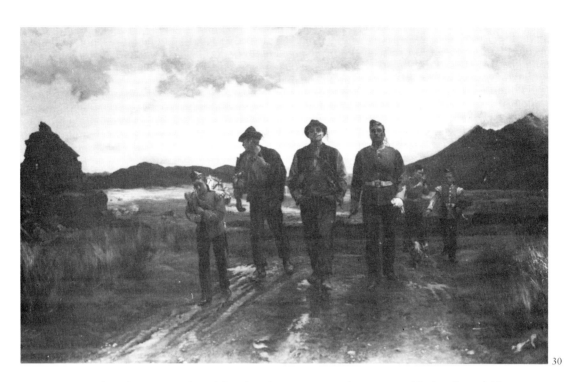

army (Cat 31), the other picture she exhibited at the Royal Academy in 1879, landscape plays a prominent role. The painter was inspired by the beautiful scenery and the picturesque Irish 'types' she encountered on her first visit to the country during her honeymoon tour in the summer of 1877. In her book, *From Sketch-Book and Diary* she described its impact; 'To one familiarised from childhood with Italy's peculiar charm, a sudden vision of the Wild West of Ireland produces a sensation of freshness and surprise difficult to adequately describe.'[1] The sketchbook which she kept while staying at Glencar, Co.Kerry (Cat 29) includes a number of drawings which show the development of the essential arrangement of the figures for the painting. The models for the two recruits were two cousins by the name of Foley, one of whom, the artist related, ' . . . had the finer physique' because, in living near the sea his diet included herring, while the other, who lived in the mountains, was denied that luxury.

In her autobiography, Elizabeth Butler described her artistic intentions;

> The deep richness of those typical Irish days of cloud and sunshine had so enchanted me that I was determined to try and represent the effect in this picture, which was a departure from my former ones, the landscape occupying an equal share with the figures, and the civilian peasant dress forming the

centre of interest. Its black, white and brown colouring, the four red coats and the bright brass of the drum, gave me an enjoyable combination with the blue and red-purple of the mountains in the background, and the sunlight on the middle distance of the stony Kerry bog-land . . . It was a joy to realise this subject.

However, the picture was not only the outcome of the painter's delight in her husband's native land but it also echoed his political views as an Irish Nationalist horrified at the increasing numbers of tenant farmers being driven from their homes. In an essay written in 1878, 'A Plea for the Peasant', William Butler argued that as the English authorities were anxious to improve recruitment to the Army, the way to proceed was to begin by ameliorating the conditions of Irish and Scottish peasants who, traditionally, had supplied the bulk of the Army's recruits. In Ireland, famine, compounded by British mismanagement, was driving many of the fit young men to emigrate to America.[2] In her autobiography the painter referred to one of the solutions he proposed, 'W. at that time was developing suggestions for forming a Regiment of Irish Guards, and I was enthusiastic in my adhesion to such a project and filling the imaginary ranks with big men like my two models.'

These unorthodox implications do not seem to have been appreciated by the public at the Royal

Academy, who viewed *"Listed for the Connaught Rangers"* as a conventional recruiting scene, showing that, despite hardships, Ireland could still provide young men willing to take the Queen's shilling. In general, the picture was well received, although not with the same degree of enthusiasm as the larger and more dramatic *The remnants of an army*.

Exhib: R.A.1879 (20); Manchester Jubilee 1887 (16)

Refs: *The Art Journal* 1879, p 126; *The Athenaeum* 17 May 1879; H Blackburn *Academy Notes* Chatto and Windus, London 1879, p 8; *The Graphic* 17 May 1879; *The Illustrated London News* 3 May 1879; *The Times* 12 May 1879

1. Elizabeth Butler *From Sketch-Book and Diary* Adam and Charles Black, Burns and Oates, London, 1909, p 3

2. William Butler *Far Out: Rovings Retold* Wm Isbister, London, 1880

31. The remnants of an army: Jellalabad, January 13th, 1842

Oil on canvas 132 × 234 1879

Insc: *E(mon)T/18EB79*

Prov: Purchased by the Fine Art Society 1881. Presented to the Tate Gallery by Sir Henry Tate, 1897. (On loan to the Somerset Military Museum Trust)

The Trustees of the Tate Gallery, London

'. . .the man has come back to tell of a powerful army blotted out, of the shame and humiliation of a great people.'[1]

Elizabeth Butler's largest picture commemorates one of the worst disasters in British military history. In 1842, during the First Afghan War, the British Army in Kabul was forced to retreat sixty miles over snow-covered passes to the fort at Jellalabad, while being continually harried by the Afghans. When Dr William Brydon, an Assistant Surgeon in the Bengal Army, arrived alone at the gates of Jellalabad it was thought that he was the sole survivor of a force which had been some 16,000 strong. A few others eventually struggled through to the fort.

In 1878 the Disraeli Government launched a second British invasion of Afghanistan. Once again the purpose was to establish a 'secure' North-west frontier for British India against Russian hegemony. Elizabeth Butler noted in her diary, 'We are now at war with poor Shere Ali, and this new Afghan War revived for me the idea of the tragedy of '42, namely, Dr. Brydon reaching Jellalabad, weary and fainting, on his dying horse . . .'. In the same year William Butler wrote an essay entitled 'Afghanistan and the Afghans', which sarcastically condemned;

. . .the favourite theory of the "forward school" that the Afghans [have] only to be freely shot, plundered and otherwise knocked about to become our firm and fast allies and hate the Russians with something of the fervour of a music-hall audience.[2]

31

The essay ends significantly with a description of just that pathetic spectacle which *The remnants of an army* presents. Brydon's own account of his journey had been published for the first time in 1874 as an appendix to Sir George Lawrence's memoirs, *Reminiscences of Forty-Three Years in India* (John Murray, London).

If the choice of subject for *The remnants of an army* sprang from the Butlers' dismay at current British policy in Afghanistan, there is no indication that its message was apparent to the Royal Academy audience when it was displayed in May 1879. At this time the British public was satisfied with the progress of the Second Afghan War. An article published on 10 May 1879 in the *Illustrated London News*, just after the opening of the Royal Academy exhibition, recounted the story of the destruction of General Elphinstone's army in 1842 and took the attitude that at last those dreadful events were being avenged.[3] Had the painting been exhibited at the end of 1879 rather than in May its reception might well have been different, for in September the army in Afghanistan suffered a series of setbacks which resulted in a marked shift in public feeling towards the war.

'The picture of the year', declared *Punch*. 'Let us write Mrs Butler R.A. -i.e. "Really Admirable!".'[4] This was the year of the painter's almost successful bid to become a member of the Academy and the initials for the title 'Royal Academician' reflect support for her election. Other reviewers commended the telling use of details; the broken knees and bloodshot eyes of the pony and the way in which the wounded surgeon clings to the saddle to prevent himself from falling. The assured handling of the landscape was also admired, but above all, the reviewers responded to the picture's pathos. One Academician told the artist that ' . . . it is impossible to look at that man's face unmoved' and there were reports of men with tears in their eyes before the picture.

In both theme and treatment *The remnants of an army* is indebted to Jean Louis Ernest Meissonier's famous painting, *1814: Campagne de France* (fig 16; see Cat 133), depicting Napoleon riding at the head of his Army as they march in sullen retreat (see below, pp 163). In turn, Butler's striking image of the solitary survivor may itself have been the inspiration for a number of works, such as Frederick Goodall's *Gordon's last messenger* (R.A. 1885 No 432).

> Exhib: R.A.1879 (582); 'Silver Bugle', Durham Light Infantry Museum & Arts Centre, Durham 1982 (9)
>
> Refs: *The Architect* 13 May 1879; *The Art Journal* 1 May 1879; *The Athenaeum* 17

May 1879; *The Graphic* 17 May 1879; *The Illustrated London News* 3 & 10 May 1879; *Punch* 24 May 1879; *The Times* 12 May 1879

> Engr: Mixed method engraving by J J Chant, 43.7 × 76.2 published by the Fine Art Society (Ltd), 7 November 1882

1. The Archbishop of York in a speech reported by *The Architect*, 10 May 1879 \
2. William Butler: *Far Out: Rovings Retold* Wm Isbister, London, 1880, p xvii
3. This article is illustrated by the paper's 'special artist', William Simpson, who, in January 1879, painted a watercolour showing Brydon approaching the gates of Jellalabad on his pony (private collection).
4. *Punch* 24 May 1879

32. Sketchbook 1878

30 pages (inc. 5 loose), 17.8 × 25.4

Insc: *1878*

Mr Christopher Wilkinson-Latham

This sketchbook may have been in use on a number of occasions over several years. Studies for the overall design and some of the individual figures in *The defence of Rorke's Drift* (Cat 33) predominate, dating from the autumn of 1879 when the artist received the commission from Queen Victoria. There are also two sketches of lancers wearily plodding forward, suggestive of the group on the right of *Balaclava* (Cat 25), exhibited in 1876, and one small drawing of the drummer boy in "*Listed for the Connaught Rangers*" (Cat 30) R.A.1879. Another sketch of a Crimean foot-soldier standing by his wounded comrade is reminiscent of a group on the right of *The Return from Inkerman*, exhibited in 1877 (Cat 26).

There are another two drawings which may date from the early 1880s. One of a rider reining in his horse is almost certainly a study for the figure of General Wolseley in "*After the Battle*", (Cat 41) and another of a bugler on a camel may have been a figure for *A Desert Grave* (see Cat 44), now believed to have been destroyed.

32–1. Study for The defence of Rorke's Drift, kneeling figure

Pencil

Insc: *Jenkins*

When the 24th Regiment returned to England from Zululand, some of those who had fought at Rorke's Drift were sent to the artist's studio to model for her. She also went to Portsmouth where the regi-

32–1

ment was quartered to see a re-enactment of the action by the survivors in the same uniforms they had worn on the day.

Private M Jenkins of 1st Battalion, 24th Regiment, the only man present at the action with this surname, did not survive. The artist may have been told of his death when she wrote the name at the top of the sketch. While Jenkins was defending one of the doorways in the hospital with his bayonet, his ammunition exhausted, he was seized by his hands, dragged out and killed instantly by the Zulus. This is thought to be a portrait of either Robert or William Jones, both of whom won the Victoria Cross for their part in the action.[1] William Jones had been a witness to Jenkins's fate.

The figure and studies of hands holding a Martini-Henry rifle are preliminary sketches for the kneeling figure at the bottom left of the canvas. The pose was altered to a more hunched position to follow the downward angle of the rifle, set between the mealie-bags.

1. C Wilkinson-Latham 'The Defence of Rorke's Drift. A Painting in the Royal Collection' *Tradition* No 55, 1970, pp 6–8

32–2. Study for The defence of Rorke's Drift, left-hand standing figure

Pencil (photograph only)

Insc: *hard/against/to face so as to get full/ profile*

This figure appears on the extreme left hand edge of the painting. In the final composition the painter depicted the barricade round the outpost as being about waist-height and, following her notes, she altered the pose so that the soldier no longer looks down his gunsight but leans over to use his bayonet.

33. The defence of Rorke's Drift, January 22nd, 1879

Oil on canvas 119.3 × 213.3 1880

Insc: *18 EB 80*

Prov: Commissioned by Queen Victoria

By gracious permission of Her Majesty the Queen

Exhibited at the National Army Museum only

The defence of the mission station at Rorke's Drift was one of the few redeeming features of the Zulu War of 1879. On the afternoon of 22 January, the garrison of 84 men of the 2nd Battalion, 24th (2nd Warwickshire) Regiment (later the South Wales Borderers), 36 hospital cases and others, under the command of Lieutenant Chard R E, were attacked by as many as 4,000 of King Cetewayo's warriors.[1] Despite a succession of Zulu assaults upon the makeshift barricades, the attackers were kept at bay and after about 12 hours of fighting the enemy retired. For this action 11 Victoria Crosses were awarded, the highest number for a single engagement.

In the autumn of 1879, Elizabeth Butler had already begun work on *Scotland for Ever!* (Cat 36), when Sir Henry Ponsonby, the Keeper of the Queen's Privy Purse, called at her studio to convey the Queen's wish to have a picture painted of a war

32–2

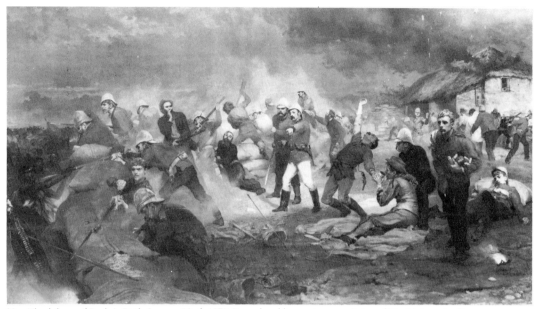

33. *The defence of Rorke's Drift, January 22nd, 1879.* Reproduced by gracious permission of Her Majesty the Queen

from her own reign. The artist's friends pressed her to undertake the subject of the defence of Rorke's Drift which was then still at the forefront of public attention. However, it was one of Butler's personal rules never to portray actual conflict and the subject demanded that the British troops be shown engaged with the enemy. She was probably also aware that her husband disapproved of the conduct of the Zulu War and that he thought that organisational inefficiency had led to its being needlessly prolonged. At this time William Butler was still in South Africa serving as Assistant-Adjutant and Quarter-Master-General at Durban, the operational base. His view was that ' . . . five sixths of our African wars have their beginnings in wrongs done in the first instance by white men upon natives.'[2] When the Zulus were eventually defeated, he visited Cetewayo in prison at Capetown and, in a characteristically humanitarian gesture, he took the Zulu king some bundles of green rushes in order that he might be able to sleep in comfort on a rush mat; an action which moved the prisoner to tears.

With such considerations in mind, the painter initially chose to depict the finding of the body of Louis Napoleon, the Prince Imperial and son of the former French Emperor, Napoleon III, who was killed while serving with the British Army in Zululand. It was a subject of which William Butler would have approved. He had organised the transport home of the prince's body from the Cape and concurred with many in holding the British staff responsible for the tragic death. At first the Queen agreed to the painter's proposal but, fearing that it

was not, after all, a tactful subject, she subsequently stated a firm preference for Rorke's Drift.

Elizabeth Butler had never before been faced with the task of including portraits of living people in her paintings. When the 24th Regiment returned to England, after a summons to Windsor Castle some of the 'principal heroes' were sent to her studio. She also made further trips to Portsmouth, where the regiment was quartered, to make studies as the men who fought in the action were made to re-enact it, dressed in the uniforms which they had worn on the day. The painter recalled that;

> Of course, the result was that I reproduced the event as nearly to the life as possible, but from the soldier's point of view – I may say the *private*'s point of view – not mine, as the principal witnesses were from the ranks.

She related that she managed to include portraits of all of the Victoria Cross winners including the two officers, Lieutenants John Chard and Gonville Bromhead in the centre of the scene. Other portraits have been identified as Private F Hitch VC, on the right, with a bandaged shoulder, carrying ammunition; Surgeon-Major Reynolds VC, Army Hospital Corps, in a white helmet, assisting a wounded man; Acting Commissariat Officer Dalton VC, Army Commissariat Department, with his arm flung upwards having just been shot; the Reverend C Smith, Army Chaplain's Department, to the right of the two lieutenants; Corporal Schiess VC, Natal Native Contingent, lying on the ground centre left and Privates Robert Jones VC

79

and William Jones VC on the extreme left.[3]

The greatest difficulty she encountered was in presenting a night-time scene illuminated only by the firelight from the burning hospital and the consequent effect of this upon the perception of colour. Notes in the sketchbook containing studies for the picture (Cat 32) show Butler wrestling with this problem, ' . . . sky reddes-yellowes and more blurred'. Furthermore, the picture needed to convey a sense of the enormous size of the Zulu army. The solution which the painter arrived at was to suggest this by ' . . . dark masses, rather swallowed up in the shade', but for the one visible figure grasping a soldier's rifle on the left of the picture, she found 'a sort of Zulu' for a model, in a London show.

At the 1881 Royal Academy exhibition *The defence of Rorke's Drift* was poorly hung in 'the Black Hole' of the Lecture Room, the only dark room, where *The 28th Regiment at Quatre Bras* had once been displayed. A smaller version of the subject by Alphonse de Neuville (fig 18), had been acclaimed in 1880 when it was shown at the Fine Art Society, but several reviews of Butler's painting were rather critical. It was accused of having a wooden, theatrical quality like that of the stilted heroics of the Victoria Cross series by Louis Desanges. The reviewers also found the orange-red lighting strange and the treatment of the Zulu perfunctory. Nevertheless, while the Academy's Hanging Committee and the press had their reservations, the public and the Queen were entirely satisfied. *The defence of Rorke's Drift* proved to be the last great popular success which Butler enjoyed at the Royal Academy.

Exhib: R.A.1881 (899); Guildhall 1892

Refs: *The Art Journal* 1881, 189; *The Graphic* 14 May 1881; *The Magazine of Art* 1881, 304; *The Spectator* 25 June, 1881

1. Colonel George Paton et al *Historical Records of the 24th Regiment, from its formation, in 1689* Simpkin, Marshall, Hamilton Kent & Co, London, 1892
2. William Butler *Far Out: Rovings Retold* Wm Isbister, London, 1881, p ix
3. C Wilkinson-Latham 'The Defence of Rorke's Drift' A Painting in the Royal Collection *Tradition* No 55, 1970, pp 6–8. See also the roll of honour, compiled from pay records by Major F Bourne in Jack Adams *The South Wales Borderers* Hamish Hamilton, London, 1968, p 103

33A. The defence of Rorke's Drift

Colour photographic print, published by the Royal Corps of Transport 1982 63.5 × 101

National Army Museum 8208-219

Exhibited at the Durham Light Infantry

Museum & Arts Centre and Leeds City Art Gallery only

34. A Vedette of the Scots Greys

Oil on canvas 60 × 50 1879

Insc: *18 EB 79/E(mon)T*

Baroness Elliot of Harwood, DBE

As with *Chasseur Vedette* (Cat 16), the artist has again used the theme of the trooper on picket duty in depicting a single figure, following the example of Meissonnier's *Vedette au Hussards*. This private of the 2nd Dragoons (Royal Scots Greys), sitting motionless on his horse on a wet road, was painted at the time Elizabeth Butler had begun work on *Scotland for Ever!* (Cat 36), her canvas commemorating the charge of the Scots Greys at the battle of Waterloo. Like the historical picture, this painting involves a difficult exercise in fore-shortening and adopts a low viewpoint, but its subject is contemporary. She wrote to a friend;

Happily for the effect of this attractive regiment, the Scots Greys have changed their uniform comparatively little since Waterloo. The bearskin caps are, if anything, taller than at that date; and at the back of this towering and imposing head-dress is still worn the

34

white horse of Hanover in silver. The peak of the Waterloo head-dress, however, has disappeared, much to the advantage of the general effect.[1]

1. Wilfrid Meynell 'The Life and Work of Lady Butler', *The Art Annual*, 1898, p 12

35. Sketchbook c 1880

31 pages (missing several cut out) 18.1 × 11.5

Lt-Col P R Butler. Presented to the National Army Museum in 1963

National Army Museum 6311-193-1

This small sketchbook contains two pen and ink studies for the figure of Wolseley reining in his horse in "*After the Battle*" (Cat 41), a pencil sketch of a furious battle scene from the Indian Mutiny and a number of sketches of individual bandsmen, sailors and staff officers. There is also a rough draft for the composition of *Scotland for Ever*! (Cat 36) in pen-and-ink, and a page at the end of the book, dated 1880, lists the various pigments used in painting it, including the brilliant white *blanco de plata* for the horses.

35–1. Study for the composition of Scotland for Ever!

Pen-and-ink

Although Butler relates in her autobiography that the impulse to paint *Scotland for Ever*! was the immediate result of her distaste at viewing an exhibition of the work of the 'Aesthetes', whose style was influenced by the French Impressionists, she must have been considering the project for some time. She had already watched the Scots Greys charging on two previous occasions at manoeuvres, standing in front to watch the effect, and this small, hastily-drawn sketch may have been the instant result of her observations.

36. Scotland for Ever!

Oil on canvas 101.5 × 193 1881

Insc: *EB/Plymouth 1881*

Prov: Purchased from the artist by Colonel T Walter Harding and presented by him to the City of Leeds in 1888

Leeds City Art Galleries

According to Wilfred Meynell, the artist's brother-in-law, the title of Elizabeth Butler's most sensational picture was taken from a manuscript account of the charge of the 2nd Royal North British Dragoons (Scots Greys) at Waterloo, by an eyewitness, 'Mr. James Armour, rough-rider to the Scots Greys'. At the start of the charge the Greys had to pass through the ranks of the Highland Brigade and Armour recalled 'The Highlanders were then ordered to wheel back; when they did so we rushed through them; at the same time they huzzaed us, calling: "Now, my boys, Scotland for ever!"'[1] In fact the 'Muster Role of the Waterloo Men' of the regiment, compiled at Rouen on 11 September 1815, lists the name of Alexander Armour, not James, and contemporary accounts of

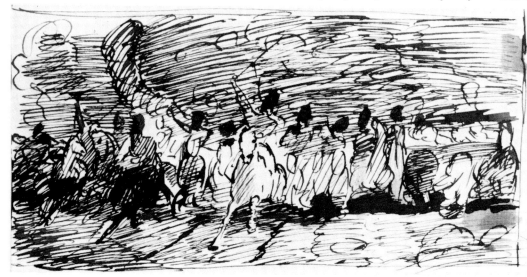

35–1

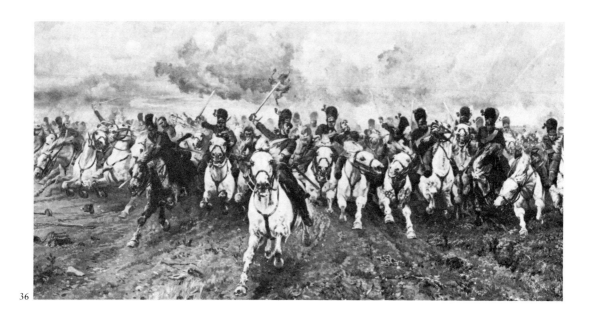

36

the charge of the Union Brigade differ as to whether the Greys began their gallop during or after passing through the regrouping ranks of Pack's Highland Brigade.[2] The result however is certain, as the French infantry could not withstand the charge and it was in the ensuing mêlée that Sergeant Ewart captured the eagle of the French 45th Regiment, the 'Invincibles'. So carried away were the officers and men by their success, that they continued galloping under a hail of fire towards the French guns. They were able to inflict considerable damage upon the enemy, but a counter-attack by French cavalry while they were returning from this mad-cap venture led to their being cut to pieces and reduced to little more than a squadron in number.[3]

The painter gives a vivid account of how she came to choose this subject in 1879;

> . . . I owe the subject to an impulse I received that season from the Private View at the Grosvenor Gallery, now extinct. The Grosvenor was the home of the 'Aesthetes' of the period, whose sometimes unwholesome productions preceded those of our modern 'Impressionists'. I felt myself getting more and more annoyed while perambulating those rooms, and to such a point of exasperation was I impelled that I fairly fled and, breathing the honest air of Bond Street, took a hansom to my studio. There I pinned a 7-foot sheet of brown paper on an old canvas and, with a piece of charcoal and a piece of white chalk, flung the charge of 'The Greys' upon it.

Butler does not relate which artists' works caused this reaction but the exhibition of the 'Aesthetes' that year included works by James McNeil Whistler, Lord Leighton and Albert Moore. As the antithesis of their 'unwholesome productions' she set out to paint an image of men as being sturdy and masculine, as well as embodying the virtues of discipline and courage. She must also have been aware of Ernest Crofts's painting *Wellington's march from Quatre Bras to Waterloo* (Cat 135), exhibited at the Royal Academy the previous year, which gives a prominent place to a troop of the Scots Greys.

Work on *Scotland for Ever!* was deferred for a year while the artist undertook the Royal commission, *The defence of Rorke's Drift*. She re-started it at Plymouth where her husband had been appointed Assistant Adjutant and Quarter-Master-General, Western Command, and where she had '. . . any amount of grey army horses as models'. In painting them Butler used the last of her supply of a particularly brilliant white pigment, *blanco de plata*, made by an old widow of Seville who kept secret the process of its manufacture. By the time she painted the picture the artist had twice watched a charge of the Scots Greys during manoeuvres, standing in front to see the effect. 'One cannot, of course, stop too long to see them close,' she commented.[4]

In 1881, to her disappointment, the painting was not exhibited at the Royal Academy where *The defence of Rorke's Drift* was on show, but because of a law suit, she was eventually obliged to accept its exhibition by the purchasers of the copyright,

Fig. 7. A German version of *Scotland for Ever!* Reproduced in Elizabeth Butler *An Autobiography*, p 332. National Army Museum

S Hildesheimer and Co, at the Egyptian Hall in Piccadilly. The Fine Art Society's MS Minute Book reveals that the dispute concerned an agreement Butler had made with the Society, giving them first refusal of any picture painted after *"Listed for the Connaught Rangers"* (R.A.1879, Cat 30), provided that the picture was not painted by Royal Command.[5] An injunction was sought against the painter in March 1881 and the Society settled out of court, receiving a cheque for £500 from Colonel Butler ' . . . as a compromise in this matter' (see above, p 00).

Disappointed as she was at not being able to show the picture at the Royal Academy and so create ' . . . a bright effect with all those grey and white hippogriffes bounding out of the Academy walls', nevertheless *Scotland for Ever!* was one of Butler's last popular successes and was widely reviewed. *The Athenaeum* took her to task for a lack of variety in the troopers' faces, always in the past one of her strong points, as well as what they considered to be the poor drawing of the horses' heads.[6] Other reviewers, however, responded readily enough to the dramatic onrush of horsemen and found nothing to object to in the extreme foreshortening of the horses. At the time and since, the picture has been read as a patriotic celebration, but this is probably simplistic in terms of the artist's own intentions. As she stated, she did not paint 'for the glory of war' and it is likely that she was again primarily concerned to show the soldiers' experience of battle, and their emotions, ranging from elation to terror, at the moment of the charge. However, the effect of this upon the spectator is naturally overwhelmed by the sensation of being placed in the path of oncoming cavalry.

The picture has always been much reproduced and a colour poster of it is currently in print.

Meynell recounted that Prince Louis Napoleon had come across an engraving of the picture in a shop window in Moscow which he purchased as a gift for Tsar Nicholas II, then Honorary Colonel of the Scots Greys, and that another print was given to the Kaiser by his cousin, Edward, Prince of Wales.[7] Later, during the Great War, both the British and Germans used the image for propaganda; the Germans produced a New Year card with the Scots Greys transformed into Prussian cavalry (fig 7). More recently, it has been used in advertising by a manufacturer of safety razors. It also had a great influence on the generation of painters who succeeded Lady Butler, men such as Richard Caton Woodville, Robert Hillingford, John Charlton, C E Stuart and Stanley Berkeley. All, at some time, made use of its simple but dramatic arrangement; a dynamic variant of *The Roll Call*'s stationary line of figures. Butler, herself, used the idea again in *The Camel Corps* (R.A.1893, see Cat 58).

Exhib: S Hildesheimer & Co, the Egyptian Hall, Piccadilly, 1881; 'City Art Gallery Inaugural Exhibition', Leeds 1888 (46); 'International Exhibition', Glasgow, 1901; 'Irish Exhibition', Dublin 1907; 'Canadian Exhibition', Toronto 1908; Guildhall 1894 (33); 'The Waterloo Centenary, 1815–1915', Leicester Galleries 1915 (7); 'British Empire Exhibition', Wembley 1924; 'Early Days', Leeds 1974 (20); Arts Council 'Great Victorian Pictures', Leeds, Leicester, Bristol & Royal Academy, 1978

Refs: *The Art Journal* 1881, pp 157–8; *The Athenaeum* 16 April 1881; *The Graphic* 11 June 1881; *The Illustrated London News* 16 April 1881; *The Magazine of Art*

1881, p 304; *Punch* 16 April 1881; *The Times* 13 April 1881

Engr: Photogravure, 72 × 115, published by S Hildesheimer & Co, 1 December 1882

1. Meynell, *op cit*, p 12
2. Edward Almack *The History of the Second Dragoons "Royal Scots Greys"* (privately printed), London, 1908 (between pp 64 & 65)
3. *Historical Record of the Royal Regiment of Scots Dragoons ... commonly called the Scots Greys* Longman, Orme and Co, William Clowes and Sons, London, 1840; Charles Grant *Royal Scots Greys* Osprey, London, 1972
4. Meynell, *op cit*, p 12
5. Fine Art Society MS Minute Book 12 March 1881
6. *The Athenaeum* 16 April 1881
7. Meynell, *op cit*, p 11

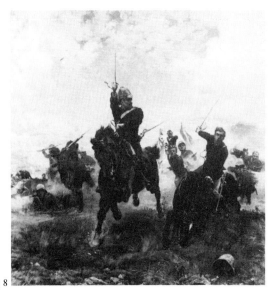

Fig 8

Fig 8. "Floreat Etona!"

Oil on canvas (photograph only)

Insc *18EB82/Plym.*

Prov: A E Perkins in 1898

Private collection

"*Floreat Etona!*" depicts an incident in the attack on Laing's Nek on 28 January 1881, during the Transvaal War, as it was described by an eye-witness. 'Poor Elwes fell among the 58th. He shouted to another Eton boy (adjutant of the 58th), whose horse had been shot; "Come along, Monck – *Floreat Etona!* – we must be in the first rank," and he was shot immediately.' Referring to the picture, Wilfred Meynell claimed that 'Sport and battle each have a share in the aspiration, gravity, and happiness of a worthy fight, as an Englishman understands it. If there is evident joy in the serious affair of war, is there not an extraordinary seri-

ousness in the trivial affairs of the cricket-ground and the hunting-field?'[1]

However, it was an odd subject to choose to portray. Following the Boer declaration of independence for the Transvaal in 1880, the British suffered a series of disastrous defeats in attempting to regain the territory. At Laing's Nek, the commander of the British forces, Sir George Pomeroy Colley, tried to force a way into the Transvaal through the pass in the Drakensberg Mountains but the Boers had already established defensive positions and had little difficulty in repulsing his inadequate force. Of a total of approximately 1,000 men, the British suffered casualties of 198 killed or wounded; the Boers admitted losses of 141 from a force of about 500. Colley himself was killed at the battle of Majuba on 27 February 1881 which ended the war and led to the recognition of the Transvaal as an independent state by the British. It is probable that the subject was chosen at the behest of the painter's husband. He believed that Colley, like himself one of the 'Wolseley Ring', was blamed unfairly for all the the British failures in the war; a view which he expounded in his biography of the general.[2]

The painting was regarded as one of Butler's least successful compositions. An upright picture of battle, with a large area of sky, it gives a truncated view of the whole action. As in *Scotland for Ever!* (Cat 36) there are extremely foreshortened galloping horses, but the beasts themselves are not so convincingly drawn. When it was shown at the Royal Academy in 1882 it received harsh treatment from some reviewers. The colour was described as ' ... rather crude and criant' and the title as 'affected'. *The Times* was particularly scornful;

> Looked at as representations of war, her compositions are simply futile; they are *coups de théâtre* from beginning to end; looked at as pictorial renderings of purely emotional feeling connected with war they have considerable truth. The vein of sentiment they disclose is thin but genuine; it is surface gold and needs little washing. Perhaps, on the whole, the moral and meaning of such paintings are more adapted to 'Miss Skimpton's Academy for Young Ladies' than it is for men. We cannot quite believe in these renderings of the most painful facts of civilisation.

The picture was condemned for its treatment of a débâcle in which, unlike the charge of the Light Brigade, there was precious little honour. Rather than discuss the picture itself, *The Illustrated London News* chose to pass judgement on the action at Laing's Nek. It quoted the comment of Marshal Bosquet, the French divisional comman-

der, on the charge of the Light Brigade, '*C'est magnifique, mais ce n'est pas la guerre.*'

Exhib: R.A.1882 (499)

Refs: *The Architect* 13 May 1882; *The Art Journal* 1882, p 211; *The Athenaeum* 27 May 1882; *The Illustrated London News* 6 May 1882; *The Times* 3 June 1882

1. Meynell, *op cit*, p 14
2. William Butler *The Life of Sir George Pomeroy-Colley* John Murray, London, 1899

37. Sketchbook 1885

10 pages 13.5 × 18

Insc on cover: *1885*

Prov: Lt-Col P R Butler. Presented to the National Army Museum in 1963

National Army Museum 6311-193-6

In addition to several pen-and-ink studies for the figure of Sir Garnet Wolseley and men of the Gordon and Cameron Highlanders for "*After the Battle*" (Cat 41), this sketchbook also contains a number of studies of various mounted troops and horses.

37–1. Study for the Figure of Sir Garnet Wolseley in "After the Battle"

Pencil

Insc: *Can't accentuate/all anat. too much/all muscles/most sharp/N.B./ So(?)down as to/ crease fetlock*

As it would have been impossible to make studies from a stationary model for the attitude of Wolseley's mount as it appears in the picture, stopping sharply with straight forelegs pushed into the sand and rear legs splayed apart, the artist was obliged to make notes of her observations of a horse's anatomy against her sketch. When the painting was exhibited in 1885 it was, however, criticised for depicting the horse on too small a scale.

38. Studies of the Cameron Highlanders

Watercolour and pencil 31.5 × 23

Mrs Marie Kingscote Scott

Although this page of studies of Cameron Highlanders is not dated, it appears to be part of the extensive preparations which the artist made before starting work on "*After the Battle*" (Cat 41). Since the painting's destruction in the early part of this

37–1

38

century only the central section of Wolseley and some of the Staff officers remains, but a comparison with the engraving of the whole work (Cat 124) reveals similarities between some of the cheering Highlanders and the heads in this sketch. For example, the seated figure seen peering over the left-hand parapet in the picture is reminiscent of the anxious-looking young man, bottom left of the page; standing just to the right of him, a bearded Highlander touches his helmet to the general and may derive from the stern-faced man, with his sun helmet pushed back on his head, lower left centre of the sketch. The half-length figure in the watercolour drawing also has the same attitude as two of the soldiers marching towards the bridge to the right of Wolseley; that is seen front on, he looks over their right shoulder with his body turned slightly away.

39. Piper, Cameron Highlanders

Watercolour 48 × 33.5

Insc: *Piper, Cameron Highlanders*

Prov: Presented to the Officers' Mess, 1st Bn the Queen's Own Cameron Highlanders by Lt-Col J D MacLachan in 1913

Regimental Trustees, Queen's Own Highlanders

Exhibited at the National Army Museum only

39

40. Private, Cameron Highlanders

Watercolour 48 × 33.5

Insc: *Cameron Highlander/Tel-el-Kebir kit*

Prov: Presented to the Officers' Mess, 1st Bn the Queen's Own Cameron Highlanders by Lt-Col J D MacLachan in 1913

Regimental Trustees, Queen's Own Highlanders

Exhibited at the National Army Museum only

These two watercolours are detailed studies of two men of the 1st Battalion Queen's Own Cameron Highlanders who were depicted standing on the right of the painting, "*After the Battle*" (Cat 41), welcoming the arrival of their commander-in-chief and his staff. Unfortunately, the section of the original canvas which included these figures was destroyed, but it is possible to compare them with the engraving of the whole work (Cat 124).

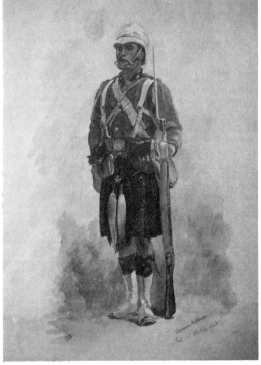

40

The piper and private are shown wearing full marching order, with kilts of regimental tartan and full dress sporrans. Although the painting commemorates Sir Garnet Wolseley's victory at Tel-el-Kebir on 13 September 1882, the watercolours may not have been executed until about 1884, as the oil was not submitted to the Royal Academy until the spring of 1885. Later that year, Elizabeth Butler journeyed to Egypt, joining her husband at the garrison in Wadi Halfa shortly after the battle of Ginniss on 30 December, at which this battalion also fought. Colonel William Butler is said to have remarked about this action, 'Well there has been nothing very stout about this battle except its name.'[1]

1. Lt-Col A A Fairrie 'Regimental Prints. "After Tel-el-Kebir" by Lady Butler' *The Queen's Own Highlander* 1982, pp 136–7

41. "After the Battle": arrival of Lord Wolseley and staff at the Bridge of Tel-El-Kebir at the close of the action

Oil on canvas 61 × 30.5, (remaining portion of the original canvas) 1885

Prov: Lt-Col P R Butler; 1954 to Prof J Lehmann; 1986 to present owners

Mr & Mrs Geoffrey W Fielding, Baltimore, USA

"After the Battle" commemorates Sir Garnet Wolseley's victory at Tel-el-Kebir on 13 September 1882 over the Egyptian nationalist forces led by Arabi Pasha. This triumph was immensely popular with the British public, as it provided a cause for celebration after a series of military disasters in Afghanistan and southern Africa. In the words of William Butler, it '. . . gave the god Jingo a new start'. In November 1882 hundreds of thousands of people came to watch the review of the returned British forces in St James's Park, London.

Yet the scene is not of the battle itself, nor of the daring night march by troops in battle formation that had made the victory so sudden and so complete. Instead, it portrays a moment during the British pursuit of the retreating Egyptian forces. As described by Wilfrid Meynell;

The Commander-in-Chief (Wolseley) reached the bridge almost as the forefront files of the Gordon and Cameron Highlanders gained that point; and, dismounting on the short causeway leading to the drawbridge, he there dictated the order for pursuit of the cavalry and Indian Division, and the despatch home

that was to announce a victory for England. Lady Butler chooses for her moment in the picture that just before the General has dismounted. It is the moment of the decision of the victory, and the slight frame of the General has not relaxed from the long strain of watchfulness and command.[1]

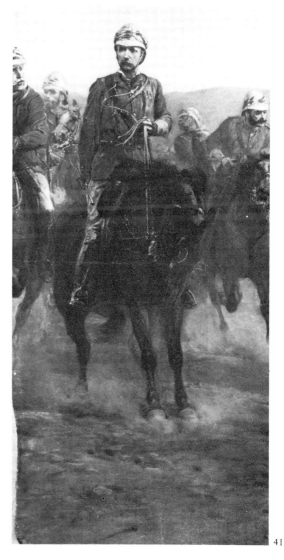

41

The other staff officers in the painting who are still to be seen in the remaining portion of canvas, are Lieutenant-General Sir John Adye, on the left, leaning forwards to speak to Wolseley; Major-General the Duke of Connaught in the background between them and Lieutenant-Colonel William Butler, bending forwards in his saddle on the right.

"*After the Battle*" was Elizabeth Butler's major work of the 1880s. In her autobiography, the painter stated that she gave a '. . . long period of my precious time to making preparations . . . I had crowds of Highlanders to represent, and went in for the minutest rendering of the equipment then in use.' This statement seems to be borne out by the number of preparatory drawings for the picture to be found in her 1880 sketchbook (Cat 35) and the watercolour studies (Cats 38, 39 and 40).

The figure of Wolseley in the centre of the picture, seen head-on standing up in his stirrups as he reins in his pony, presented another problem in foreshortening for the artist. A *Punch* cartoon of the time lampooned the figure as being top-heavy in comparison to its mount (Cat 42). Butler briefly mentioned the general modelling for her; 'Lord Wolseley gave me a fidgety sitting at their house in London, his wife trying to keep him quiet on her knee like a good boy.' However, the sketches for his figure which appear in the artist's sketchbooks of 1878, 1880 and 1885 (Cat 32, 35 & 37) show the pose, rather than being recognisable portraits of the man, and so may have been drawn from another model.

Once again, the painter had her husband's views of the subject to consider. She herself referred to William Butler going out to Egypt in August 1882 with Wolseley's staff to '. . . suppress poor old Arabi and his "rebels"' and she may have shared his view that the battle of Tel-el-Kebir was neither glorious nor necessary. 'To beat those poor *fellaheen* soldiers was not a matter of exultation', he told her and related that '. . . the capture of Arabi's earthworks had been like "going through brown paper".' Like his friend the Arabist, Wilfred Scawen Blunt, he considered the British Government's decision to give its support to the weak and corrupt Khedivate, rather than to Colonel Ahmed Arabi, a matter of grave folly which was due to the sinister machinations of the Egyptian bondholders in the City of London. So disgusted was he with Britain's policy towards the nationalist leader, that when the war was over, he made it his business to contact those in authority in London to try to forestall moves in Cairo for the man's execution.[2] This act of considerable courage and some foolhardiness must have put his career at risk. Arabi Pasha's sentence of death was commuted to exile in Ceylon after British intervention, although this was unlikely to have been as a result of Butler's unsolicited appeal.[3]

Certainly, William Butler did not approve of this picture and the artist admitted that 'He thought the theme unworthy and hoped I would drop the idea'. Nevertheless, because his wife was determined to persevere, he did all he could to assist her. She submitted the painting to the Royal Academy in 1885, but it was only '. . . a moderate success'. As Butler herself implied in her autobiography, the composition remained strangely unresolved – almost a combination of the onrushing cavalry of *Scotland for Ever!* and the stationary row of foot-soldiers of *The Roll Call*. 'Depend upon it, if you do not "see" the thing vividly before you begin, but have to build it up as you go along, the picture will not be one of your best. Nor was this one!' Furthermore, by the time "*After the Battle*" appeared, three years after the event, it was no longer topical. Richard Caton Woodville and Frederick Villiers had not only drawn illustrations of Tel-el-Kebir for *The Illustrated London News* and *The Graphic*, but had also exhibited pictures of the battle at the Royal Academy before her. Butler's painting was compared unfavourably by reviewers with Godfrey Douglas Giles's first picture of Tamai (National Army Museum 6311–5), also in the Academy exhibition of 1885. *The Athenaeum* alone was enthusiastic, noting that while the 'touch' lacked the crispness of her former works, the colour was clearer and the draughtsmanship as firm as ever.

It has been estimated by the present owner, on the basis of comparison with the engraving of the complete picture (Cat 124), that the whole canvas measured over 200 cms across. The exact date of its destruction is not established, although it is known that the picture was still in existence in 1896. It seems likely that the picture was cut up at William Butler's death.[4]

Exhib: R.A.1885 (1081); Victoria Cross Gallery, Crystal Palace, London 1896 (45)

Refs: *The Art Journal* 1885, p 258; *The Athenaeum* 20 June 1885; *Punch* 9 May 1885; *The Spectator* 27 June 1885

1. Meynell, *op cit*, pp 14–15
2. William Butler *An Autobiography*, pp 241–5
3. McCourt, *op cit*, p 156
4. *Ibid*, p 158. In the opinion of Mr Antony Preston, a descendant of the artist, the painting was cut up even before Sir William Butler's death.

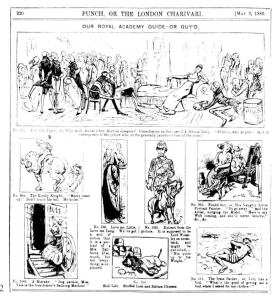

43–1

42. Our Royal Academy Guide – or Guy'd

Engraving, published in *Punch* 9 May 1885

Criticisms of the paintings shown at the Royal Academy in 1885 included a caricature of the central figure of Wolseley in Butler's "*After the Battle*". The size of his horse, seen with its hind legs bent as it is pulled up short, led to the suggestion that the painting be retitled 'Not quite up to his Weight'.

43–1. Study of a British soldier and two camels

Oil on panel 20.9 × 12 1886

Prov: Lt-Col P R Butler. Presented to the National Army Museum in 1963

National Army Museum 6311-194-2

It is most probable that Elizabeth Butler made this sketch when she travelled to Wadi Halfa, following the rout of the Dervish forces at the battle of Ginniss on 30 December 1885. It depicts a soldier and two camels of one of the four regiments of the British Army's Camel Corps in Egypt and is thought to be a study for her 1887 Royal Academy painting, *A Desert Grave: Nile Expedition, 1885* (see Cat 44), since completely destroyed. It is comparable with two studies from life for this picture, reproduced in Wilfrid Meynell's monograph, 'The Life and Work of Lady Butler'.[1]

The artist took particular trouble to make an accurate study of the furniture and equipment carried by the camels.

On the reverse of this panel is an oil sketch of a Breton peasant boy, c1887, who appears in the crowd of *To the front* (R.A.1889, Cat 45).

1. Meynell, *op cit*, p 4

43–2. Breton boy leaning on a stick

Oil on panel 20.9 × 12 c1887

Prov: Lt-Col P R Butler. Presented to the National Army Museum in 1963

National Army Museum 6311-194-2

This fluently painted figure is a study for a Breton peasant boy in the crowd of *To the front* (Cat 45), where he appears as almost an exactly reversed image to that in this sketch. In the final painting he

43–2

<div style="column 1">

leans to the left, holding the stick in his left hand with his right hand in his pocket. The study is likely to have been executed from life, in the period of late 1886 to the spring of 1888, while the painter was living near Dinan.

44 . A "Lament" in the Desert

Oil on canvas 76 × 62.5 1925

Insc: *19 EB 25*

Prov: By direct descent

The Hon Robert Preston

After a brief period of leave from Egypt in the aftermath of the ill-fated Gordon Relief Expedition, in the summer of 1885 William Butler returned to a command on the new frontier at Wadi Halfa. Elizabeth, who had intended to join him there with their two eldest children, had to remain at Cairo because fighting still continued along the frontier

</div>

railway line. Eventually, the Arabs were routed at the battle of Ginniss on 30 December by a force under the command of General Sir Frederick Stevenson, using William Butler's suggested plan of action, and the artist travelled up the Nile to join her husband at Aswan. Together, they continued to Wadi Halfa by houseboat, where they remained until March, when the increasing heat forced Elizabeth to return with her children to England.

In her second book of travel reminiscences, *From Sketch-Book and Diary*, the artist recalled how, one evening during their trip up the Nile, her husband described a memorable night just before the battle of Ginniss;

> They were out in the desert, the moon was full; the Dervishes were 'sniping' at long range, when afar off was heard a Highland 'lament'. The 'sniping' ceased all along the enemy's line and dead silence fell upon the night but for the wail of the bagpipes. The Dervishes seemed to be listening. The 'lament' increased in sound, and presently the Cameron Highlanders approached, bearing, under the Union Jack, the body of an officer who had died that day of fever, to add yet another grave to the number that lay at intervals along the shores of the great river. You should hear the pipes in the desert, as well as on the mountain side, to understand them.[1]

The illustration which accompanies the text at this point is reproduced from a watercolour, of which this late oil painting is an almost exact copy. The artist was obliged to abandon her practice of making sketches in oil early on in the journey to Wadi Halfa, finding that the sand blew into the paint rendering it unusable. She turned, therefore, to the fast-drying medium of watercolour. It is not known for what reason she painted this copy in 1925, but the original watercolour has not been traced; the oil may perhaps have been a replacement for the missing work.

Elizabeth Butler later related her own experiences of watching a Highland funeral party, the incident which the painting aptly illustrates;

> It was at Wady Halfa, on the second Cataract, late in the afternoon, and a burial party thus clad (i.e. in khaki) were carrying a dead comrade covered with the Union Jack towards the little cemetery in the desert; and as they moved over the plain obliquely away from me, with their backs to the low sun, nothing could be seen of them but the black shadow of each soldier as it was projected upon the back of his front- rank man. One thus saw literally a little troop of shadows

44

moving towards the grave, with the stiff
automatic motion peculiar to the military
funeral step; and in the midst of these phan-
toms shone out, in vivid colours, the flag that
shrouded their burden. The faint sound of
the Dead March in Saul, so frequently heard

on the Nile shores of late years, came
towards me on the desert wind . . .[2]

During her sojourn at Wadi Halfa, the artist also
made a number of sketches for her next Royal
Academy exhibit, *A Desert Grave: Nile Expedi-*

91

tion, 1885. A note by the artist's eldest son, Lt-Col P R Butler, written in 1954 and attached to the back of the remaining fragment of *"After the Battle"*, records that this picture was also destroyed by the artist.[3] Unfortunately, no reproduction of it remains, but it is known that, like *A "Lament" in the Desert*, it dealt with the subject of a funeral following an action during the Sudan campaign. According to Wilfrid Meynell, it represented ' . . . a typical burial in the arid wilderness, with that hungry hole in it' and included some of the Camel Corps among the mourners.[4] A small study in oil on panel of a dismounted soldier and two camels (Cat 43–1) is probably a preliminary sketch for this canvas. Elizabeth Butler, in writing of this work, recalled that;

> The Upper Nile had these graves of British officers and men all along its banks during that terrible toll taken in the course of the Gordon Expedition and after, some in single loneliness, far apart, and some in twos and threes. These graves had to be made exactly in the same way as those of the enemy, lest a cross or some other Christian mark should invite desecration.

Among the illustrations which she provided for her husband's book, *The Campaign of the Cataracts*, Elizabeth Butler included one entitled *The Burial of General Earle and Colonels Eyre and Coveney at Kirkeban* (p 342, Cat 127).[5] This drawing, although showing three open graves and lacking any troops on camels, is possibly similar to the original composition of *A Desert Grave*. Butler was dissatisfied with the oil painting and wished that it was ' . . . more poetical than it turned out to be'. Like her husband, she revered General Gordon and saw Wolseley's attempt to rescue him as the one morally justifiable campaign of the age. At the Royal Academy exhibition in 1887 the picture was well placed, but it was almost entirely ignored by the press; the only review appeared in *The Art Journal*. It should be noted, however, that in the years after the fall of Khartoum, although Gordon's death obsessed the nation, it was rarely commemorated in Academy pictures; George William Joy's well-known *The death of General Gordon, Khartoum, 26th January 1885* (R.A.1894, No 934) was one of the few which did address the subject.

1. Elizabeth Butler *From Sketch-Book and Diary* Adam and Charles Black, Burns and Oates, London, 1909, pp 73–4
2. *The Daily Graphic* 4 Jan 1890
3. Information courtesy of Mr G W Fielding
4. Meynell, *op cit*, p 15
5. William Butler *The Campaign of the Cataracts* Sampson Low, London, 1887, p 342

45. To the front: French cavalry leaving a Breton city on the declaration of war

Oil on canvas 112 × 164.8 1888–89

Insc: *EB/DINAN.DELGANY/1888–9*

Prov: By direct descent. On loan to Mr and Mrs P Mostyn

The Hon Robert Preston

To the front was the main product of the painter's sojourn in Brittany. When William Butler was invalided home from his post at Wadi Halfa in July 1886, the Butler family went to live in an old farmhouse near Dinan, where they stayed until the spring of 1888. Elizabeth Butler related that 'Thither we went for a rest, and to give the children the habit of talking French'. However, it appears likely that the move was made in order to avoid the publicity of a notorious high society divorce, Campbell versus Campbell, in which the painter's husband was cited as one of 40 co-respondents. The case was followed avidly by the press and *The Times* gave verbatim reports each day throughout November and December 1886. Events took a new turn when William Butler, recently honoured with a KCB and promoted to Brigadier-General, refused to testify. Public opinion was outraged and it was suggested in court that this action proved the general's guilt; it was assumed that he was refusing to add the sin of perjury to those he had already committed.[1]

To the front depicts the departure of the French *24ième Régiment de Dragons* from the old Porte St Malo, Dinan, during the Franco–Prussian War. The painting is uncharacteristic of Butler's post-*Roll Call* work, both in its French subject-matter and the inclusion of women and children, although in her next picture, *Evicted*, shown the following year, a woman is the principal figure. The composition is a variant of the arrangement in *"After the Battle"*, with horsemen advancing towards the viewer through a crowd of bystanders on either side.

Butler's son, Patrick, remembered 'huge dragoons' in their boots and cuirasses clanking up the stairs to the attic of the Butlers' home to serve as models for the soldiers. Family legend reports that members of the Butler family and their household sat for the figures in the crowd. It is understood that the woman in the foreground on the left, waving a handkerchief, is a self-portrait. Some of the children in the crowd are portraits of the painter's three eldest; the younger Elizabeth, in a tam o'shanter bonnet, standing next to her mother, and the two small boys further along the front row of the crowd are believed to be her sons, Patrick and Richard.

45

The similarity between the figure of the taller boy and the pencil sketch entitled *Patrick, aet. 5 years* (Cat 48) supports this idea. The painter's younger daughter reported that the Butlers' French cook posed for the figure behind the stone cross on the right. 'When at long last the cook was told that she might rest she gave in her notice. It was, understandably, *'un peu fort ça'*- and not even one's face showing itself!'[2] A small sketch of the Breton peasant boy, leaning on a stick (Cat 43–2), shows a preliminary working of the figure in oil. The picture was completed at the Butlers' home in Delgany, Ireland, '. . . under the Wicklow Mountains'.

Following her husband's knighthood in 1886, *To the front* was the artist's first picture as Lady Butler, but it made no impact at the Royal Academy in 1889. The Franco–Prussian War had ended 18 years previously and was extensively illustrated in painting at that time; it no longer had any importance for the British art-viewing public. The theme of civilians gathered at the gate to bid farewell to their menfolk may also have become somewhat hackneyed, reminiscent, for instance of John Everett Millais's *The Huguenot* of 1852, Hubert von Herkomer's *To the Front* in 1882 and Samuel Edmund Waller's *Sweethearts and Wives*. By 1889, people had become accustomed to the

Fig. 9 detail of *To the front*

93

depiction of stirring spectacle of contemporary battles by artists such as Godfrey Douglas Giles who had the advantage of having been present at the events which they portrayed.

Exhib: R.A.1889 (578)

Refs: *The Art Journal* 1889, p 219; *The Illustrated London News* 18 May 1889; *The Spectator* 25 May 1889; *The Times* 1 June 1889

1. McCourt, *op cit*, pp 186–99
2. Eileen Gormanston *A Little Kept* London and New York, Sheed and Ward, 1953, p 55

46. Evicted

Oil on canvas 236 × 177.8 1890

Insc: *EB/90*

Prov: Lady Gormanston, the artist's younger daughter; bought by the Irish Folklore Commission for 30gns

Department of Irish Folklore, University College Dublin
Lent by the kind permission of the President of the College

Lady Butler's second Irish picture, following *"Listed for the Connaught Rangers"* of 1879, is exceptional among her major works in treating a non-military topic. Nevertheless, in keeping with many of her pictures, it does deal with the effects of violence. The subject is an eviction in the 'black eighties', a period when many tenant farmers were driven off the land in Ireland. It was a bold theme to present in an Academy picture and, but for the artist's still considerable reputation, might not have been exhibited at all. By the late 1880s such evictions were less common than they had been in previous years, but they had become a central issue of British politics. The protection of tenant farmers, unable to pay their rent, was an especial concern of the burgeoning Irish Home Rule movement.[1]

Evicted was exhibited at a particularly tense moment in Irish affairs. In May 1890 the fate of the great Nationalist leader, Charles Stewart Parnell, was about to be decided and, with him, the future of the Home Rule movement. Parnell had been cited as a co-respondent in a divorce case and was to appear in court in November. Reviewers were wary, therefore, of discussing the painting's contentious subject matter and confined themselves to discussing such aspects of it as the 'melodramatic' attitude of the young woman who stands before the burnt ruins of her home. The critic of *The Art*

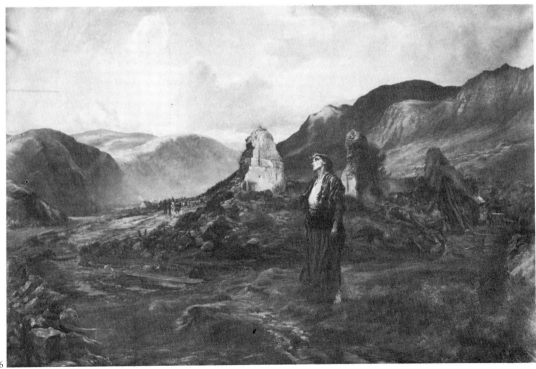

46

Journal, for example, compared *Evicted* with another 'modern genre' painting, Stanhope Forbes's *By Order of the Court* (Walker Art Gallery, Liverpool), a sombre Social Realist work depicting a forced auction in a humble English dwelling. He preferred Forbes's less controversial picture, praising it for the 'discreetly individualised' facial expressions.

However, while any consternation caused by the picture was carefully avoided by the press, by chance the main speaker at the Academy Banquet that year was Lord Salisbury, the Prime Minister and a leading advocate of the policy of coercion as a response to Irish agitation. He discerned in Butler's painting a direct attack on his administration's handling of Irish affairs and, unlike the reviewers, was impelled to comment on it, albeit in an indirect and facetious manner;

> I will only say with respect to it that there is such an air of breezy cheerfulness and beauty about the landscape which is painted, that it makes me long to take part in an eviction myself whether in an active or a passive sense.[2]

The painter recounted the incident in her autobiography and added the comment, 'How like a Cecil!'

In *Evicted* the artist reiterated in paint the views her husband committed to paper. He was a confirmed opponent of Salisbury's policy of 'strong government' in Ireland and a fervent admirer of Parnell. At the time that Lady Butler embarked upon the canvas, Sir William spent a weekend grouse-shooting with the Irish nationalist leader at his mountain retreat at Aughavanagh and later wrote, 'I looked upon Parnell as one of the most remarkable men then living in the Empire.'[3]

The subject had intense personal significance for Lady Butler too, as the picture was based on an incident that she witnessed. While the Butlers were at Glendalough, Co.Wicklow, for the shooting season, she heard a report that some evictions were to take place nine miles away. She seized the opportunity immediately;

> . . . I got an outside car and drove off to the scene, armed with my paints. I met the police returning from their distasteful "job", armed to the teeth and very flushed. On getting there I found the ruins of the cabin smouldering, the ground quite hot under my feet, and I set up my easel there. The evicted woman came to search amongst the ashes of her home to try and find some of her belongings intact. She was very philosophical, and did not rise to the level of my indignation as an ardent English sympathiser.

To capture the effect of the mountain scenery in all its varied, luminous colour, she returned to the spot on further occasions, and strove to paint in the open air, despite certain setbacks;

> What storms of wind and rain, and what dazzling sunbursts I struggled in, one day the paints being blown out of my box and nearly whirled into the lake far below my mountain perch! My canvas, acting like a sail, once nearly sent me down there too.

Despite the practical difficulties she encountered and aware of the controversy that the picture would cause in London, Lady Butler persisted. She was satisfied with her production on this occasion, recounting in her autobiography, 'I seldom can say that I am pleased with my work when done, but I *am* complacent about this picture. It has the true Irish atmosphere. . .'. A photograph taken in 1898 at Dover Castle, the Butlers' home at the time, shows *Evicted*, which remained unsold, hanging in a place of honour above the fireplace in the dining-room.

The design of *Evicted* has since been used for the dust-cover of Cecil Woodham-Smith's classic, *The Great Famine: Ireland 1845–9* (Hamish Hamilton, London, 1962).

Exhib: R.A.1890 (993)

Refs: *The Art Journal* 1890, p169; *The Spectator* 17 May 1890; *The Times* 20 June 1890

1. F S Lyons *Ireland Since the Famine* Fontana, London, 1978, pp 188–90
2. *The Times* 5 May 1890
3. William Butler *An Autobiography*, p 351

47. Plymouth Sound

Watercolour 25.5 × 35.5 c1881

Insc: *Plymouth Sound*

Prov: By direct descent

Mrs Marie Kingscote Scott

In 1880 Lt-Col William Butler was offered the post of Assistant-Adjutant and Quarter-Master-General, Western District, at Devonport and the Butlers set up home in Plymouth, near the Hoe. Here Elizabeth Butler completed *Scotland for Ever!*, after she had put it aside to paint the Royal commission, *The defence of Rorke's Drift*. The artist wrote of those days;

> Life at 'pleasant Plymouth' was very interesting in its way, and the charm of the West Country found me in the heartiest appreci-

47

Fig. 10. Photograph of Colonel William Butler, CB, in the uniform of ADC to the Queen, c1883. Mr Rupert Butler

ation. But the climate is relaxing, and conducive to lotus eating. One seems to live in a mental Devonshire cream of pleasant days spent in excursions on land and water, trips up the many lovely rivers, or across the beautiful Sound to various picnic rendezvous on the coast.

48. Patrick Butler, aged 5

Pencil 29.2 × 22.9 1885

Insc: *Patrick/aet 5 years*

Prov: By direct descent

Mrs Marie Kingscote Scott

Patrick Butler, the painter's eldest son was born at Plymouth in 1880. When this pencil sketch was executed in 1885 the Butlers were still living there. The portrait bears a great similarity to the taller of the two little boys to be seen in the left-hand crowd in *To the front* (Cat 45) begun in Brittany in the later part of 1886.

In his teens Patrick also posed for the figure of one of the drummer boys of the 57th (West Middlesex) Regiment, who restrains a smaller boy, (his

48

49

youngest brother, Martin) in *"Steady the drums and fifes!"* (R.A. 1897, Cat 61). In 1902 he joined the Royal Irish Regiment, and saw service in the Great War (see Cat 98).

49. Eileen and Elizabeth Butler, the artist's daughters

Pencil 29.2 × 22.8 c1885

Insc: Eileen/Coos

Prov: By direct descent

Mrs Marie Kingscote Scott

These two portraits of the Butlers' daughters, Eileen and 'Coos', the family name for the younger Elizabeth, were probably executed in Plymouth in 1885, at the same time as the drawing of the eldest boy, Patrick (Cat 48).

Elizabeth, the eldest surviving child, was born in 1879, the year that *The remnants of an army* and *"Listed for the Connaught Rangers"* were shown at the Royal Academy and she provided a consolation for her parents after the loss of their firstborn, Mary Patricia, who died in infancy. Eileen, later Viscountess Gormanston, with whom her mother spent the last 11 years of her widowhood, was born in 1883.

50. On the Terrace at Shepheard's Hotel, Cairo

Pen-and-ink with blue crayon 17.1 × 26
1885

Insc: *EB/On the Terrace at Shepheard's*

Prov: By direct descent

Mrs Marie Kingscote Scott

Although this pen and ink drawing appeared as an illustration in Elizabeth Butler's full page contribution to the first issue of *The Daily Graphic*, published on 4 January 1890 (Cat 118), it was a product of her first visit to Egypt in 1885. As she waited for her husband's message to tell her that it was safe to travel on to Wadi Halfa, she passed much of the time on the wide terrace at Shepheard's Hotel, the centre of fashionable life in Cairo. In the article she recalled;

Shepheard's Hotel! – Shepheard's Hotel! Those afternoons on its shady terrace, where one can sit at ease, and watch the life of Cairo rolling to and fro in the tree-lined street before one, while chatting with one's English friends; those very bright table d'hote dinners where the ladies toilettes are so pretty; and the evenings, out on the terrace again, in that wonderful moonlight, or in the drawing-room, with the deep divans round

the walls, which has the Western newspapers on the table, affording us a touch of dear old Europe – how nice this all is.[1]

Two months after the article appeared in *The Daily Graphic*, the artist returned to Egypt and found to her disappointment, that;

> When next we visited Cairo the creepers were being torn down, and the terrace demolished. Then a huge hotel was run up in avaricious haste to reap the next season's harvest from the thronging visitors, and now stands flush with the street to echo the trams.

1. *The Daily Graphic* 4 Jan 1890, p 9

51. The "Fostât" Becalmed

Watercolour 10½ × 17½ in, 27 × 44.3 cms
1902

Insc: *19EB02*

Prov: By direct descent

Private collection

This view of the becalmed *dahabieh*, an Egyptian sailing boat, is the original watercolour for one of the illustrations in Chapter II of Lady Butler's travels in Egypt in *From Sketch-Book and Diary*. The chapter recounts the artist's journey up the Nile, early in 1886, where she was reunited with her husband at Aswan (see also Cat 43–1 and 44). On the way, as she recounted in the book;

> I remember one memorable grey day which we spent in turning the loveliest river reach of the whole series below Assouan, the wind having completely dropped – a day which dwells in my memory as a precious passage of silvery colour amidst all the gold. The palm-tree stems towards sundown were illuminated with rosy light against the pallid background of sand-hills facing the West, and of the delicate pearl-grey sky. The greens were cool and vivid, the water like a liquid opal.[1]

Exhib: Leicester Galleries 1919 (6), *On the Nile: a Dahabieh becalmed*

1. Elizabeth Butler *From Sketch-Book and Diary*, pp 62–3, illus. Pl 12

52. At Philae

Watercolour 28.7 × 21 c1886

Insc: *EB*

Prov: By family descent

Executry of Maj M D D Crichton-Stuart,
Palace of Falkland, Fifeshire

During Elizabeth Butler's journey up the Nile by
dahabieh, early in 1886, the party halted for some
time at Philae, '... the culminating point of the
Nile's beauties and marvels'. There, as she related
in the book *From Sketch-Book and Diary*, she was '
... particularly anxious to get a souvenir of the
doorway in the court of the temple on Philae Island,
where Napoleon's soldiers engraved their high-
sounding *"Une page d'histoire ne doit pas"*, etc.'[1]

She made the original sketch in oil under great
difficulties. A high wind blew sand into her eyes, as
well as into the wet paint, and eventually it carried
the panel from her easel, depositing it on the
ground with the painted surface downwards. In
illustrating the book, she substituted this wat-
ercolour copy of the study, ' ... *minus* the
smudges'.

> Exhib: Leicester Galleries 1912 (39), *At
> Philae. Before the submersion of the
> Temple*

1. Elizabeth Butler *From Sketch-book and Diary*, pp 69–70,
 illus. Pl 13

52

53. Threshing Corn in Brittany

Watercolour 21 × 45 1887

Insc: *EB/Dinan/1887*

Prov: By direct descent

Mr Antony Preston

This watercolour was painted during the end of
summer harvest in 1887, while the Butlers were
staying at a farmhouse in Brittany and ' ...
ruralised amidst orchards and amongst the Breton
peasantry' (see Cat 45). Their youngest son, Martin
William, was born there, thus becoming liable for
service in the French Army if he had remained in
the country until his eighteenth birthday.

Reproduced in Meynell, *op cit*, p 23

54. Zouave teaching a dog to beg

Oil on canvas 35.8 × 45.2 1888

Insc: *EB 1888*

Mr J N Fowles

This small genre scene of a musician from a French
regiment of Zouaves and a hopeful dog was painted
during the eighteen months or so that Elizabeth
Butler spent in Brittany with her family. It does not
appear to have been exhibited previously and prob-
ably constituted a study from life for the artist's
own exercise.

Zouaves were originally formed in French North
Africa in the 1830s from the Zouaoua tribe. By the
time of the Crimean War, they were composed of
French nationals and had become part of the
metropolitan French Army. Their exotic uniforms
were greatly admired and copied by both sides in
the American Civil War of 1861–65 and by British
colonial troops in West Africa and the West Indies.

54

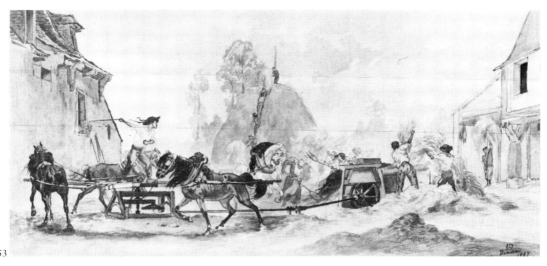

53

55

55. Monavoe(?), Delgany, Co.Wicklow

Pen and ink 29.2 × 22.8 c1890

Insc: *Mon⟨avoe⟩ Delgany/Co.Wicklow*

Prov: By direct descent

Mrs Marie Kingscote Scott

In 1888, the Butler family moved from Brittany to Delgany, '. . . a beautiful little village lying between the sea and the Wicklow Mountains . . .'.[1] This tranquil view is possibly of the path to their house. During this period, while her husband conducted an inquiry into the organisation of the Army Ordnance Department, Lady Butler continued to paint for exhibition at the Royal Academy. When the controversial *Evicted* (Cat 46) was shown there in 1890, the Butlers had already departed for Alexandria, where Sir William had been appointed garrison commander.

Until the autumn of 1893, when Sir William took command of the 2nd Infantry Brigade at Aldershot, Lady Butler returned to Delgany each year to escape the hottest months in Egypt and to see her children. She could also work on her Academy pictures in peace, without the interruptions necessitated by a life of official engagements in Alexandria.

1. McCourt, *op cit*, p 200

100

3. Napoleonic Themes 1890–1899

During the 1890s there was an increasing tendency for British battle painters to take their subjects from past campaigns, such as the Peninsular War of 1808–14, the Waterloo campaign or the Crimean War of 1854–56. In this period, for example, Andrew Carrick Gow (1848–1920) and Ernest Crofts (1847–1911), both exhibited four pictures at the Royal Academy illustrating events from the Napoleonic Wars. There was a reluctance to treat subjects from the recent colonial wars, partly for pictorial reasons, as British soldiers now wore khaki on active service, but also because, with the exception of the 1898 Omdurman campaign in the Sudan, the colonial wars of the 1890s were not especially glamorous affairs.

Elizabeth Butler was no exception to this trend. Five of her major Academy exhibits illustrate past wars and only one, *The Camel Corps*, (R.A.1893), untraced, deals with a contemporary subject, although it was based on studies made in 1885. Her approach reflected another development in British painting of the period, which veered away from social realism towards a more escapist vision of the past.[1]

However, subject-matter was only one aspect of the way in which the artist's work changed in this period. Her figure drawing became less firm, the colour and brush-work more pronounced. At the same time, with her belief that war provided an Homeric test of the nation's manhood, she emphasized more than ever the courage and self-sacrifice of the soldier. If, for example, *Dawn of Waterloo* (Cat 60) is compared with the painter's earlier treatment of the Scots Greys at that battle, *Scotland for Ever!* (Cat 36), the change is apparent. In place of the terror and exhilaration of the charge, in *Dawn of Waterloo* the dignity of the troopers and the portentous effect of the sun breaking on the horizon anticipate what Butler herself referred to in her autobiography as 'the awful glamour' of the great battle. Similarly, the figures in *"Steady the drums and fifes!"* (Cat 61) are willowy drummer-boys, whose discipline under fire belies their extreme youth, rather than the sturdy guardsmen of *The Roll Call* (Cat 18). In contrast to her earlier works, both *Dawn of Waterloo* and *"Steady the drums and fifes!"* show scenes in advance of an action, in which the spectator is forced to consider the serious consequence of war and the sacrifice about to be made by these uncomplaining men and boys.

1. John Sunderland *Painting in Britain 1525 to 1975* Phaidon Press Ltd, London, 1976, pp 43–4

Fig. 11. Photograph of the artist, c1893. The Viscount Gormanston

102

The painter's last Academy picture of the century, *The Colours: advance of the Scots Guards at the Alma* (Cat 64), in treating a Crimean subject for the first time since *The Return from Inkerman* of 1877 (Cat 26), also shows a change of emphasis. That the picture was commissioned by the regiment to commemorate the battle inevitably dictated the subject matter, but the result represents a complete departure from her earlier Crimean scenes. With this work, she moved entirely away from her previous concern with the awful conditions under which the army fought the campaign. Here instead is a scene of heroism and the active engagement of British troops during battle. Although there are compositional similarities to the Napoleonic War pictures, *The 28th Regiment at Quatre Bras* (fig 5) and *"Steady the drums and fifes!"*, and the enemy is unseen, this painting, with the advancing guardsmen, went further than ever before in removing the emphasis from the stoical and passive resistance of men under fire. This was Butler's last Academy painting to show a 'close-up' view of an historical battle.

As was the case with her rivals, Lady Butler's pictures fared better in the 1890s than in the previous decade. This may have been partly because their historic images were more suited to a certain public taste and also perhaps because, after several decades of expansionist foreign policies, British culture was more attuned to militaristic patriotism. The painter's work continued to receive scant attention from reviewers, but she did find buyers for it on occasion.

Napoleonic Themes 1890–1898

56. Study for Halt on a forced march

Watercolour and pencil 68.6 × 137.2 c1891

Prov: Presented to W J A Fox by Holland Tringham 'Artist "Illustrated London News"/August 1895'

Mrs A E Douglas

This large, loosely-treated study for Elizabeth Butler's Royal Academy exhibit of 1892, *Halt on a forced march: Peninsular War* (Cat 57), was probably painted in Egypt when the painter returned there from Ireland in November 1891. She had already begun work on the oil painting and took it with her in order to finish it. In depicting the weary Royal Horse Artillery gun-team, she had been unable to find suitably emaciated horses in Ireland, but in Egypt she had plenty of choice. She was of the opinion that ' . . . had I not been able to put the finishing touches to my team *there*, the picture would never have been so strong . . .'

Although the design is essentially the same as that of the finished picture, there are no seated figures on the right and slightly less landscape in view on the left, with the result that the sketch has a greater vitality than the final work.

57. Halt on a forced march: Peninsular War

Oil on canvas 96.5 × 154.3 1892

Insc: *EB/1892*

Prov: By direct descent and presented to the regiment in 1976

The King's Shropshire Light Infantry Regimental Trustees

Halt on a forced march depicts a gun-team of the Royal Horse Artillery carrying wounded soldiers on their limber during Sir John Moore's retreat to Corunna in the winter of 1808–9. After a desperate march through rain and snow and a series of stubborn rearguard actions, the depleted British army managed to rally at Corunna, inflict a defeat on the pursuing French and cover its evacuation by sea.

Once again, the artist chose to emphasize the suffering of the common soldier, as opposed to the more conventional theme of the campaign, that of Sir John Moore receiving his death-wound during the Corunna battle on 16 January 1809. In its conception the subject derives from French military

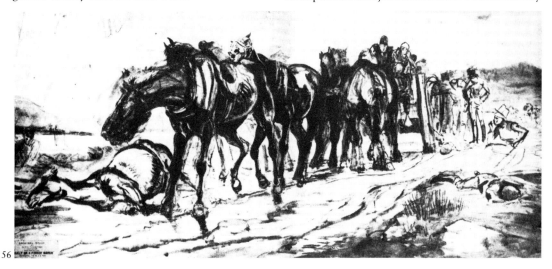

56

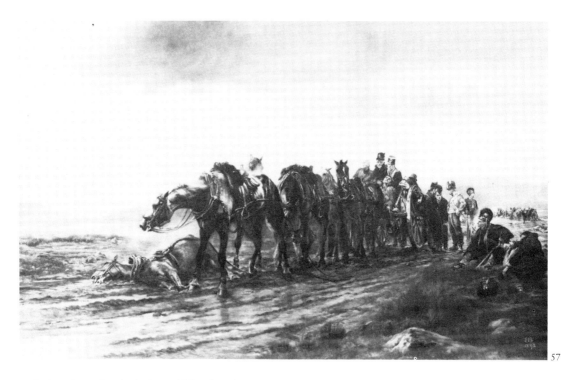

painting since the depiction of Napoleon's retreat from Moscow, with bad weather conditions, the troops wearied by a long march and continually fighting rearguard actions, was an established theme. (For example Adolphe Yvon's *Retreat from Moscow* in Manchester City Art Gallery).

Elizabeth Butler began the picture at Delgany, Co. Wicklow in the summer of 1891 but finished it at Alexandria when she went out to Egypt to rejoin her husband in November. She was keen to seize the opportunity to study ' . . . spent horses, "lean unto war"', of which there were many in Egypt, and the preliminary watercolour study (Cat 56), concentrates upon this aspect of the picture. At the Royal Academy the picture was advantageously placed and well received, but the painter felt that it did not sell because it was ' . . . too sad a subject'. *The Athenaeum*, however, harshly declared that the technique was crude, ' . . . like a third-rate military piece at the Salon', and pronounced the subject-matter to be 'commonplace'.

Exhib: R.A. 1892 (27); 'Silver Bugle',
 Durham Light Infantry Museum & Arts
 Centre, Durham, 1982 (10)

Ref: *The Athenaeum* 14 May 1892

58. The Camel Corps

Watercolour 24.1 × 34.3 c1885

Insc: *EB*

Prov: By direct descent

Mrs Marie Kingscote Scott

In 1893 Elizabeth Butler exhibited a painting entitled *The Camel Corps* at the Royal Academy (No 848). She described it as being eight feet wide, (approximately 244 centimetres), which would make it one of her largest works in oil. The painting has not been traced,[1] but a reproduction in Wilfrid Meynell's monograph reveals that in composition, as well as in the attitudes of the riders and camels, this watercolour is almost identical.[2]

During the artist's first visit to Egypt in 1885, she attended the manoeuvres at Abassieh in the desert beyond Cairo and witnessed the strange spectacle of the Camel Corps at the charge. As at the Aldershot manoeuvres, she ensured that she watched the charge ' . . . stem on'. As she recalled in *From Sketch-Book and Diary*;

> It was a sight worth seeing, and surprising to me, who, before I landed, had never seen a camel worthy of the name. When the 'halt!' was sounded, down fell the three hundred creatures on their knees in mid-career, close up to us, and the panting riders leapt off,

their accoutrements in most admired disorder, and their puttees for the most part streaming along the ground. I was in a hurry to get back to Shepheard's to take the impression down, for I was greatly struck by so novel a sight. The red morocco-leather saddle covers were most effective, and very sorry I was on my next visit to Egypt to find they had gone the way of all 'effective' bits of military equipment, and were replaced by dull brown substitutes.[3]

She later related that the watercolour was made while the subject remained fresh in her memory.

When Elizabeth returned home to Delgany in 1891 during the second summer of her husband's command at Alexandria, she had ' . . . a good stock of studies of camels and Camel Corps troopers' for the oil painting, but the picture must have taken some time to complete, for on her last trip to Egypt, she took the canvas with her ' . . . to finish it on its native sands.' Although the final oil painting appears to be essentially the same as the watercolour of 1885, the artist had been able, in her privileged position as the commandant's wife, to select from a choice of models and to observe the gait of cantering camels, in which both legs on one side move forwards together, while the animal's head sways from side to side. Butler was unable to do more than sketch the native troops, however, as she crossly recorded that 'These graceful Orientals become the stupidest, stiff lay figures the moment you ask them to pose as models. Besides, the sincere Mohammedans refuse to be painted at all.'

At the 1893 Royal Academy exhibition the picture was not hung in a good position, nor was it reviewed. It did not find a buyer, perhaps because it was too remote from the accepted, more exotic depictions of Egyptian life invested with Biblical associations, as exemplified by the work of Frederick Goodall. Moreover, within British military circles, some officers held a rather disparaging attitude towards the Egyptian Army, which Sir Evelyn Wood and others were in the process of reorganising.[4]

The painting was exhibited at the Paris Salon in 1894 (No 337), but again failed to find a buyer.

1. In *A Little Kept* Sheed and Ward, London and New York, 1953, p 116, Eileen Gormanston stated that the painting hung in the hall of the United Service Club. It was understood to have been in the collection of the Royal United Service Institution. However, it was not listed among their holdings upon the dispersal of the collection in the 1960s.
2. Meynell, *op cit*, p 5
3. Elizabeth Butler *From Sketch-Book and Diary*, pp 42–3, illus. Pl 8
4. George H Cassar *Kitchener: Architect of Victory* William Kimber, London, 1977, p 36

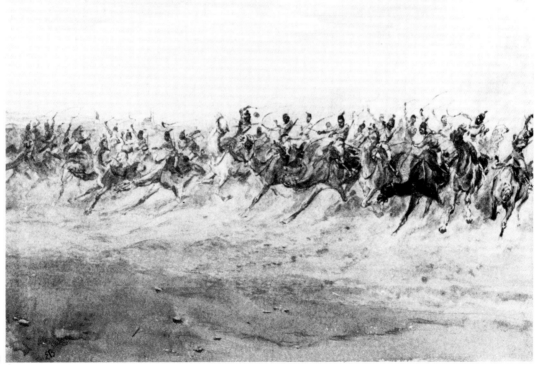

58

106

59. Sketchbook c1893–94

37 pages 14.1 × 23

Prov: Lt-Col P R Butler. Presented to the
National Army Musem in 1963

National Army Museum 6311-193-7

Like the 1890 sketchbook, this includes various
sketches in pencil, pen-and-ink and watercolour,
made in Egypt. There are landscapes and various
figures, such as a Highlander and an Egyptian in a
fez. A view of Cairo, seen from the Pyramids, is
dated 27 April 1893.

There are also several studies for the Royal
Academy painting of 1895, *Dawn of Waterloo* (Cat
60), executed in Ireland in the summer of 1893 and
at Aldershot, where the Butlers lived from Novem-
ber. One of these, a study of a dark landscape, is
inscribed 'Normanton House Farnboro' Rd'.

59–1

59–1. Study for the bugler and central group of Dawn of Waterloo

Pencil

Insc: *½ lb tea per/fortnight*

This preliminary sketch reveals the essential
concept of the picture, with a bugler blowing the
reveille in the centre and groups of Scots Greys
sitting up or rising at the call, although the final
composition has a more complex arrangement of
figures set in a much broader landscape.

59–2. Study for a sleeping group in Dawn of Waterloo

Pencil (photograph only)

The sitting and somnolent forms in this sketch,
wearing undress forage caps, were used in the
painting for the dimly seen third row of figures,
centre left.

59–2

60. Dawn of Waterloo. The "Reveille" in the bivouac of the Scots Greys on the morning of the battle

Oil on canvas 126.4 × 196.3

Insc: *18 EB 95*

Prov: By family descent

Executry of Major M D D Crichton-Stuart,
Palace of Falkland, Fifeshire

This painting has been interpreted as an anti-war
image, since it has been assumed that, in this scene,
Elizabeth Butler was dwelling on the sombre
thought that for many of these men it would be the
last dawn they saw, thus forcing the spectator to
consider the ultimate sacrifice which all soldiers
must face.[1]

It depicts young troopers of the 2nd Royal North
British Dragoons (Scots Greys) awakening on the
morning of 18 June 1815. They were later to take
part in the heroic but murderous charge of the
Union Brigade commemorated by Butler's earlier
picture, *Scotland for Ever!* (Cat 36).

The artist began work on the picture at Delgany,
Co.Wicklow in the summer of 1893 where she was
able to make twilight studies outside, '. . . not a
thing painted in the studio', she stated. 'I pressed
many people into my service as models, and I think
I got their fine Irish faces very true to nature. I even
caught an Irish Dragoon home on leave in the
village, whose splendid profile I saw at once would
be very telling.' This model appears as the central
figure in the foreground.

In November 1893 William Butler took
command of the 2nd Infantry Brigade at Aldershot
and there the picture was continued in the old
court-martial hut which the painter used as a
studio, after it had been converted with four
skylights fitted in the roof. Sketchbook drawings,
also made at Aldershot, show the principal figures,
slumbering and awakening in the foreground (Cat
59).

In March 1895 the picture was put on show at
the Club House, Aldershot and was much admired
by the crowds of soldiers, ' . . . from the generals

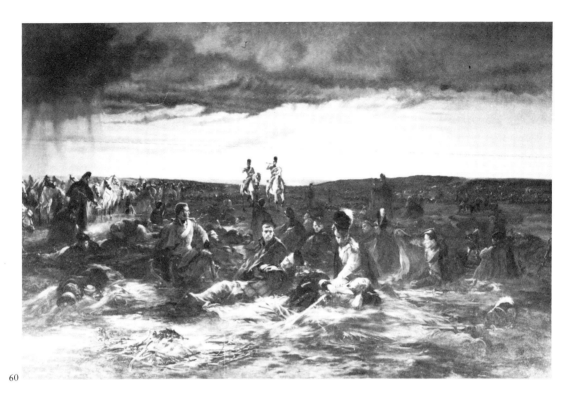

60

down to the traditional last drummer', who flocked to see it. At the Royal Academy a couple of weeks later it was poorly placed and was thus ignored by both press and public. The painter thought this treatment 'unkind' and did not submit a picture the following year.

Although Elizabeth Butler referred to her visit to Waterloo on her nineteenth birthday as one of the great experiences of her youth, she had only depicted the great battle once before. It may have been the successes of painters such as Ernest Crofts and Andrew Carrick Gow with their Waterloo pictures of the 1890s that prompted her to return to it at this point in her career. With its rows of sleeping men under an ominous sky and the strange quality of the light, *Dawn of Waterloo* is close in treatment to Edouard Detaille's popular *Le Rêve* (*The Dream*, Salon 1888), a work in which an eerie dream inspires the soldiers with hopes of glory in battle. It may also have represented a return to an idea which she had considered at the start of her career, in the unfinished *Dawn of Sedan* (1875). She had described this as depicting French *cuirassiers*, watching by their horses, in ' . . . the historic fog of that fateful morning'.

Exhib: R.A.1895 (853)

1. Joan Hichberger 'Military Themes in British Painting 1815–1914', unpublished PhD thesis, University of London, 1985

61. "Steady the drums and fifes!" The 57th (Die-hards) drawn up under fire on the ridge of Albuera

Oil on canvas 127 × 180.4 1897

Insc: *EB/1897*

Prov: The Middlesex Regiment, now amalgamated into The Queen's Regiment

The Queen's Regiment, Canterbury

Exhibited at the National Army Museum only

When "*Steady the drums and fifes!*" was exhibited at the Royal Academy in 1897, the following text was printed in the catalogue under the title;

The highest courage in a soldier is said to be standing still under fire . . . It is the self-command of duty in obedience to authority. In a forlorn hope there is the excitement of action and the forgetfulness of self which comes with it. But to stand under fire, still and motionless, is a supreme act of the will.

These lines were quoted from Cardinal Manning's essay on courage in *Pastime Papers* (1892), which was edited and introduced by the painter's brother-in-law, Wilfrid Meynell.

The drummer-boys of the 57th (West Middlesex)

108

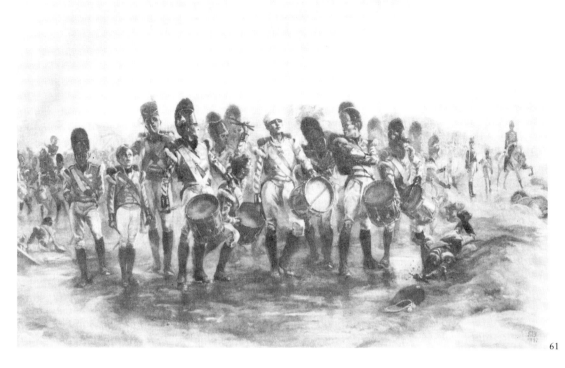

61

Regiment, some of whom appear to be less than ten years old, are shown waiting under fire for the order to advance during the Peninsular War battle of Albuera, 16 May 1811. Meynell himself commented;

> To look from one or other of the band of boys with their various characters and tempers as they face the bullets but are forbidden even the action of their instruments (for their music is hushed) is to go through a drama of boyish life. The artist has not shrunk from the too great pathos of a child of nine or ten consciously shaken by the fear of death and yet proud of his disciplined attitude; nor from the brutality of a much older lad inclined to bully his comrades into quietness; nor from the writhing death of the boy whose hand clings round a little comrade's ankle.[1]

This sombre, underlying suggestion of the sacrifice of youth is allayed by the differing tensions and responses between the boys. The arrangement of figures in a ragged line is clearly derived from *The Roll Call* (Cat 18), although the boy soldiers are more heroic in manner.

Lady Butler may have been drawn initially to this subject by the famous passage describing the advance down the slope at Albuera in Sir William Napier's *History of the War in the Peninsula*.[2] For its part in this action the regiment earned the nickname of 'The Diehards'. The artist's sketch-book of 1894 (Cat 79) contains a drawing which could indicate that the subject was under consideration as early as three years before it came to fruition. Most of the work on the picture, however, was undertaken at Dover Castle where the family resided from February 1896 to the end of 1898, while Major-General Sir William Butler was in command of the South Eastern District. In her autobiography the painter related that models for some of the boys were from the Gordon Boys' Home in Dover, and her own sons ' . . . were sufficiently grown to be of great use, though, for obvious reasons, I could not include their dear faces in so painful a scene.'

Once again, the painter took a great deal of trouble over correct details of uniform and was pleased to discover that, as the facings of the regiment were canary yellow, the drummer-boys, as musicians, wore jackets of that colour. Since she had always experienced difficulty in painting great expanses of red, with the bright tunics and coatees of the British Army standing out to startling effect, she felt ' . . . a tremendous relief' on this occasion. She had once asked Edouard Detaille whether he would consider painting British troops, and the Frenchman had owned that he would have liked to, ' . . . but the red frightens us'. By the 1890s Butler

109

was much more concerned about colour relationships in her pictures than she had been previously.

When the painting was completed she was pleased with the result and stated, 'I place "Steady, the Drums and Fifes!" among those of my works with which I am the least dissatisfied. The Academy treated me well this time, and gave the picture a place of honour.' It was moderately well received by reviewers, although it was one of three Peninsular War scenes in the exhibition; the others being *Fuentes Onoro, May 5, 1811* by Richard Caton Woodville and *Norman Ramsay at Fuentes Onoro* by William Barnes Wollen.

> Exhib: R.A.1897 (663); Leicester Galleries 1917 (9)
>
> Refs: *The Art Journal* 1897, p 182; *The Illustrated London News* 15 May 1897
>
> Engr: Photogravure, 62.6 × 86.1, published by Manzi, Joyant & Co, 1904

1. Meynell, *op cit*, p 17
2. Maj-Gen Sir W F P Napier *History of the War in the Peninsula and in the South of France from the year 1807 to the year 1814* Frederick Warne & Co, London, 1892, Vol III, p 170

62. On the morrow of Talavera: soldiers of the 43rd bringing in the dead

Oil on canvas 76.2 × 63.8 1923

Insc: *19 EB 23*

Prov: By direct descent

The Hon Robert Preston

This is a copy, executed in 1923 by Lady Butler, of the picture which she exhibited at the Royal Academy in 1898 (No 303), and which she described as being smaller than usual. The original oil has not been traced although it was probably the painting on which the artist is seen working in a photograph taken at Dover Castle c1898 (fig 1).

On the morrow of Talavera depicts the aftermath of the first great victory of the Peninsular War on Spanish soil by the British army under the command of Lieutenant-General the Hon Sir Arthur Wellesley, later the Duke of Wellington. It was a ferocious battle, commencing on 27 July 1809 but not decided until the following evening, by which time British casualties amounted to nearly 5,000 out of a force of 20,000 and the French had lost 7,000 of their 50,000 men. The soldiers carrying the body of a bugler on a litter, whom Wellington is shown saluting, belong to the 43rd

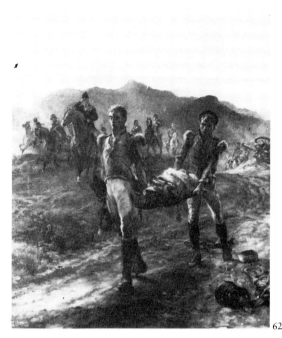

62

(Monmouthshire Light Infantry) Regiment, part of the Light Infantry Brigade which served with particular distinction at Talavera and throughout the Peninsular War.

The painting is unusual amongst Lady Butler's works in a number of respects; it is upright in format, there is no semblance of the usual row-of-figures composition and it gives a prominent place to the commanding officer. However, the Iron Duke's sympathy with the men who bore the brunt of fighting was well known and it is this quality that the picture honours. The theme of Wellington saluting his troops after battle was common in late Victorian military painting and the artist would have been aware of such works as Ernest Crofts's *Wellington's march from Quatre Bras to Waterloo* (Cat 135) of 1878 and Richard Caton Woodville's *Badajos: 1812* (R.A.1894). Elizabeth Butler's picture was ' . . . very kindly placed at the Academy . . . ' but drew no comment from the art critics. Among the hundreds of pictures on display, there was nothing particularly novel or unusual about this one.

Another version of this work, painted in watercolour by the artist in 1911, is in the Anne S K Brown Military Collection, Rhode Island, USA (fig 12). It differs from the 1923 copy in several respects, which indicates that there may be similar changes between the original work of 1898 and this oil. The watercolour has a different body of staff officers riding behind the commander, whose horse is also seen head on; a more effective example of

110

Fig. 12. *On the morrow of Talavera* watercolour, 1911. Anne
S K Brown Military Collection, USA

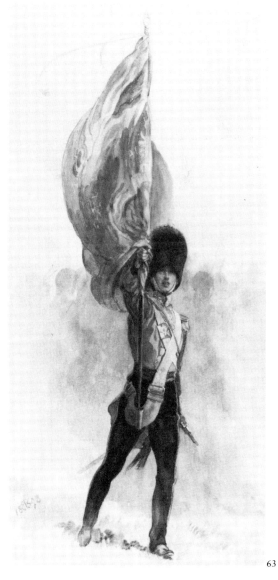

dusty, moth-eaten Alma colours taken down from
their place on the walls, and held the Queen's
colour once more in his hands for me to see.' The
artist took the opportunity to make studies of the
remnants on the spot, while Wantage advised her as
to their original colouring.

foreshortening. In place of the shattered cannon on
the right of the oil painting, the watercolour shows
a line of infantry bringing up more dead. The
mountainous landscape has also been reduced to a
low hill in the distance, so that Wellington and his
staff are emphasized against the sky.

63. The Flag. Study for The Colours: advance of the Scots Guards at the Alma

Watercolour and pencil 52.5 × 26 1898

Insc: *18 EB 98*

Prov: By family descent

Executry of Major M D D Crichton-Stuart,
 Palace of Falkland, Fifeshire

This study for the central figure in Lady Butler's
Royal Academy exhibit of 1899 (Cat 64) depicts
Captain Lloyd Lindsay of the Scots Fusilier
Guards, who won the Victoria Cross for his gallantry
at the battle of the Alma on 20 September
1854.

Lindsay had been one of those admirers of *The
Roll Call* in 1874 who had been most keen to buy
the painting, before Queen Victoria expressed her
own interest in it. When, in 1898, Lord Wantage,
as he had become in 1885, heard of the painter's
intention to depict this subject, he conducted her to
the Guards Chapel in London and, as Butler
recalled, ' ... there and then [he] had the old,

63

In the Foot Guards, unlike other regiments, the
Union Flag is the regimental colour and it is this
that Lindsay is carrying in the watercolour. In the
oil painting he carries the crimson Queen's colour.

Exhib: Leicester Galleries 1912 (28)

111

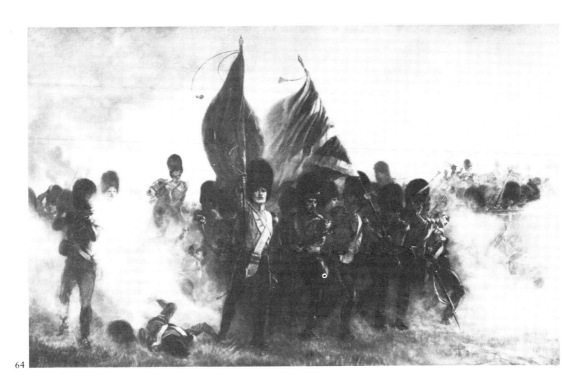

64

64. The Colours: advance of the Scots Guards at the Alma

Oil on canvas 98 × 155.6 1899

Insc: *EB/1899*

Prov: Commissioned by the Scots Guards to commemorate the battle of the Alma

Regimental Headquarters Scots Guards

The Colours illustrates a famous incident in the battle of the Alma, 20 September 1854, during the Crimean War. The Scots Fusilier Guards were advancing to support the 23rd (Royal Welch Fusiliers) in front of the Great Redoubt, when suddenly, a determined Russian onslaught broke the Welsh regiment's line;

When the formation of the line of the regiment (the Scots Fusilier Guards) was disordered ... , Captain Lindsay stood firm with the colours, which were shot through and through and the staff broken, and by his example and energy succeeded in restoring order. At Inkermann, November 5th, at a most trying moment, he, with a few men, charged a party of Russians, driving them back, and running one through the body himself.[1]

For these two actions Lindsay was awarded the Victoria Cross.

A study for the central figure of Lindsay holding the colour aloft, was painted in watercolour in 1898 (Cat 63). The painting, commissioned by the regiment, was begun that summer, during the Butlers' last year at Dover Castle and finished early in 1899, before the artist embarked to join her husband in South Africa. Lindsay himself, now Lord Wantage and an old, although energetic man, assisted the artist in her efforts to capture an accurate impression of the scene and took her to view the remnants of the original colours in London. He had been responsible for commissioning from the French artist, Chevalier Louis Desanges, a series of paintings of actions for which the Victoria Cross was awarded, which also included one of himself at the Alma (Wantage Town Council).

The 1899 Royal Academy catalogue entry quoted General Earle; 'It was the last battle of the old order. We went into action in all our finery, with colours flying and bands playing.' On this occasion Butler appears to have relished the use of so much red and seized the opportunity given by the flags themselves to balance its use in the composition, further echoing the strong hues with the pink of uniforms seen through gunsmoke and in the clouds above.

After so many pictures of Crimean War scenes by

112

various artists working in the latter part of the nineteenth century, it is possible that this work may be viewed as another conventional set-piece. Despite the advice of Wantage himself, it is probably a rather fanciful rendering of his rallying of the troops. It also adheres to the old-fashioned academic requirements of painting in the use of a triangular compostion set almost on one plane. However, although the figure of Lindsay stands out from the shadows cast on the men, he is not the sole focus of interest. By successfully combining the individual figures into a cohesive whole, the painting has a great vitality. The treatment of the dead and wounded is unsentimental and the heroism of the officer is handled with restraint.

Exhib: R.A.1899 (912)

Ref: *The Illustrated London News* 13 May 1899

1. *Catalogue of the Pictures of the Victoria Cross Gallery painted by Chevalier L.W.Desanges, and presented to the Town of Wantage by Lord Wantage, V.C., K.C.B., 1900* Nichols and Son, Wantage, n.d., p 8

65. Sketchbook 1890

28 pages 11.4 × 17.8

Prov: By direct descent

The Hon Robert Preston

This sketchbook was kept on board the P & O Steamship, *Hydaspes*, on Elizabeth Butler's journey out to Alexandria to join her husband, the commander of the garrison, at the end of March 1890 and during her return to Ireland on the same boat in November. The book includes pencil and watercolour sketches of views of Brindisi, Ancona and the Greek islands, as well as passengers and the crew on board ship.

There are also a number of sketches of views in Egypt, including Arab boats and herds of goats which the artist saw during a cruise to Rosetta in November 1890.

65–1. Passing Candia

Watercolour and pencil

Insc: *Passing Candia/some of my fellow/ passengers/Hydaspes 11 Nov 90*

Butler greatly enjoyed the trips on the *Hydaspes*, partly because she found ' . . . a bright company' on board, but also because ' . . . one is hardly ever out of sight of land, and such classic land too!' Candia, modern day Heraklion, is the main port of Crete.

66. Vignettes for the 'head' and 'tail' of 'From Sketch-Book and Diary', Egypt, Chapter III

Pen-and-ink 25.5 × 35.5 1890

Insc: *Head piece marked Egypt No.5/ Chap.III/EB/The Vaganieri/Brindisi/30 March / 90/Reduce to 2) inches high Tail piece marked Egypt No.6/Chap.III/EB/ Reduce to 3 inches high*

Prov: By direct descent

Mrs Marie Kingscote Scott

These pen-and-ink vignettes are the original drawings, with notes for the publisher, reproduced at the beginning and end of Chapter III of the second section of *From Sketch-Book and Diary*, entitled 'Egypt'.

The left hand sketch was drawn from the artist's observations at Brindisi, on her first voyage out to Alexandria in March 1890, where, ' . . . the Italian chatter and laughter along the quays never stops.' The *Vaganieri*, or cab-drivers waited to collect passengers disembarking at the port.

On 24 May 1890, Queen Victoria's birthday was celebrated by the ceremony of Trooping the Colour on the Moharrem Bey parade ground at Alexandria. The drummers in the right hand vignette were from the Suffolk Regiment who took part in the occasion.

65–1

113

Head piece marked Egypt No 5
Chap. III

Tail piece marked Egypt No 6
Chap. III

66

67. Goats in Egypt

Watercolour 26.5 × 44.5 1890

Insc: EB

Prov: By direct descent

Mr Antony Preston

Lady Butler visited Egypt four times from 1890 to 1893, while her husband was in command of the garrison at Alexandria, spending the months of June to November at home with her children in Ireland. While abroad she drew and painted avidly,

despite the social commitments of her position. She was particularly delighted by the goats which abounded in the country, ' . . . with their long, pendant ears, and kids skipping in impish gambols in front'. The watercolour also shows how the artist revelled in the bright colours of outdoor life, illuminated by the strong sunlight, which she found to be the glory of Egypt.

68. Friday afternoon on the Mahmoudieh Canal

Watercolour and pencil 8⅞ × 13 in, 22.6 × 33.1 cm c1890

Insc: Friday afternoon on the Mahmoudieh Canal. EB

Prov: By direct descent

Private collection

During her residence at Government House on the Boulevard de Ramleh, Elizabeth Butler was at the social centre of Alexandria, but she was not above amusement at the conventions of that community. She described the scene illustrated by this watercolour;

114

68

Not even the drive on the old Shoubra Road at Cairo surpassed the Alexandrian Rotten Row on the Mahmoudieh Canal on a Friday afternoon in its heterogeneous comicality. Every type was on the Mahmoudieh, in carriages, and on horseback – Levantine, Greek, Jew, Italian, Arab; up and down they rode on the bumpy promenade, under the shade of acacias and other flowering trees that skirted the picturesque canal. Across this narrow strip of water you saw the Arab villages of a totally different world; and I really felt a qualm every time I saw a *fellah* over the way turning his back to the western sun (and to us) to pray, in absolute oblivion of our silly goings-on. On our side was Worldliness running up and down, helter-skelter; on the other, the repose of Kismet. Here comes a foreign consul – you know him by his armed, picturesque ruffian on the box – in a smart Victoria, driven by a coal-black Nubian in spotless white necktie and gloves; the Arab horse is ambling along with high measured action. Much admired is Monsieur le Consul – the observed of all observers; he looks as though he felt himself 'quite, quite.'[1]

Reproduced in Meynell, *op cit*, p 10

1. Elizabeth Butler *From Sketch-Book and Diary*, pp 86–7

69. Our Picnic on Camels at Alexandria

Watercolour 46 × 35.5 c1891

Prov: By direct descent

Mr Antony Preston

Somewhat in the nature of a modern holiday snapshot, this records a picnic at Mex, west of Alexandria, during which Lady Butler rode a camel for the first time. It was probably made during the painter's second stay in Egypt, in November 1891 to summer 1892, when she was working on *The Camel Corps* (R.A.1893, untraced, see Cat 58). She had found these animals much easier to depict

69

115

in motion than horses, since it was possible to emphasize speed with their long legs and also to show them, for variety and with all accuracy, with heads and necks twisted right round.

The picnic, she recalled, ' . . . was distinquished by a great camel ride we all had on the soft-paced, mouse-coloured mounts of the Camel Corps, the Englishwomen looking so nice in their well-cut habits, sitting easily on their tall steeds . . . I have one sketch of ourselves starting for our turn in the desert.'

Reproduced in Meynell, *op cit*, p 6

70. Well in the Nile Delta

Watercolour 29 × 44.5 1892

Insc: *18 EB 92*

Prov: By direct descent

Mr Antony Preston

Elizabeth Butler found Egypt delightful, despite the poverty of which she was well aware. She wrote, 'The East has always had for me an intense fascination, and it is one of the happiest circumstances of my life that I should have had so much enjoyment of it.' This characteristic scene was probably painted during her third visit to Alexandria, where, during an epidemic of influenza in which many died, including the Khedive Tewfik, she took advantage of the cessation of social duties to make many sketches and to complete the oil, *Halt on a forced march* (Cat 57).

71. The Egyptian Donkey Barber

Watercolour over pencil 79.6 × 58 1903

Insc: *19EB03*

Prov: By direct descent

Private collection

Although painted in 1903, this watercolour is based on at least three sketches which the artist made during her visits to Alexandria between 1890 and 1893 and which are reproduced in Wilfrid Meynell's monograph. *Study of an Egyptian Donkey Barber* (p 10) shows the central figure of the man clipping the donkey's mane, and two studies of donkeys from life (p 26) were the models for the beast lying on the ground before him, and also the two right hand animals, all arrayed in colourful harness and saddlery. These sketches may have been made on an occasion such as a picnic

70

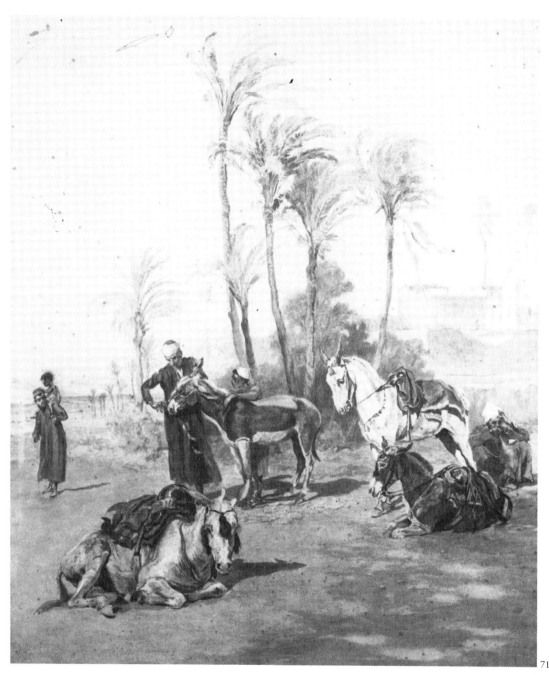

which Elizabeth Butler enjoyed in 1892, beside the Mediterranean at Aboukir Bay;

> We were shaded by clumps of pomegranate trees in flower as well as by the waving, rustling palms, and a cool wind blew round us most pleasantly, while the white and grey donkeys that brought us rested in groups, their drivers and the villagers squatting about them in those unconsciously graceful attitudes I love to jot down in my sketch book. The moving shadows of the palm branches on the sand always capture my observation; no other tree shadows produce that effect of ever-interlacing forms.

117

ILLUSTRATIONS FOR 'LETTERS FROM THE HOLY LAND', 1891

Elizabeth Butler's first book of travel reminiscences was composed of a series of letters from what was then known as Palestine, to her mother, Christiana Thompson, at whose instigation the volume was published (Cat 128). In company with her husband, the artist spent the month of April 1891 touring the Holy Land on horseback, there being no railway at that time. A devout Christian, she remembered the journey as one of the most joyful experiences of her life.

Illustrated with sixteen colour plates of ' . . . scenes connected with Our Lord's revealed life', the book was an unexpected success when it was published in 1903 and this encouraged the artist to publish further memoirs in *From Sketch-Book and Diary* in 1909 and *An Autobiography* in 1922.

72–77 Illustrations for 'Letters from the Holy Land'

72. The Start

Watercolour 34 × 25, the original for the frontispiece illustration

Incs: *Ready for the/Start/EB*

Prov: By direct descent

Mrs Brigid Battiscombe

A *syce*, or groom holds the artist's Syrian pony, Minnow, ready for her to mount at the moment of the Butlers' departure from Alexandria. The pony did not accompany them to Palestine, where the travelling arrangements had been organised by the firm of Thomas Cook.

A sketch from life of the pony, standing in the same attitude, is reproduced in Meynell, *op cit*, p 9.

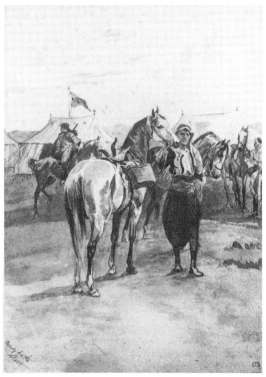

72

73. Solomon's Pools, near Jerusalem, looking towards Dead Sea

Watercolour 24.1 × 34.3, the original for Plate 7

Insc: *EB*

Prov: By direct descent

The Hon Robert Preston

This shows the central pool of three reservoirs which were built on a slope of the valley of the Dead Sea. Here the Butlers spent their first night under canvas, an experience which was both ' . . . new and delightful' for the artist.

74. The Plain of Jordan looking from "New Jericho" towards Mount Pisgah

Watercolour 16.5 × 24.5, the original for Plate 9

Insc: *EB*

Prov: By direct descent

The Hon Robert Preston

This watercolour shows a view of the mountains of Moab at sunset, from the camp at "New Jericho", ' . . . a huddled group of mud-pie houses situated in a garden of lovely trees . . .'.

75. Our First Sight of Lake Galilee

Watercolour 24.1 × 34.3, the original for Plate 11

Insc: *EB*

Prov: By direct descent

The Hon Robert Preston

This was our most glorious day's journey for it took us to the shores of the Lake of Galilee. Hermon in distant Lebanon was visible ahead of us throughout . . . Here Christ preached

the Sermon on the Mount, and down there, intensely blue, lay that dear lake whose shores were so often trodden by His feet.

76. Nazareth at Sunrise

Watercolour 18.7 × 25.1, the original for Plate 14

Insc: *EB*

Prov: By direct descent

The Hon Robert Preston

Elizabeth thought that Nazareth was an attractive town, ' . . . exquisitely situated on the slope of a cypress-topped hill', but she found the heavily-tattooed faces of the women and the air of 'pious fraud' too much and did not linger there.

Exhib: Leicester Galleries 1919 (12)

77. St Jean d'Acre

Watercolour 24.5 × 34, the original for Plate 15

Insc: *EB*

Prov: By direct descent

The Hon Robert Preston

77

While her husband, a keen student of the Napoleonic Wars, explored St Jean d'Acre, which had been besieged by the French in 1799, Lady Butler remained in their carriage about a quarter of a mile outside the town to make this sketch. Although it included the fortifications, she was surprised to find that this was of little concern to the military authorities there.

78. Royal Horse Artillery Halt!

Watercolour 36.8 × 52.7 c1893

By gracious permission of Her Majesty the Queen

This probably dates from the period of 1893 to 1896, when the painter's husband had command of

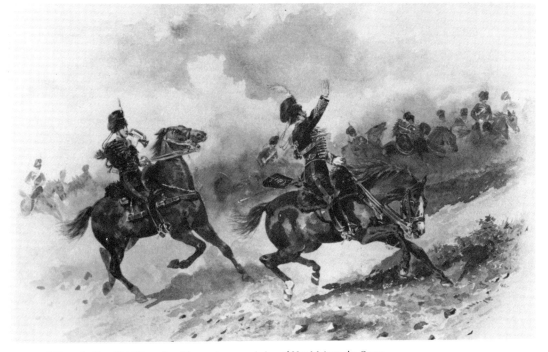

78. *Royal Horse Artillery Halt!* Reproduced by gracious permission of Her Majesty the Queen

the 2nd Infantry Brigade at Aldershot. There were many reviews and parades, several of which were taken by Queen Victoria. On one occasion, Elizabeth Butler witnessed how a troop of hussars, charging towards the Queen's carriage, were pulled up short by the command 'Halt!', within yards of the assembly. The effect was stirring, but the artist had not been the only one to feel that, had the order come a moment later, the cavalry would have been precipitated upon the royal party.

79. Sketchbook 1894

24 pages (including 4 loose sheets) 17.3 × 25.4

Insc: *Elizabeth Butler Aldershot 1894*

Prov: By direct descent

The Hon Robert Preston

From November 1893 to January 1896, while the Butlers lived at Aldershot, the artist had the opportunity to make these pencil and watercolour studies of soldiers on manoeuvres. The book includes various preliminary drawings for oil paintings such as a study for "*Steady the drums and fifes!*" (Cat 61); a double-page of Scots Greys with lances, inscribed *Halt! surprise by cavalry* which may be the basis of "*Right Wheel!*" (Cat 81) and a cursory sketch of horse artillery fleeing from the enemy, entitled *Saved*, which may be the germ of *Rescue of wounded, Afghanistan* (Cat 90).

A pencil sketch entitled *The gallop according to Kodak* (Nos 1–11) appears to be based on Edweard Muybridge's photographic studies of horses in motion, first published in America c1880. The revelations of the camera were a sensation and even caused Meissonier to repaint the legs of Napoleon's charger in one of his pictures. Lady Butler, however, insisted that she did not normally rely on 'snapshots' but preferred to work from her sketches or from memory.

79–1. The return of the Coldstreams

Watercolour and pencil

Insc: *return of Coldstreams after New Forest manoeuvres/very hot/Hops given by Hop-pickers along the roads./Officer carrying man's rifle*

The weary guardsmen must have fraternized with the hop-pickers as many of them wear bunches of the foliage in their bearskins.

79–2

79–2. The Duke of Cambridge and staff

Pencil (loose page)

Despite the cursory nature of this sketch, it has an instantly recognisable portrait of the Duke, holding up his spy-glass to survey the troops. The picture may have been drawn on the occasion of the Queen's Review at Aldershot, on 17 May 1894, during the Duke of Cambridge's final year as Commander-in-Chief of the British Army. He retired in 1895 and was replaced by Field Marshal Lord Wolseley. General Butler is probably the foremost figure, seen in quarter profile.

79–1

80

kind friends, the Sweetmans, in Queen's Gate, my husband was managing all the tiresome work of the move.' In August 1933, shortly before the artist's death, Gertrude Sweetman stayed with Elizabeth Butler and recorded the final memories of her long and varied life.[1]

1. Gertrude Sweetman TS Personal Recollections of Elizabeth Thompson (Lady Butler); Collection of Mrs Hester Whitlock Blundell

80. Trooper, Life Guards

Watercolour, pen-and-ink 8.5 × 11.5 1894

Insc: *A happy New Year/to/dearest/Gertrude/ E B/1894*

Prov: By direct descent from Mrs Gertrude Sweetman

Mrs Hester Whitlock Blundell

Elizabeth Butler's friendship with Gertrude Sweetman was of many years standing. When the Butlers moved from Aldershot to Dover Castle in the spring of 1896, the artist related, 'As usual, I was spared by Sir William all the trouble of the move, and while I was comfortably harboured by my ever

81. "Right Wheel!"

Oil on canvas 54.6 × 102.2 1895

Insc: *E B/1895*

The Cavalry and Guards Club

Elizabeth Butler was working on this oil of a squadron of the Royal Scots Greys, on manoeuvres on Laffan's Plain in the Long Valley at Aldershot, in the summer of 1895. A label on the reverse states that, in accordance with her custom, the portraits of the dragoons and the details of the horses were based on studies made after the event, in barracks. The painting may be based on a study in the sketchbook of 1894 (Cat 79).

In her autobiography, the artist related that following the Queen's review of the troops on 13 July 1895, she hurried back to her studio to paint the effect of the bearskins blown by the wind while it was fresh in her mind, but, as Princess Louise unexpectedly called to see her, she was obliged to change hurriedly out of her 'painting dress' to attend to her social duties.

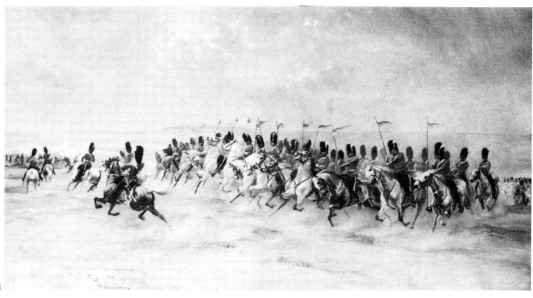

81

During this period at Aldershot, her major picture, *Dawn of Waterloo* (Cat 60), was an historic treatment of the Scots Greys before battle. The painter also executed a number of watercolour studies of cavalry, several of which are reproduced in Meynell (*op cit*, pp16, 18, 28 & 30).

82. "Bravo!!"

Watercolour 38 × 53 1898

Insc: *"Bravo!!"/Officer 19th,(Princess of Wales' Own) Hussars/at "Tentpegging"/ Elizth. Butler/1898*

By gracious permission of Her Majesty the Queen

This sketch of an officer, with his lance across his shoulders as he gallops triumphantly off with the impaled tentpeg, was presented by the artist to the Princess of Wales, the Colonel-in-Chief of the 19th Hussars, for her album of watercolours. Although the regiment was stationed in India at the time, the officer depicted must have been one of those who remained at the cavalry depot in Canterbury. Elizabeth Butler may have travelled there from Dover Castle to make the sketch.

Another version of the same subject, dated 1899, is now in the Anne S K Brown Military Collection, Rhode Island, USA and was reproduced in Meynell (*op cit*, p 7).

82. *"Bravo!"* Reproduced by gracious permission of Her Majesty the Queen

4. The Boer War and the Edwardian Era 1899–1914

In the decade and a half before the Great War Lady Butler exhibited only six paintings at the Royal Academy. Her pictures treated contemporary subjects in a more conventional manner, and she ceased to depict the themes for which she had been celebrated; the courage of the British soldier in battle, even under the most adverse conditions. In addition, she devoted much of her time to writing, publishing two books, *Letters from the Holy Land* in 1903 and *From Sketch-Book and Diary* in 1909 (Cat 128, 129). She did paint some Boer War scenes but, for personal reasons, she found the subject melancholy and only one picture of the war, *Within sound of the guns*, was exhibited at the Academy.

The Boer War immediately followed a crisis in her husband's career. In October 1898, Sir William Butler, with the local rank of lieutenant-general, was appointed Commander-in-Chief in South Africa. He was also made Acting Governor of the Cape Colony and High Commissioner in South Africa, during the temporary absence of the High Commissioner, Sir Alfred Milner. This might have been the climax of his career. Instead, as he had come to realise, his views were at variance with the intentions of a powerful faction of British colonials headed by the influential Cecil Rhodes. They were determined on a course designed to lead to the British annexation of the Boer colonies, the Transvaal and the Orange Free State. The Cape Colony was in a state of considerable political unrest; anti-Dutch agitation was being fuelled by local press, with constant appeals and petitions to the British government. While Butler attempted to defuse the situation he had, initially, the support of the government at home, but through the early months of 1899, he found War Office directions to be increasingly inadequate and contradictory. The High Commissioner saw a war with the Boers as the inevitable consequence of the situation, while Butler believed that not only was it against the real interests of all parties, but it was also avoidable. He knew that, in any case, the military forces were insufficient to deal with a conflict and made every effort to convince his superiors of this fact, but he was eventually outmanoeuvred by the politicians. The War Office finally suggested that his sympathies lay entirely with the Boers and that '. . . Imperial interests would suffer' if he continued in post. His resignation was accepted on 8 August.[1]

Lady Butler had joined her husband in South Africa in March 1899, but returned to Britain with her family in late August. Sir William had been

1. William Butler *An Autobiography*, p 453

THE NAVY & ARMY ILLUSTRATED.

Vol. VII.—No. 96.] SATURDAY, DECEMBER 3rd, 1898.

MAJOR-GENERAL SIR W. F. BUTLER,
COMMANDING IN SOUTH AFRICA
(See "Ships and Ashore")

Fig. 13. Major-General Sir W F Butler, Commanding in South Africa *The Navy and Army Illustrated* 3 December 1898. National Army Museum

offered the command of Western District at Devonport, but even then, as the British suffered a series of reverses in the early stages of the Boer War, he was the subject of many attacks in the press, being accused not only of pro-Boer sympathies but of failing to assemble sufficient military forces in South Africa. Neither charge had any real substance and after the war the Army made some attempt to make amends by giving him the difficult and responsible task of heading the inquiry into the 'War Stores Scandals', following the discovery of widespread profiteering by defence contractors.

In October 1905, at the age of 67, Sir William· was placed on the Retired List and, with his wife and youngest child, moved to Bansha Castle, Co.Tipperary, to spend his remaining years near his birthplace. In June 1906, he was appointed Knight Grand Cross of the Order of the Bath and, three years later, he became a member of the Privy Council in Ireland. He died on 7 June 1910. After the marriage of her daughter, Eileen, in the autumn of 1911, Lady Butler remained at Bansha alone.

The Boer War and the Edwardian Era 1899–1914

83. Lieutenant-General Sir William Butler KCB

Oil on canvas 91.4 × 71 1899

Insc: *18EB99*

Prov: By direct descent

Mr Rupert Butler

This equestrian portrait of the painter's husband, in his general officer's undress uniform, was engraved for the frontispiece to Sir William's autobiography, published posthumously in 1911 (Cat 130). The caption to the illustration notes that the painting was taken from a sketch made at the Cape in June 1899, which was shortly before he tendered his resignation as General Officer Commanding, South Africa. The portrait is conventionally posed, the tall, upright figure of Butler astride his large grey.

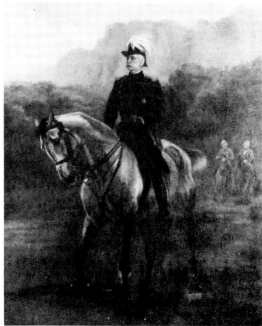

83

Elizabeth Butler exulted in the scenic beauty of the country, particularly in the unusual effects of light and colour upon the vegetation. The background to this painting shows a lush landscape with Table Mountain towering behind. The Butlers' house at Rosebank was overshadowed by the mountain, but it is possible that there is intentional symbolism in the way it is shown looming behind the general. The artist also thought the mountain appeared like an altar at night, when it was lit by the Milky Way. With this fancy, she reflected, 'Would that all the evil brought to South Africa by the finding of gold could be gathered together and burnt on that altar as a peace offering!'[1]

1. Elizabeth Butler *From Sketch-Book and Diary*, p 109

84. Manuscript letter to Sir William Butler, 1 November 1898

The Viscount Gormanston

Sir William's letter of appointment as 'Lieutenant-General on the Staff to Command the Troops in South Africa' is signed by Major-General Sir Coleridge Grove KCB, Military Secretary, The War Office.

85. "Change direction RIGHT!"

Pen-and-ink 21.5 × 34.5 c1900

Insc: *"Change direction RIGHT!" A Royal Horse Artillery gun team practising in the Long Valley, Aldershot, circa 1899/By my mother, Lady Butler (Action & speed). The gun is not shown./P.R.B.*

Prov: Lt-Col P R Butler. Presented to the National Army Museum in 1963

National Army Museum 6310-353-1

Following Sir William Butler's resignation from his South African appointment, he was given

'Change direction RIGHT!' A Royal Horse Artillery gun Team practising in the Long Valley, [illegible] By my mother Lady Butler (Action & spirit) The gun is not [illegible]

command of Western District at Devonport. In September 1900, at the request of Lord Wolseley, he took concurrent command of the garrison at Aldershot for five months during General Sir Redvers Buller's absence in South Africa. During this period Elizabeth Butler painted many watercolours, some of them of scenes from the Boer War, and this lively treatment of a gun team may have been sketched from life in Aldershot, as the artist's son suggested in his caption, prior to the unit's departure for the war. A similar pen and ink sketch of a galloping artillery battery, with gunners in khaki service dress, is reproduced in the artist's autobiography (p 284), entitled *Sketch for "The Relief"*, but a finished work of this title has not been traced.

86. "a Radical General"

Chromolithograph after 'Spy' (Sir Leslie Ward, 1851–1922) published in *The Vanity Fair Album*, 1907, p 1048, 32.5 × 20

National Army Museum 6112-439-7

This portrait of the painter's husband was published after Sir William's retirement from the Army, when he had just written a series of articles, later published as *From Naboth's Vineyard*[1], giving his views on the political situation in South Africa. At the time, Butler's stance in opposing the belligerent policy against the Boers had earned him the reputation of being a 'political' general and had

cost him the appointment as Quartermaster-General. The brief biography which accompanied the print found that the terrible cost of the Boer War had vindicated Butler's judgement and saw him as '. . . a great man thrown aside unused because he knew more than his superiors and the Government, and dared to tell the truth.' Officially, Butler had been exonerated by the findings of the Royal Commission appointed to investigate the conduct of the war, and to which he submitted testimony. Viscount Esher, one of the Commissioners, reported his personal assessment of Butler in a letter to King Edward VII;

> It is clear that he held strong military and political views of the situation then obtaining, which were not in accord with those of His Majesty's advisers, and Sir Wm. met the usual fate of those who give unpalatable advice. That much of his advice he gave has since proved correct, is not possibly of advantage to him in certain quarters. There is no doubt that he is among the ablest of Your Majesty's servants, and possesses an intellect capable of grasping large problems and of dealing with them in a practical manner.[2]

Vanity Fair, the leading society magazine of the age, had not always been so magnanimous to Butler. At the time of the Campbell divorce case in 1886 it had been one of those critics of his behaviour in refusing to stand in the witness box and had interpreted this as a tacit admission of guilt. It had judged that Butler's motives were to avoid being forced under oath to incriminate the lady or to perjure himself by falsely denying the charge.

1. Lt-Gen Sir W F Butler *From Naboth's Vineyard* Chapman and Hall, London 1906
2. McCourt, *op cit*, p 242

87. Yeomanry Scouts on the Veldt

Oil on canvas 99.7 × 138.7 1903

Insc: *19EB03*

Prov: Presented to Downside Abbey by the Reverend Urban Butler, the artist's son

Downside Abbey Trustees
Lent by kind permission of the Abbot of Downside

Despite the campaign of vilification against Sir William Butler that had arisen from a misunderstanding of his anti-war attitude, the Butlers

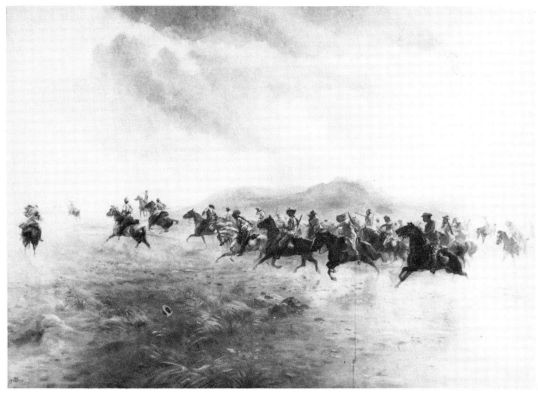

87.

129

shared a naturally patriotic concern for the British cause in the ensuing conflict. In depicting the war, however, Elizabeth avoided treating any scenes of combat and confined herself to the uncontroversial subjects of yeomanry and artillery in the field. This large canvas evokes the space of the open veldt in which the British had such difficulty locating the Boers.

The yeomanry of the day were not obliged to serve overseas, so when the regular army had to be increased to cope with the Boer commandos, they were invited to volunteer for service in South Africa. They were formed into battalions and companies of Imperial Yeomanry, emphasizing their role as mounted infantry rather than cavalry, and they were trained to emulate the Boer tactics of small, mobile groups of men who could ride and shoot well.

In its composition, the picture is similar to the Aldershot spectacle of the Scots Greys in "*Right Wheel!*" (Cat 81), but here the artist has been more concerned to convey the individuality of each horseman and the excitement of the moment when some Boers are sighted in the distance. Particular attention has been given to the atmospheric effects of light on the landscape and on the river which the yeomanry have just crossed.

Exhib: Leicester Galleries 1912 (2)

88. Within sound of the guns

Oil on canvas 66.7 × 87

Insc: *19 EB 03*

Prov: Presented to the Army Staff College by Lt-Col P R Butler in 1958

Army Staff College

Also known as *A Yeomanry Scout Galloping with Dispatches in the Boer War*, the picture shows the moment of danger as the despatch rider comes under fire from marksmen. In a later watercolour of a similar theme from the Great War, *The Yeoman's death in Palestine* (Cat 110), the despatch rider is seen at the moment he is shot by snipers.

This work was painted while Elizabeth Butler was living at Devonport, where her husband commanded the Western District. In her autobiography, she recorded that during June 1902, she was working constantly on this canvas in her studio and, 'There was much galloping and trotting of horses up and down in the Government House grounds for my studies of movement'. The autobiography reproduced a pen-and-ink sketch of the yeoman and his horse, entitled *Running the Gauntlet, Boer War* (p 284) and one of the artist's last works was another version, in watercolour (Cat 89).

The subject of an isolated horseman galloping across the veldt was a common theme in military depictions of the Boer War, for example William Barnes Wollen's *The Victoria Cross*, (R.A.1902, No 225) and Richard Caton Woodville's illustrations for H W Wilson's book, *After Pretoria : The Guerilla War* (Amalgamated Press Ltd, London 1902). However, Butler's work is the most confident, with richer colour and greater freedom in handling paint than that of her rivals; she admitted that '. . . I had greatly improved in tone by this time.' She also had the advantage of having recently returned from South Africa.

Despite the topical heroism of the subject, the drama of the foreshortened horse galloping towards the spectator and the vivid colours of the landscape, the painting was poorly reviewed when it appeared at the 1903 Royal Academy exhibition.

Exhib: R.A.1903 (412); Leicester Galleries 1912 (15)

Ref: *The Art Journal* 1903, p 175

89. Despatch Rider

Watercolour and pencil 39.7 × 39.4 1929

Insc: *19EB29*

Prov: By direct descent

The Hon Robert Preston

Painted when the artist was in her eighty-third year, this watercolour version of her 1903 Royal Academy exhibit, *Within sound of the guns* (Cat 88), is still very vivid. It combines a firm draughtsmanship in the handling of the horse and rider with a free but effective use of the brush, by which the light and the dust kicked up by the horse's hooves are carefully rendered.

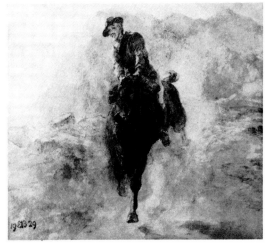

89

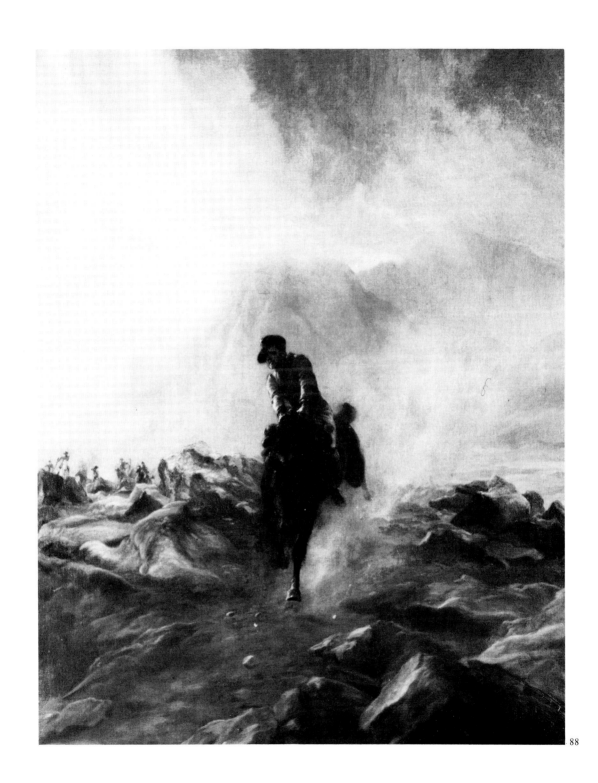

88

90. Rescue of wounded, Afghanistan

Oil on canvas 80 × 152.5 1905

Insc: *19EB05*

Prov: Presented to the Army Staff College by
Lt-Col P R Butler in 1958

Army Staff College

Although the subject of this canvas was not
identified by the painter, it probably represents the
gallant action at Maiwand, 18 July 1880, during
the Second Afghan War. The battle had been
previously treated by Richard Caton Woodville, in
his notable picture, *Maiwand: saving the guns* (Cat
137) and also by Godfrey Douglas Giles. Another
small oil painting of the last-minute evacuation of
the artillery was executed by James Prinsep Beadle
in 1893 (National Army Museum 7808–14). At
this battle, a British army of some 2,800 men was
surprised by a numerically superior Afghan force
and compelled to beat a retreat under covering fire
provided by a six-gun battery of the Royal Horse
Artillery. Eventually, 'C' Battery was forced to
limber up and cut its way out. Afghan cruelty to
prisoners was notorious and this rescue of woun-
ded gunners illustrated the courage of many men
who took great risks to prevent their comrades
falling into enemy hands.

As in Elizabeth Butler's paintings of the Boer
War, the figures are smaller in comparison to their
surroundings than in her earlier works. She was
not the only artist to find that this change of
emphasis was necessary to convey the vast African
landscape in which the actions were fought; (for
example, William Barnes Wollen's *Victoria Cross*
(R.A.1902, No 225) which depicts one mounted
soldier rescuing another whose horse has been shot
beneath him, or Georges Scott's *Buller's final
crossing of the Tugela* c1900, (National Army
Museum 6610–10) and she applied this change of
scale in depicting the landscape of Afghanistan.
She was delighted when the painting '. . . was given
an excellent place in the *Salle d'Honneur*' at the
Royal Academy, although it did not find a pur-
chaser.

Exhib: R.A.1905 (152); Leicester Galleries
1912 (13), *A Surprise by the Enemy,
Afghanistan*

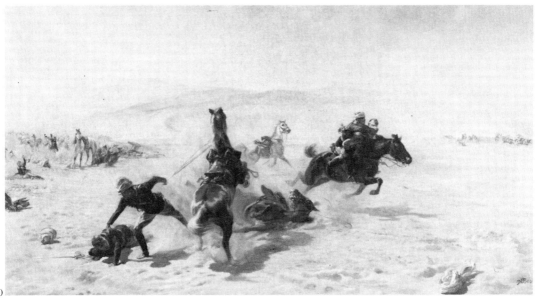

90

'FROM SKETCH-BOOK AND DIARY'

Following the success of her first book *Letters from the Holy Land* in 1903, Elizabeth Butler wrote this account of her experiences in other foreign lands, between her student days in Florence and her visit to Rome in 1906, and dedicated it to her sister, Alice Meynell (Cat 129). The book published in 1909, and divided into four sections entitled 'Ireland', 'Egypt', 'The Cape' and 'Italy', was based on her diaries, which remain untraced, and also on her letters to their mother, Christiana Thompson. It was illustrated by 28 colour plates of the artist's own watercolours, and a number of pen and ink drawings which provided head- and tailpieces to each chapter within the four main sections. For illustrations of the chapters on Egypt, covering the artist's trip up the Nile in 1886 and her visits to Alexandria between 1890 and 1893, see Cat 50 to 52 and Cat 65 to 71.

From Sketch-Book and Diary

91. Off to the Paarl!

Pen-and-ink 15.2 × 22.9 1899

Insc: *EB/Off to the Paarl!/Head piece "Cape No.3 Chap II"*

Prov: By direct descent

Mrs Marie Kingscote Scott

This drawing records a trip that the painter made during her short stay at the Cape in 1899 when, accompanied by her husband, children and some friends, she travelled to Stellenbosch, where '. . . I saw a long sort of char-à-banc driven at a hand gallop into the station yard, drawn by three mules and three horses – the vehicle ordered by W. [William Butler] to convey us to the *Paarl*.'[1] The party spent a delightful day amongst the exotic flora and fauna that abounded on the slopes of the Paarl, the Boer name for 'the Pearl', a high, double-peaked mountain to the north-east of Cape Town.

1. Elizabeth Butler *From Sketch-Book and Diary*, p 118, illus. p 105

92. A Corner of Our Garden at Rosebank

Watercolour, 8¾ × 12¼ in, 22.2 × 31 cm, 1899

Insc: *1899/EB*

Prov: By direct descent

Private collection

Lady Butler arrived at the Cape in March 1899, little realising at the time that she would leave the country before the end of August, under the cloud of her husband's resignation. In *From Sketch-Book and Diary*, her recollections of those months, although tinged with sadness, reflect the wonder that she felt at the beauty of the country, as well as her distaste for the ugliness which she felt English colonial rule had brought to it. The Butlers' house at Rosebank was separated from the eyesore of Cape Town by Table Mountain, which towered

91

92

over their garden, and here, the artist was free to capture in paint ' . . . the effects of light and colour on these landscapes that I never saw elsewhere.'[1]

1. Elizabeth Butler *From Sketch-Book and Diary*, p 108, illus. Pl 19

93. Bersaglieri at the Fountain, Perugia

Watercolour 25 × 35

Prov: By descent from Mrs Gertrude Sweetman

Mrs Hester Whitlock Blundell

During a short tour of Italy in the spring of 1900, accompanied by her eldest daughter, Elizabeth

Butler came upon the sight which must have compelled her to instantly commit it to paper. This view of Italian troops at the Pisanos' fountain, Perugia (1278) was reproduced in her book, *From Sketch-Book and Diary* (Cat 129), accompanied by the following description from her diary for 23 April 1900;

> . . . we saw the fountain suddenly surrounded by an eruption of Bersaglieri, who woke the echoes of that erst-while silent Piazza with their songs and chaff. They were on manoeuvres and were halting here for the day. Shedding heavy hats and knapsacks, they had run down to fill their canteens and waterbarrels. *Toujours gais* are the Bersaglieri, and a very pretty sight it was to see those good-looking healthy lads in their red fatigue fezes unbending in this picturesque manner.[1]

> Exhib: Leicester Galleries 1912 (37), *On the Italian Manoeuvres: Bersaglieri at Niccola Pisano's Fountain, Perugia*

1. Elizabeth Butler *From Sketch-Book and Diary*, p 155, Pl 25

94. Bringing in the Grapes

Watercolour 58.5 × 43.2 1905

Insc: *19EB05*

Prov: By direct descent

Mrs Marie Kingscote Scott

Elizabeth Butler exclaimed in *From Sketch-Book and Diary* 'How we English do love Italy!'.[1] She visited the country many times in her life, between the 1850s with her childhood winters in Genoa, and the last recorded journey in 1911, to Rome, to witness her son Richard's ordination to the priesthood in the Church of St John Lateran. The chapter of the book, headed 'Vintage-time in Tuscany' and addressed to her sister, Alice, is a series of reminiscences of their experiences of Tuscany in the summer of 1869 and of the vintages the two sisters enjoyed while staying at the Marchese della Stufa's villa near Castagnolo in 1875 and 1876. Although painted in 1905, this watercolour appears as an illustration to these memories, which the painter summed up with the words;

135

95

To recall the happy labour of those precious three days of grape-picking in the mellow heat on the hillside, and then the all-pervading fumes of fermenting wine of the succeeding period in the *Fattoria* [farm]; the dull red hue of the crushed grapes that dyes all things, animate and inanimate, within the sphere of work, is one of the most grateful efforts of my memory.[2]

1. Elizabeth Butler *From Sketch-Book and Diary*, p 125
2. *Ibid*, p 126, illus. Pl 22

95. The Quirinal Palace, Rome

Watercolour 17.8 × 25.4 1906

Insc: *EB/1906*

Prov: By direct descent

Mrs Marie Kingscote Scott

This view of the *Quirinale*, the magnificent palace in Rome which had been in turn the residence of popes and of the kings and presidents of Italy, was executed in 1906, when the artist and her younger daughter, Eileen, joined her sister Alice there. Sir William Butler was in South Africa, following the commissioning of a series of articles by the London

Tribune on the state of the Transvaal under British rule.[1]

Although the watercolour does not appear as an illustration to *From Sketch-Book and Diary*, it relates to the last chapter of the book describing the visit to the city, which, in the artist's eyes, was the cultural centre of the world. Curiously, the highlight of that vacation for Elizabeth Butler was omitted from this reminiscence, but in her autobiography she related that she enjoyed the privilege of receiving Holy Communion from Pope Pius X, at a private Easter Mass in the Sistine Chapel.

1. Lt-Gen Sir W F Butler *From Naboth's Vineyard* Chapman and Hall, London, 1906

96. Croagh Patrick, Clew Bay

Watercolour, 12½ × 19¼ ins, 31.7 × 49cm 1905

Insc: *EB*

Prov: By direct descent

Private collection

Just before Sir William's retirement in 1905, the Butlers took a summer vacation in Co. Mayo, Ireland, staying in Mulranny, which looks across the bay to Croagh Patrick. The mountain takes its name from the Irish saint who is supposed to have cast out all the snakes in Ireland from this spot. Elizabeth found the clean air and unspoilt scenery charming, and she wrote;

> To me Ireland is very appealing although I owe her a grudge for being so tantalizing and evasive for a painter. The low clouds of her skies cause such rapid changes of sun and shadow over her landscapes that it requires feats of technical agility to catch them on the wing beyond my landscape powers.[1]

136

96

Perhaps for this reason she painted Croagh Patrick several times, and two illustrations of the mountain appear in *From Sketch-Book and Diary*. One of these, entitled *Clew Bay, Co. Mayo* (Plate 5), was painted virtually on the same spot that this tranquil view was taken, although it shows the mountain peak bathed in pink light and the sea reflecting the early evening sky.

1. Elizabeth Butler *From Sketch-Book and Diary*, p 25 (see also Pls 4 & 5)

97. "A Request". Sir William Butler's obituary poem

Manuscript in pen-and-ink, dated 2 June 1904

Prov: By direct descent

The Viscount Gormanston

Sir William Butler died of heart failure on 7 June 1910, aged 71. His younger daughter, Eileen, transcribed the final version of his poem in her own memoirs and described the funeral;

> The remote little country cemetery of Killadrigh, the burial place of the Butlers since the sixteenth century, lies near the banks of the river Suir and at the foot of the Galtee mountains. Here, on a serene summer morning, my father was laid to rest with full military honours. So narrow in parts were the lanes, or 'boreens', through which the gun-carriage passed on its two-mile journey from the parish church that the meadowsweet which tufted their hedges brushed the sides of the coffin. The rear of the long cortège, headed by officers of high rank, was composed of a straggling line of peasants, many of them barefooted.

Thus were provided, in strangely minute detail, all the things for which my father had pleaded many years before, in a little poem found among his papers after his death, entitled 'A Request'.

Give me but six-foot-three (one inch to spare)
Of Irish earth, and dig it anywhere;
And for my poor soul say an Irish prayer
 Above the spot.

Let it be hill where cloud and mountains meet,
Or vale where grows the tufted meadow-sweet,
Or 'boreen' trod by peasants' shoeless feet:
 It matters not.

I loved them all – the vale, the hill,
The moaning sea, the water-lillied rill,
The yellow gorse, the lake-shore lone and still,
 The wild birds' song.

But more than hill or valley, bird or moor,
More than the green fields of the river Suir,
I loved those hapless ones, the Irish poor,
 All my life long.

Little did I for them in outward deed,
And yet be unto them of praise the meed
For the stiff fight I waged 'gainst lust and greed:
 I learned it there.

So give me an Irish grave, 'mid Irish air,
With Irish grass above it – anywhere;
And let some Irish peasant say a prayer
 For my soul's care.[1]

1. Eileen Gormanston *A Little Kept* Sheed and Ward, London and New York, 1953, pp 37–8

5. The Great War and Late Works 1914–1933

At the outbreak of hostilities in August 1914 Lady Butler was 67 years old, but despite her age, her output increased during the course of the Great War. After celebrating the centenary of Waterloo with an exhibition, she put aside historical works to depict subjects from the various contemporary campaigns. She was convinced of the justice of the allied cause and proud that her two elder sons served their country, one as an infantry officer and the other as a chaplain, although appalled at the enormous cost in human lives. On 22 September 1914, she travelled to Southampton to see her eldest son, Patrick, who was with the troops of the 7th Division assembling in the New Forest. As an artist, Elizabeth Butler also used this opportunity to study the modern Army 'under war conditions'. Her diary entry on that day provides a record of her feelings;

> . . . this most eventful time, when the biggest war the world has ever been stricken with is raging. To think that I have lived to see it! It was always said a war would be too terrible now to run the risk of, and that nations would fear too much to hazard such a peril. Lo! here we are pouring soldiers into the great jaws of death in hundreds of thousands, and sending poor human flesh and blood to face the new 'scientific' warfare . . .

In sketching the troops she perceived a difference in the men, their seriousness when confronting the prospect of death, compared to her Aldershot impressions of the 1890s. Realising the enormity of this war, she was moved to exclaim, 'Who will look at my "Waterloos" now?' But whilst noting that ' . . . the gallant plumage, the glinting gold and silver, have given way to universal grimness', she added, 'why dress up grim war in all that splendour? My idea of war subjects has always been anti-sparkle.'

Even so, Elizabeth Butler's pictures do not convey what is now understood to have been the 'universal grimness' of the Great War. She was precluded by her sex and years from joining those Official War Artists who witnessed the war at first hand. Although to a great extent the press shielded the public from the harsh realities, with the appearance of the film of the first battle of the Somme in cinemas throughout Britain in August 1916, the true nature of the conflict was becoming evident to the public at home. Nevertheless, during the war, Butler's work eschewed such horrifying spectacles. Even though she still avoided any glorification of war, her view of the individual soldier on the contemporary battlefield

Fig. 14 Photograph of Lady Butler with her eldest son, Patrick, in the New Forest, October 1914. Mr Rupert Butler

was different in character to the visions of courageous suffering typical of her earlier work. She may even have felt that to dwell on such things would be unpatriotic. With the exception of "*In the retreat from Mons: the royal horse guards*" (fig 15), painted in 1920, and *A Detachment of Cavalry in Flanders* of 1929 (Cat 115) she presented an anodyne vision of the conflict: courageous cavalry charges in Palestine, scenes of heroism in broad landscapes adapted from her Boer War depictions and full-length portraits of Victoria Cross winners. Indeed, it might be said that *The Roll Call* of 40 years earlier, is closer in spirit than these works to the grim image of the Western Front as revealed by photographs and the work of the new generation of war artists. Whereas she had been one of the first artists to depict war with a grim realism in the 1870s, Lady Butler's Great War paintings were the emotional antithesis of her early work. In comparison with the productions of the contemporary war artists such as Christopher Nevinson, Eric Kennington, Paul Nash and Stanley Spencer, they were also stylistically outmoded. Butler's pictures were now more in keeping with the popular patriotism of the home-based graphic arts, as typified by recruiting posters.

From 1913, Elizabeth Butler was engaged in preparing for a 'Waterloo Centenary Exhibition', mounted at the Leicester Galleries in 1915. The exhibition enjoyed the patronage of Queen Mary, since the proceeds were donated by the artist to the 'Officers' Families Fund'. The centrepiece, *Scotland for Ever!*, lent by Leeds City Art Gallery, was shown beside a new oil painting, *On the Morning of Waterloo. The Cuirassier's Last Reveille* (untraced), with 24 watercolours commemorating the great battle. In 1917, she exhibited 22 watercolours in her first 'khaki' show at the same gallery, entitled 'Some Glimpses of the Great War', prefacing the catalogue with a justification for painting war pictures. Using the same metaphor as in the autobiographical account of her visit to Waterloo in 1865, she argued that as war brings out both the basest and noblest attributes of man, the artist should concentrate on the higher virtues to be seen, like the summits of the Alps, in the distance, rather than focusing on the evil perceived close at hand in the foothills. She concluded by asking, 'May not the sensitive painter, who shrinks from too near an approach, share, after all, the truer insight?' Another exhibition, 'Some Records of the World War', which also included several earlier watercolours used to illustrate her travel books among its 27 pictures, was held at the Leicester Galleries in 1919.

After the Armistice Lady Butler continued to live at Bansha Castle, Co. Tipperary, but in 1922, when the house was sequestered by Republicans, she departed indignantly, leaving all her belongings, and went to live with her younger daughter, Eileen, Viscountess Gormanston, at Gormanston Castle in Co. Meath. Among those items which were later recovered from Bansha by her eldest son were three large oil paintings, including *The Camel Corps*, and a number of watercolours. Though frail and very deaf, Elizabeth Butler continued to work throughout the 1920s, often painting versions of her earlier pictures. Her last oils were of Great War subjects, a second version of "*In the retreat from Mons: the royal horse guards*" (Cat

114), and an untitled work, now called *A Detachment of Cavalry in Flanders*. The latter was finished in 1929, when the artist was in her 83rd year. Elizabeth Butler died at Gormanston Castle on 2 October 1933 and was buried at the nearby village of Stamullen. Her obituary in *The Times* included a quotation summing up her attitude to her subject matter; 'Thank God, I never painted for the glory of war, but to portray its pathos and heroism. If I had seen ever a corner of a real battlefield, I could never have painted another war picture'.[1]

1. *The Times* 4 Oct 1933

The Great War and Late Works 1914–1933

98. Patrick, Au Revoir!

Watercolour over pencil 15 × 10.2 1914

Insc: *EB/Lyndhurst/5 Oct. / 14/Patrick/Au Revoir!*

Prov: By direct descent

Mr Rupert Butler

Sketched on the day that Elizabeth Butler's eldest son departed for Belgium as aide-de-camp to General Thompson Capper, commanding the 7th Division, this small watercolour was a memento of him. Patrick was severely wounded on 2 November, during the first battle of Ypres, and was invalided home shortly afterwards. He later wrote an account of his experiences in Flanders, *A Galloper at Ypres* (T Fisher Unwin Ltd, London, 1920), for which Lady Butler supplied the frontispiece illustration (Cat 131).

Patrick Butler began his army career in 1902, when he joined the Royal Irish Regiment. As a second lieutenant he saw service in the Boer War and by 1909 had reached the rank of captain. After his convalescence in 1914, he rejoined his regiment to the west of Ypres and later served with it in Macedonia and Palestine, which may have been an influence on his mother, as she turned to the Middle East for subject matter in 1917. He rose to the rank of lieutenant-colonel and died in 1967, aged 87.

98

99. Kettledrummer, 18th Hussars

Watercolour over pencil 33 × 22.5 1914

Insc: *EB/1914*

Prov: By family descent from Mrs Lucy Hamilton Evans, whose name appears on a label on the back of the frame

Private Collection

From 1913, Elizabeth Butler was engaged in preparing works for her 'Waterloo Centenary' exhibition held at the Leicester Galleries, all of works showing scenes from the battle or depicting contemporary uniform. It was not until this was opened in May 1915 that she turned to painting scenes from the Great War. However, the inaccuracy of the dress demonstrates the difficulties which she encountered in depicting historical subjects. Kettledrummers of the Napoleonic period were seldom illustrated, but this figure appears to have been based on Plate 12 of Colonel Charles Hamilton Smith's *Costume of the Army of the British Empire* (1812–15), with the addition of a pelisse slung on the left shoulder, trimmed with black fur

99

have drawn any of them from life, portrait photographs of these men appeared in the newspapers of the time. Other watercolours depict a soldier of the 1st Battalion, the Lancashire Fusiliers, who won the supreme award for valour at Gallipoli (Cat 102), Drum-Major Walter Ritchie of the Seaforth Highlanders (Cat 103), A *"V.C." of the Welsh Fusiliers* (CSM Frederick Barter, VC, in the Royal Welch Fusiliers Museum, Caernarfon Castle) and also, possibly, one of the East Kent Regiment (the Buffs), (Cat 111) and one of the Black Watch (Major J L R Samson).[1]

On 1 February 1915, Lance-Corporal O'Leary (1890–1961) took part in the attack at Cuinchy, near Ypres. His citation read;

> When forming one of the storming party which advanced against the enemy's barricades he rushed to the front and himself killed five Germans who were holding the first barricade, after which he attacked a second barricade, about 60 yards further on, which he captured, after killing three of the enemy and making prisoners of two more. Lance-corporal O'Leary thus practically captured the enemy's position by himself, and prevented the rest of the attacking party from being fired upon.[2]

O'Leary was immediately promoted to sergeant, and in the summer of 1915 received a rapturous welcome in London and on leave in Ireland. After

rather than white. Another discrepancy is the red shabraque or saddlecloth which should have been blue (see also below, pp 177–9).

Described in the Leicester Galleries exhibition list as a sketch, this is a fine example of Elizabeth Butler's adept watercolour technique.

Exhib: Leicester Galleries 1915 (4)

100. Invitation card to the Waterloo Centenary Exhibition, Leicester Galleries, 1915

The Viscount Gormanston

101. A "V.C." of the Irish Guards

Watercolour 58.8 × 43.5 1915

Insc: *EB/1915*

1st Battalion Irish Guards

Lance-Corporal Michael O'Leary, 1st Battalion, Irish Guards, was the first subject in a small series of Victoria Cross winners which Lady Butler painted during the Great War. Although she could not

101

143

the war, he joined the Ontario Province Police in Canada. He re-enlisted with the British Army in the Second World War and served with the Middlesex Regiment, then with the Pioneer Corps.[3]

Exhib: Leicester Galleries 1917 (8)

1. Reproduced on the front cover of Major J L R Samson, FSA Scot *A Short History of the Black Watch and its Movements* Samson Books Ltd, Salisbury, 1984. This is Lady Butler's only recorded painting of the Black Watch during the Great War and, at the Leicester Galleries exhibition in 1917, its title was given as *"The Black Watch" on Aubers Ridge, May 1915*. The format of a single figure, set in a landscape of war conforms to that of the identified VC winners' portraits. As two soldiers of the regiment won the Victoria Cross for their part in the assault on German machine-gun emplacements near Aubers Ridge on that day, it seems likely that this watercolour depicts either Corporal John Ripley of the 1st Battalion or Lance-Corporal David Finlay, 2nd Battalion, the Black Watch.
2. *The London Gazette* 18 Feb 1915
3. *The Times* 3 Aug 1961

102. A "V.C." of the Lancashire Fusiliers

Watercolour 56.5 × 41.3 1915

Insc: *EB/1915*

Regimental Museum XXth The Lancashire Fusiliers, Bury

102

At Gallipoli on 25 April 1915, the 1st Battalion, Lancashire Fusiliers '... won 6 V.C.'s before breakfast'.[1] This watercolour commemorates one of the men who received the award and may be intended as a portrait of William Kenneally, the only private soldier among them, who was killed two months later on 26 June.

General Sir Ian Hamilton's first despatch after the action, stated that;

So strong ... were the defences of 'W' Beach that the Turks may well have considered them impregnable, and it is my firm conviction that no finer feat of arms has ever been achieved by the British soldier – or any other soldier – than the storming of these trenches from open boats on the morning of 25 April. The landing at 'W' had been entrusted to the 1st Battn. Lancashire Fusiliers (Major Bishop), and it was to the complete lack of the senses of danger or of fear of this daring battalion that we owed our astonishing success ... While the troops were approaching the shore no shot had been fired from the enemy's trenches, but as soon as the first boat touched the ground a hurricane of lead swept over the battalion. Gallantly led by their officers, the Fusiliers literally hurled

themselves ashore, and, fired at from right, left and centre, commenced hacking their way through the wire. A long line of men was at once mown down as by a scythe, but the remainder were not to be denied. Covered by the fire of the warships, which had now closed right in to the shore, helped by a flanking fire of the company on the extreme left, they broke through the entanglements and collected under the cliffs on either side of the beach. Here the companies were rapidly re-formed, and set forth to storm the enemy's entrenchments wherever they could find them.[2]

Exhib: Leicester Galleries 1917 (10)

1. Maj-Gen G Surtees CB CBE MC *A Short History of XX the Lancashire Fusiliers* Malcolm Page Ltd, London, 1955, p 67; see also Maj-Gen J C Latter CBE MC *The History of the Lancashire Fusiliers 1914–18* Gale and Polden, Aldershot, 1949.
2. Sir O'Moore Creagh and E M Humphris *The V.C. and D.S.O.* Standard Art Book Co Ltd, London, c1920, Vol 1, p 187

103

103. A "V.C." of the Seaforths

Watercolour over pencil 58.2 × 43.7 1916

Insc: *EB/1916*

Russell-Cotes Museum, Bournemouth, on
loan to the National Army Museum
6109-14

Another of Lady Butler's freely-painted portraits of
a Victoria Cross winner, this depicts Drummer
Walter Ritchie (1892–1965), 2nd Battalion,
Seaforth Highlanders. Ritchie, a Glaswegian, won
the award for his actions near Beaumont Hamel, on
the first day of the Somme, 1 July 1916. *The
London Gazette* reported that Ritchie was;

> Awarded the V.C. for most conspicuous
> bravery and resource when, on his own
> initiative, he stood on the parapet trench,
> and, under heavy machine gun fire and bomb
> attacks, repeatedly sounded the 'Charge',
> thereby rallying men of various Units, who,
> having lost their leaders, were wavering and
> beginning to retire. This action shows the
> highest type of courage and personal initia-
> tive. Throughout the day Drummer Ritchie
> carried messages over fire-swept ground
> shewing the greatest devotion to duty.[1]

Although drummers and buglers were not
employed in their usual capacity in the early part of
the war, Ritchie, in common with the other drum-
mers of his battalion, always carried his bugle on
duty. The bugle on which he sounded the charge is
now in the Queen's Own Highlanders Museum,
Fort George, Inverness-shire. During the Great War
Ritchie was wounded twice and gassed twice. On
5 July 1921, he joined the first battalion of his
regiment, was promoted to sergeant and appointed
drum-major of the battalion. He retired from the
army in 1929, after 21 years' service.[2]

Exhib: Leicester Galleries 1917 (6)

1. *The London Gazette* 9 Sept 1916
2. *Cabar Feidh. The Quarterly Magazine of the Seaforth
 Highlanders* Dec 1929, p 424

104. The London Irish at Loos

Watercolour 30.5 × 25.5 1916

Insc: *EB/1916*

Trustees of the London Irish Rifles

According to the regimental history, the football
team of the 1st Battalion, 18th (County of London)
Battalion The London Regiment (London Irish
Rifles), kicked a football across No Man's Land at
the battle of Loos on 25 September 1915.[1] By this
means they led the assault, and the ball found its
way into the German front line. It was later recov-

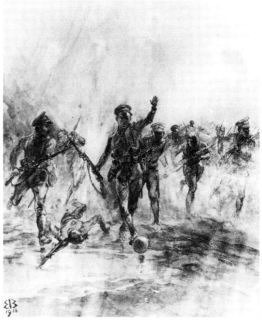

104

145

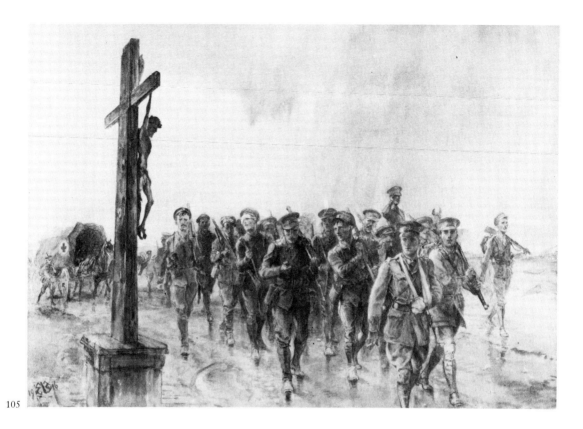

105

ered and is now in the Regimental Museum. This feat was repeated on other occasions during the war.[2] A painting by Richard Caton Woodville, of the East Surrey Regiment kicking a football at Montauban Ridge on the first day of the first battle of the Somme, is in the regimental museum at Canterbury.

This freely-handled watercolour is a good example of the way in which Lady Butler avoided the unpleasant aspects of warfare on the Western Front and strove instead to portray the courage and humour of soldiers in the face of adversity.

Exhib: Leicester Galleries 1917 (21)

1. Lt-Col M F P M Corbally *London Irish Rifles 1859–1959* (no imprint), p 31
2. Paul Fussell *The Great War and Modern Memory* Oxford University Press, New York and London, 1975, pp 27–8

105. "Eyes Right!"

Watercolour over pencil 41 × 58 1916

Insc: *19EB16*

Prov: Purchased from the Leicester Galleries by the Rev E P Gatty, 1917

Lent by the kind permission of the Parish Priest of St Osmund's, Barnes, the Rt Rev Mgr D P Wall

This painting of a column of British infantry and a horse-drawn ambulance passing a roadside calvary depicts men returning from the front. The absence of steel helmets suggests that this is a scene from 1915 or early 1916. As with *Balaclava* (Cat 25) and *The Return from Inkerman* (Cat 26), this picture shows exhausted troops withdrawing from the field of conflict, but on this occasion, the soldiers receive comfort from the image of the crucified Christ. Lady Butler was a devout Catholic who would have intended this scene as a reminder of Christ's suffering and the heavenly reward awaiting those who also selflessly sacrificed themselves. Calvaries were a common sight at French and Belgian crossroads, which were frequently named 'Crucifix Corner'.

The watercolour was reproduced as a photogravure and published by George Pulman & Sons Ltd and the Leicester Galleries c1917.

Exhib: Leicester Galleries 1917 (16)

146

107

was commanded by Captain Francis N Blundell, father of the owner, and the nephew of Mrs Gertrude Sweetman, a close friend of the artist (see Cat 80). The printed card was inscribed 'D Squadron, Lancashire Hussars Yeomanry/British Expeditionary Force/Christmas, 1916./A Merry Christmas/and/A Happy New Year.' At the time the unit was serving in France, enduring the coldest winter there for over 30 years.

Exhib: Leicester Galleries 1917 (20), *Scout, Lancashire Hussars*

106. "Action Front!!"

Manuscript letter of 9 October 1916, with printed letterhead 1915

Insc: *EB/1915*

Collection of Hermia Eden, Catherine Eden and Elizabeth Hawkins

During the Great War, Lady Butler had some stationery printed with a design based on her own pen and ink drawing of a galloping Royal Horse Artillery gun team. This example was sent as a letter to Alice Meynell, on the occasion of the artist's sister's 69th birthday. It includes a report of Elizabeth's progress on *"The Dorset Yeoman at Agagia 26th Feb. 1916"* (Cat 108).

107. Trooper of the Lancashire Hussars Yeomanry

Pen-and-ink 22.8 × 38.1 cm 1916

Insc: *EB/1916*

Mrs Hester Whitlock Blundell

This spirited pen-and-ink drawing of a trooper of the Lancashire Hussars was reproduced as a greetings card by D Squadron in 1916. The squadron

108. "The Dorset Yeoman at Agagia, 26th Feb. 1916"[1]

Oil on canvas 97.8 × 185.5 1917

Insc: *Eliz.th Butler/1917*

Prov: Commissioned by Col J R P Gooden, Honorary Colonel of the Dorset Yeomanry and Chairman of Dorset County Council on behalf of 110 subscribers. Presented to Dorset County Council by the Rt Hon Viscount Portman on their behalf.

Dorset County Council

The picture illustrates the action at Agagia in the Libyan Desert which ended the threat of attack on Egypt by the Turkish-backed Senussi tribe. Three squadrons of Dorset Yeomanry, totalling about 180 men, succeeded in cutting off the enemy rearguard by galloping across open sand for about two-thirds of a mile under direct fire from machine guns. As the yeomanry reached the tribesmen, the fire became more erratic and the Senussi broke and ran. In the ensuing melée, their leader, Gaafar (or Ja'far), surrendered to Lt J H Blaksley, who com-

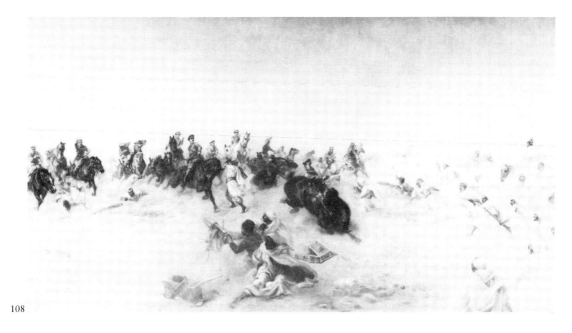

mented, 'The whole thing was a marvellous instance of the awful terror inspired by galloping horses and steel'.[2]

This painting is unusual in Lady Butler's *oeuvre* in depicting a greater number of the enemy, including the Turkish officers handling the machine guns, than the charging British cavalry. The artist found that the flowing burnouses of the Senussi enhanced the overall sense of movement. She was able to refer to studies of these 'picturesque fellows' made during her visits to Egypt in 1885 or the early 1890s.[3] In her autobiography, Butler related that all the officers were portraits, despite the fact that 'Their own mothers would not know the men in the heat, dust, and excitement of a charge . . .'. She felt that she had succeeded in bringing into the painting as many of them as she could without breaking the 'distance' regulation. By this, she was referring to the disposition of the cavalry, who went into action in two lines, each man of the front rank being eight yards apart, while those of the second rank were spaced at intervals of four yards.

Exhib: R.A.1917 (652); Leicester Galleries 1919 (7)

1. *Royal Academy Exhibitors 1905–1970* E P Publishing Ltd, London, 1973, Vol I, p 249, incorrectly lists the title date as 1915.
2. C W Thompson *Records of the Dorset Yeomanry 1914–1919* F Bennett & Co, Sherborne, 1921
3. MS letter to Alice Meynell, 9 Oct 1916; Collection of Hermia Eden, Catherine Eden and Elizabeth Hawkins

109. The Charge of the Warwickshire and Worcestershire Yeomanry at Huj, 8th November 1917

Watercolour with white bodycolour 45.7 × 88.9 1918

Insc: *EB/1918*

Prov: Presented by Warwick Town Council to Warwickshire Yeomanry Trust

Warwickshire Yeomanry Trust

The charge at Huj on 8 November 1917, one of the last cavalry actions in British military history, took place during the closing stages of General Sir Edmund Allenby's Palestinian Campaign. The advance on Jerusalem, by the allied Egyptian Expeditionary Force, was halted by the rearguard action of the retreating Turkish 8th Army, covering their headquarters at Huj. In the absence of supporting artillery, several squadrons of the Warwickshire Yeomanry and the Queen's Own Worcestershire Hussars, numbering about 190, were ordered to take the enemy batteries. The attack on the horseshoe-shaped area, overlooked by artillery on three sides and reminiscent of the charge of the Light Brigade, included a charge on the main enemy position held by four 75mm guns. The yeomanry suffered appalling losses from the guns which continued to fire until the cavalry were upon them, but, unlike the Balaclava charge and, against the odds, the attack was successful. With their artillery on the remaining flanks silenced, the

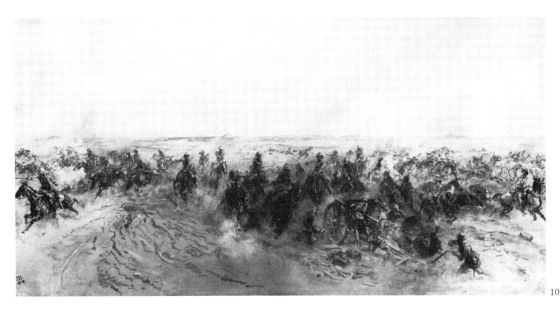

109

1,000 strong Turkish infantry fled. The Official History commented, ' ... for sheer bravery the episode remains unmatched ... The charge itself must ever remain a monument to extreme resolution, and to that spirit of self-sacrifice which is the only beauty redeeming ugly war.'[1]

For this picture, Lady Butler was fortunate in being able to consult an eyewitness, Col the Hon Richard Preston, her daughter Eileen's brother-in-law.[2] He gave her precise details about the ground plans, weather conditions and the terrain, which was described by the Worcesters' Medical Officer, Captain O Teichmann, RAMC, as ' ... very like Salisbury Plain except for the absence of vegetation.'[3] She approved of the favourable comparison that had been drawn between the charge at Huj and that of 'The Gallant Six Hundred' in the Crimea, but the most significant aspect

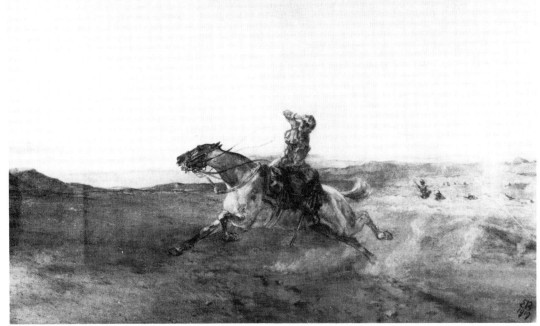

110

149

of all was that it ' . . . had opened the gates of the Holy City to us.' Her personal title for the picture was 'Jerusalem delivered'.

Exhib: Leicester Galleries 1919 (13)

1. Capt Cyril Falls *History of the Great War . . . Military Operations, Egypt & Palestine from June 1917 to the end of the war* Part 1, HMSO, London, 1930, pp 122–3. See also; The Hon H A Adderley *The Warwickshire Yeomanry in the Great War* 1922, pp 124–42; J M Brereton 'Cold Steel at Huj', *Blackwoods Magazine* March 1977
2. Preston was later to publish his own account of the campaign; Lt-Col the Hon R M P Preston *The Desert Mounted Corps. An account of the Cavalry Operations in Palestine and Syria* Constable & Co Ltd, London, 1921.
3. Brereton, *op cit*, p 187

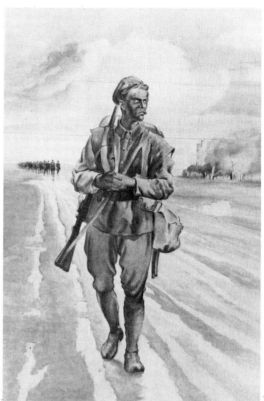

111

110. With despatches: the Yeoman's death in Palestine

Watercolour 37 × 58.3 1919

Insc: *EB/1919*

Prov: By direct descent

The Viscount Gormanston

Unlike the despatch rider in South Africa (Cat 89), this yeomanry trooper does not escape the enemy's bullets. It appears that the artist felt less constrained from painting morbid subjects once the war was over.

Lady Butler was intensely interested in the campaign in Palestine, for not only did her son Patrick fight there in the autumn of 1917 with his regiment, the Royal Irish Regiment, but it also bore the significance of a crusade for her. In her diary entry for 11 December 1917, she wrote, 'Today our army is to make its formal entry into Jerusalem. I can scarcely write for excitement. How vividly I see it all, knowing every yard of that holy ground!' She was able to refer to the sketches made on her tour of the country in 1891 for the colour and contours of the desert landscape.

Exhib: Leicester Galleries 1919 (27)

111. A Man of Kent

Watercolour 83.9 × 59.7 1919

Insc: *EB/1919*

The Queen's Regiment, Canterbury

Exhibited at the National Army Museum only

Despite the original exhibition title, *1914. A Man of Kent ("the Buffs")*, this watercolour of a soldier of the East Kent Regiment may have been intended as the final work in the series of Victoria Cross winners; as it is in much the same format as the identified portraits. If so, it would depict Lance-Corporal William Cotter, 6th Battalion, who was awarded the decoration for conspicuous bravery on 6 March 1916 near the Hohenzollern Redoubt, south of Givenchy. His citation read;

> When his right leg had been blown off at the knee, and he had also been wounded in both arms, he made his way unaided for 50 yards to a crater, steadied the men who were holding it, controlled their fire, issued orders, and altered the dispositions of his men to meet a fresh counter-attack by the enemy. For two hours he held his position, and only allowed his wounds to be roughly dressed when the attack had quieted down. He could not be moved back for 14 hours, and during all this time had a cheery word for all who passed him. There is no doubt that his magnificent courage helped greatly to save a critical situation.[1]

Exhib: Leicester Galleries 1919 (18), *1914. A Man of Kent ("The Buffs")*

1. *The London Gazette* 30 March 1916

150

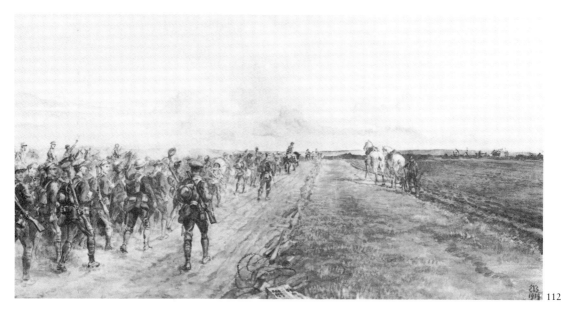

112

112. Back to his Land

> Watercolour 31.9 × 59 1919
>
> Insc: *EB/1919*
>
> Prov: Marcus S Bles Bequest 1932
>
> Manchester City Art Galleries

As a column of British troops march home across the flat landscape of northern France or Belgium at the end of the war, they cheer a ploughman who has already returned to his peacetime occupation.

> Exhib: Leicester Galleries 1919 (19)

113. Sailor

> Watercolour 70 × 49.7 1919
>
> Insc: *EB/1919*
>
> Prov: By direct descent
>
> Mr Antony Preston

It is understood by the owner that this was a design for a poster, although a printed version has not been traced. The sailor has the appropriate air of strength and dignity, but the arrangement of the guns and the foreshortened boat lying in the davits on the ship's deck are quite inaccurate.

> Exhib: Leicester Galleries 1919 (22), *An English Blue-jacket*

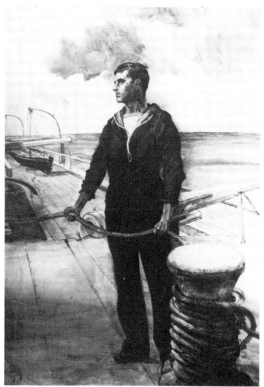

113

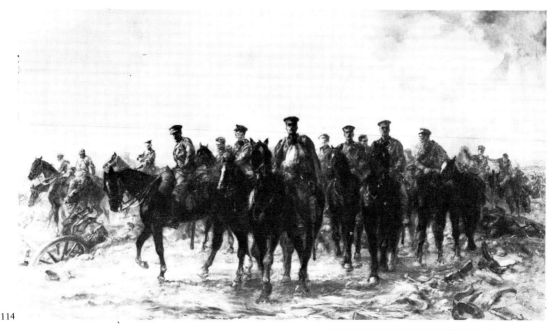

114

114. "In the retreat from Mons: the royal horse guards"

Oil on canvas 61 × 96.5 1927

Insc: *EB/1927*

Prov: Presented by Lt-Col P R Butler to the
Royal Hospital, Chelsea in 1949

Commissioners, Royal Hospital, Chelsea

Lady Butler exhibited at the Royal Academy for the
last time in 1920, (No 587). Entered in the
catalogue as *"In the retreat from Mons: the royal
horse guards"*, it is a sombre picture of a squadron
of that regiment, riding along a wet road, during
the retreat of 23 August–5 September 1914 (fig
15). This unit, under the command of Major the
Viscount Crichton, was part of the composite
Household Cavalry Regiment which sailed for
France on 15 August 1914 with the British Expedi-
tionary Force. After the battle of Mons on 23
August, as part of the 3rd Cavalry Division, the
regiment was engaged in covering the exposed left
flank of the BEF during the retreat, and saw action
at Halte, Saultain, Cambrai and Néry.

The original picture was Butler's first major work
after the Armistice and was purchased in 1921 by
Durban Art Gallery. In returning to the subject of
the European theatre she abandoned the self-
confident, sporting attitude of the pictures painted
during the war and reverted to one of her original
themes of the 1870s, that of weary and wounded
soldiers, whose appearance, as they advance along
a rutted road strewn with the debris of battle,

Fig. 15. *"In the retreat from Mons: the royal horse guards"*.Oil
on canvas, R.A.1920 (587). Durban Art Gallery, RSA

suggests the trauma they have undergone.
However, the figures are less dramatically posed
than those in *Balaclava* (Cat 25) or *The Return
from Inkerman* (Cat 26). This, and the drabness of
the scene lend it a grimmer quality.

In 1927, at the age of 81, Butler painted this
smaller and significantly different version of the
canvas. The alteration to the grouping of the Royal
Horse Guards, some of whom are turning off to the
left, imparts a change of emphasis. The gloomy
vista with the dead horses and riderless beasts has
disappeared, but the soldiers themselves have a
sterner air. The different disposition of the soldiers
may have been intended to impart a more 'realistic'
interpretation of the subject, but the effect is also
that this picture loses the immediacy of its
predecessor's direct composition.

152

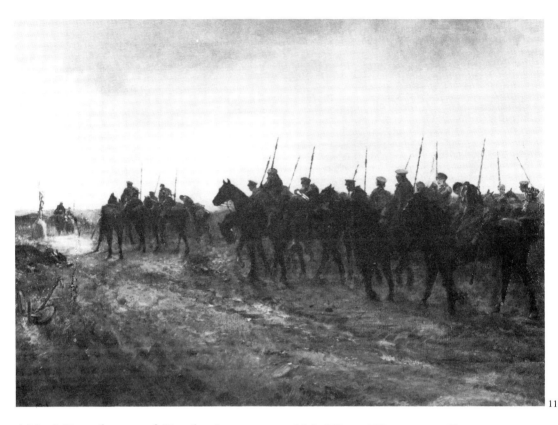

115. A Detachment of Cavalry in Flanders

Oil on canvas 59 × 76.8 1929

Insc: *19EB29*

Prov: By direct descent to Mr Rupert Butler; sold to the Christopher Wood Gallery and purchased by the present owner

Mr N S Lersten

The intended title of Lady Butler's last oil painting is not known, but a note on the stretcher indicates its subject; 'Butler's last picture painted at Gormanston Castle, Co. Meath in 1928. It shows an unnamed Cavalry patrol in Flanders halted in the light of Very lights by a stone Calvary.' The tone of this inscription suggests that it was not written by a member of Lady Butler's immediate family, although family legend has it that the scene is set at dawn.

As in *"Eyes Right!"* (Cat 105), the painting shows troops returning from battle passing a stone calvary, with its message of redemption from suffering through Christ's sacrifice. The mystical significance is heightened by the sunlight shining on the statue.

116. Eileen, Viscountess Gormanston

Oil on canvas 76.8 × 63.5 1917

Insc: *Eliz:th Butler/1917*

Prov: By direct descent

The Hon Robert Preston

Eileen Butler, the artist's younger daughter, married the 15th Viscount Gormanston in 1911. This conventional portrait was probably painted at the family home, Gormanston Castle, Co. Meath, on the east coast of Ireland. From the time of her daughter's marriage until 1922 Lady Butler lived alone at Bansha Castle, Co. Tipperary, but following the sequestration of Bansha by Republicans, she moved to Gormanston and remained there until her death.

As an act of filial duty Eileen completed and edited her father's autobiography which was published in 1911. In 1952, however she published her own memoirs, *A Little Kept*, which revealed her father to have been an autocrat within the family circle. In contrast, her mother appears as a woman of intense enthusiasms, whose devotion to painting sometimes clashed with the social demands of her life. Despite her unworldliness, she combined an

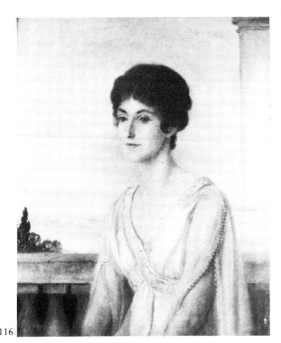

116

understanding of people with the talent of making them laugh in spite of themselves. Eileen Gormanston recalled;

> . . . whenever I get a whiff of lavender oil, the picture of my mother - rather small and slight, with a delicate face but strong hands, standing at her easel in a long gaberdine, a mahl-stick in one hand and palette and brushes in the other – is conjured up. The partial deafness from which my mother suffered since her girlhood gave to her face a certain sadness, and to her nerves an uncertain proneness to fatigue. But, hampering as it did her intercourse with the outer world, it must also have had much to do with the complete unworldliness of her outlook on life – probably, too, with her entire lack of small talk.[1]

1. Eileen Gormanston *A Little Kept* Sheed and Ward, London and New York, 1953, pp 52–3

Prints and Book Illustrations

117. Missed! A Bengal Lancer at the game of tent-pegging

Chromolithograph, published as a supplement to *The Graphic*, 25 December 1875 66 × 53

National Army Museum 7005-11

The figure of this *sowar* reining in his horse, having just missed spearing the tentpeg, is taken from that on the left of the watercolour *10th Bengal Lancers tent-pegging* (Cat 13). Butler had two other works reproduced as supplements to this weekly paper, *A Despatch-Bearer, Egyptian Camel Corps*, published 6 October 1886 and *Patient Heroes. An Artillery Team in Action* from a picture dated 1882, which first appeared in the Summer Number, 1889.

117

118. The Daily Graphic, Saturday, 4 January, 1890, p 9

Wood engravings and typography

Illustration: vignette *On the terrace at Shepheard's*

National Army Museum 7303-32-1

Elizabeth Butler's contribution to the first edition of *The Daily Graphic* was based on her experiences of Egypt in 1885. She would probably have known, however, of her husband's impending appointment to command the garrison at Alexandria, which followed five weeks later.

118. Detail

The vignette, *A Desert Grave* appeared as an illustration in Sir William Butler's book, *Campaign of the Cataracts*, published in 1887 (Cat 127) and a similar drawing to *A Mounted Soudanese* appeared at the beginning of Chapter XIV (p 293). The original pen and ink drawing for *On the Terrace at Shepheard's* is listed as Cat 50.

119. The Ballad of the Royal Irish

Manuscript by William Butler with pen-and-ink drawings by Elizabeth Butler

6 pages, missing pp iii, iv, & v, 22 × 17

Illustration: p i

Prov: Presented by Lt-Col P R Butler to the National Army Museum in 1954

National Army Museum 5407-19

This unpublished poem by the painter's husband tells an imaginary tale of the Royal Irish Regiment, taking part in an allied attack on Sevastopol, during the Crimean War. First commissioned in 1858, William Butler did not serve in the campaign himself. In the story, the Irishmen enter the city, but eventually, having held out longer than any other allied troops, they fall back with heavy losses. The narrator remembers the brigadier's words before the fight, exhorting them '. . . to fight till the mud cabins rang'. Later he turns this phrase over in his mind and ponders the question of why so many fine fighting men have come from poor Irish cabins, despite the poverty. He concludes that the Irish have fighting blood in their veins and that even the evictions from their poor cabins which leave them '. . . shadows and scarecrows of men' cannot quench the old spirit of Ireland.

119

As William Butler's 'A Plea for the Peasant', the essay that inspired *"Listed for the Connaught Rangers"* (Cat 30) of 1879, argued the case for fair treatment of the Irish, since they provided the best fighting stock of the British Army, *The Ballad of the Royal Irish* may date from the late 1870s. There is also a drawing in Elizabeth Butler's 1878 sketchbook (Cat 32), showing soldiers of the Royal Irish Regiment in Crimean uniforms. However, the vignettes of a cabin in the rain and a smouldering ruin on page viii are comparable to the scene of *Evicted* (Cat 46), painted ten years later.

120. Inkerman "The Roll Call"

Photographic postcard of the re-enactment by the Grenadier Guards at the Aldershot Military Tattoo of 1909, published by Gale & Polden, Aldershot, 9 × 14, see p 34

National Army Museum 8604-219

121. The Roll Call

Mixed-method engraving by W T Hulland, published by the Fine Art Society, London, 1 November 1882, 60.9 × 97.8

National Army Museum 5602-479

122. Quatre Bras

Mixed-method engraving by F Stacpoole, published by The Fine Art Society Ltd, London, 1879, 60 × 100.9, see p 42

The Gloucestershire Regiment

123. Scotland for Ever!

Photogravure, published by S Hildesheimer & Co, London, 1 December 1882, 72 × 115

National Army Museum 5602-420

124. After the Battle, Tel-el-Kebir

Mezzotint by Richard Josey, published by H Graves & Co, 1 May 1888, 48.9 × 100.3

National Army Museum 7209-2

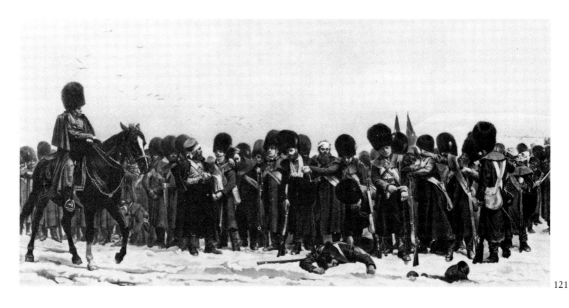

121

124

125. Steady the Drums and Fifes

Photogravure, published by Manzi, Joyant
& Co, London, New York & Paris, 1904,
62.6 × 86.1

Insc: *Elizth Butler*

National Army Museum 5602-421

126. A C Thompson **Preludes**

Published by Henry S King & Co, London,
1875

Illustration : frontispiece

Collection of Hermia Eden, Catherine Eden
and Elizabeth Hawkins

Elizabeth Thompson illustrated the first book of
poems by her sister, Alice (1847–1922), who, as the
poet, essayist and critic, Alice Meynell, later
achieved considerable fame. The author modestly
attributed the publication of her poetry to the
reputation of *The Roll Call*, which had appeared to
such acclaim the previous year; 'My first book of
verse was accepted by the publisher only because
my elder sister, who had just made a great reput-

157

126

127

ation as a battle-painter, was kind enough to illustrate it.'[1] The poems were admired by Alfred, Lord Tennyson, Coventry Patmore and John Ruskin.

1. June Badeni *The Slender Tree. A Life of Alice Meynell* Tabb House, Padstow, 1981, pp52–5

127. Col Sir W F Butler, KCB
The Campaign of the Cataracts. Being a Personal Narrative of the Great Nile Expedition of 1884–5

Published by Sampson Low, Marston, Searle & Rivington, London, 1887 (2nd edition)

Illustration: *The Burial of General Earle and Colonels Eyre and Coveney at Kirkeban*, p 342 (see Cat 44)

William Butler's vivid account of the Gordon Relief Expedition, in which he played a key role in organising the boats to carry troops up the Nile over a series of cataracts, was illustrated by his wife with 7 plates and 18 sketches round the initial letters of each chapter. General Sir Garnet Wolseley who commanded the ill-fated expedition found Butler a brilliant but irritating lieutenant. 'He has Paddy's faults in an ordinary degree, but he

has all his good qualities, talents & virtues to overflowing . . . He makes me very angry at times, but I always like him: his faults are more amusing & less objectionable than the virtues of many men.'[1]

1. Adrian Preston *In Relief of Gordon: Lord Wolseley's Campaign Journal of the Khartoum Relief Expedition 1884–1885* Hutchinson, London, 1967, p 171

128. Elizabeth Butler
Letters from the Holy Land

Published by Adam and Charles Black, London, 1912 (originally published March 1903, reprinted July 1906 and June 1912).

Insc fly leaf: *Eileen Gormanston*

Mr and Mrs Paul Mostyn

129. Elizabeth Butler
From Sketch-Book and Diary

Published by Adam and Charles Black, Burns and Oates, London, 1909

Illustration: *The Bersaglieri at the Fountain, Perugia*, Plate 25 (see Cat 93)

Insc title page: *Elizth. Butler/ 7 June /19*

The Hon Robert Preston

130. Lt-General the Rt Hon Sir W F Butler GCB
Sir William Butler An Autobiography

Published by Constable and Company Ltd, London, 1911

Insc fly leaf: *Eileen Gormanston*

The Hon Robert Preston

129

131. Major and Brevet Lt-Colonel Patrick Butler, DSO
A Galloper at Ypres and some subsequent adventures

> Published by T.Fisher Unwin Ltd, London, 1920

> Illustration: *"Brightness" (killed in action), "The Sportsman", "Dawn"* three of the author's horses, frontispiece

> Insc on fly leaf: *A J Williams/with the Author's/compliments/7th June, 1922.*

The watercolour, from which the frontispiece illustration was taken, was sketched from life on 3 October 1914 while Lady Butler was staying near the New Forest, where her son Patrick was with the 7th Division prior to its embarkation for the front. The title of the book refers to Patrick Butler's duties as ADC to General Capper, the divisional commanding officer. On 2 November, when the captain was

lying badly wounded on the field, Capper passed by, saying casually, 'Hullo, Butler! is that you? Goodbye!'[1]

1. Elizabeth Butler *An Autobiography*, p 327

132.Elizabeth Butler **An Autobiography**

> Published by Constable & Co Ltd, London, 1922

> Illustration: *Crimean Ideas*, p 103 (see Cat 18)

> Insc inside front cover: *Presented to the National Army Museum/by/Lt Col P R Butler,/son of the Authoress*

Lady Butler's autobiography is illustrated with 14 of her black and white drawings and a reproduction of a Prussian postcard of 1915 which adapted *Scotland for Ever!* to represent Prussian cavalry (fig 7, see p 83).

131

CRIMEAN IDEAS.

132

7. The Influence of French Military Painting

'Military art of this kind', wrote *The Athenaeum* with reference to Elizabeth Butler's *A Desert Grave*, William Barnes Wollen's painting *His last message*, Andrew Carrick Gow's *The garrison marching out with the honours of war: Lille, A.D. 1708* and Ernest Crofts's *Napoleon leaving Moscow* on show at the Royal Academy exhibition in 1887, 'would attract little praise in Paris, where they do these things incomparably better.'[1] The *genre militaire* had always thrived in Paris and it was natural for British battle painters to be compared with their French counterparts and judged by the standard of their work. Indeed, in the past, a commonplace criticism of French art amongst chauvinistic British critics was that it exhibited an unhealthy interest in war.

Reviewers of Butler's pictures sometimes invoked the older, post-Napoleonic, Romantic generation of battle painters, such as Horace Vernet (1789–1863), Nicholas-Toussaint Charlet (1792–1845), Auguste Raffet (1804–60) and Adolphe Yvon (1817–93). More pertinently, they also pointed to the work of the most famous of French military painters, Jean Louis Ernest Meissonier (1815–91), and the succeeding generation of war artists, particularly Alphonse de Neuville (1835–1911) and Edouard Detaille (1848–1912). These three artists exerted a powerful influence upon Butler's artistic development, for they brought an unprecedented degree of reality into the depiction of war. In the words of the painter's brother-in-law, Wilfrid;

> ... in military painting make way for the man. You cannot go beyond the man – noble, devoted, wretched, pathetic, commonplace even. All the little every-day physical miseries of a campaign are supreme in interest, provided they be given as they are – not smuggled away in unrealities. 'All the Glories of France,' rampant in the halls of Versailles, are not so glorious as a group of De Neuville's soldiers keeping warm under a bank of snow.[2]

Meissonier was celebrated for the realism of his depictions well before the British artist began her career, especially for his close-up views of soldiers whether on the battlefield or in 'off duty' genre scenes, the subtle use of facial expression and his preference for historical themes, notably from

1. *The Athenaeum* 1887
2. *The Magazine of Art*, 1879, p 26

Fig. 16. JEAN LOUIS ERNEST MEISSONIER *1814: Campagne de France* 1864, Musée d'Orsay, Paris

the life of the Emperor Napoleon I. In the much admired *1814: Campagne de France* (fig 16; see Cat 133) one of a series of Meissonier's paintings celebrating the Napoleonic epic, the Emperor leads his staff and troops along a snow-covered, rutted road; nevertheless the exact time and location of the scene are not obvious – so much so that in 1885, when the picture was reproduced in *The Magazine of Art*, it bore the title 'Napoleon in Russia'.[3] Meissonier's work, however, is often romantic as well as humanistic and Butler's popular paintings, by comparison, appear to owe more to those of her immediate contemporaries, influenced as they were by the disastrous Franco-Prussian War.

The rapid defeat of the French in 1870–71, the violence of the civil war that ensued and the ruin inflicted on Paris during the siege and the Commune engendered a feeling of pessimism in the country which was expressed in the work of many artists, writers and intellectuals. Among French military painters, Alphonse de Neuville in particular presented a morbid and often shocking view of the world in his paintings, with darkly dramatic scenes in which the defeated French soldier remained a proud

3. Clearly Butler admired the work of Meissonier, generally deemed to be the greatest living battle painter. Even at the start of the Great War she still referred to it; for instance, in her diary for September 1914 she described General Capper and his staff as '. . . a gallant group, *à la* Meissonier' (*Autobiography*, p 325). Probably not least of the ways in which Meissonier's work impressed her was in its fastidious attention to small detail; it was Meissonier's *1814: Campagne de France* that she cited in 1874 when trying to prove to her critics that the legs of the officer's horse in *The Roll Call* were properly positioned.

figure, courageous despite his sufferings. This emphasis on the courage of the common soldier was the central theme of Butler's major works, but she avoided the extreme nature of de Neuville's vision.

The artist whom she particularly admired was Edouard Detaille who, in some ways, provided a synthesis of Meissonier's and de Neuville's attitudes. Detaille had gained a new sense of purpose from the conflict with Prussia, but it inspired him to look to the ennobling aspects of war. He championed the Army, the only institution which had the whole-hearted support of the populace in the politically divided climate which followed the war. A pupil of Meissonier, he employed his master's humanitarianism with a less overtly emotional emphasis, which heightened the sense of reality in his paintings. In depicting scenes of combat, his soldiers are strong and masculine; they are dignified, patriotic and prepared to sacrifice themselves for victory. It was a compelling, contemporary view like that of de Neuville, which also centred on the common man; but it was restrained, glorying neither in heroism nor the drama of death.

It is not recorded when Butler first took notice of the work of these painters and in her autobiography she only referred to them on the occasion of her visit to Paris in December 1874, after the success of *The Roll Call* (Cat 10). The omission is revealing in itself, for Butler's 1873 works, *Missing* (fig 3) and *Chasseur Vedette* (Cat 16) are not only French in subject, but are also similar to the French treatment of such themes. She had visited the Salon in 1870, just before the Franco-Prussian War, and would also have had the opportunity of seeing examples of the 'new' French military painting at Gambart's French Gallery and Goupil's gallery in London in the early 1870s. In Paris in 1874 she visited Léon-Joseph-Florentin Bonnat's studio and an exhibition of the work of Carolus Duran, neither of which she admired. However, at Goupil's Parisian gallery she recounted that she ' . . . feasted my eyes on pickings from the most celebrated artists of the Continent', mentioning especially de Neuville's *Combat on a Street Roof (Combats sur les toits-Floing, près Sedan)*. She also visited Detaille's studio. 'He was,' she said, 'my greatest admiration at the time'[4], which suggests that she had already encountered his work. Although this is the only evidence that his post-war paintings were known to Elizabeth Butler before she painted *The Roll Call*, and it may be argued that both artists arrived independently at a similar treatment of military themes as a result of prevailing cultural influences, Butler's closest links to French battle painting are with the work of Edouard Detaille. It is in *The Roll Call* that the qualities of recent French military art and especially Detaille's battle scenes first become fully evident; that is, in the comparatively close-up view of soldiers, the ordinary rank and file whose courage is all the more evident because, although emotionally understated, their recent ordeal is implied by their physical appearance. Their condition is also emphasized by the informal composition, muted colour and anecdotal treatment of the subject.

4. Elizabeth Butler *An Autobiography* Constable & Co, London, p 128

The Influence of French Military Painting

This section is exhibited at the National Army Museum only

133. JEAN LOUIS ERNEST MEISSONIER (1815–91)
1814: Campagne de France

Engraving by A Bessé after the oil painting of 1864, 56 × 71

Prov: Presented by le Société des Amis du Musée de l'Armée in 1917

Musée de l'Armée, Paris

Influenced by the Dutch realist painters of the seventeenth century, Jean Louis Ernest Meissonier began his long career by exhibiting a genre scene in 1834. In 1846 he was awarded the *Légion d'Honneur* and in 1855, when his painting *The Brawl (Rixe)* was purchased by Napoleon III as a gift for Queen Victoria and Prince Albert, on their state visit to France, his fame was assured. He accompanied the general staff on Napoleon III's campaign in Italy in 1859 and upon his return painted not only the famous canvas, *Napoleon III at the battle of Solferino*, but also embarked on the works which were to be a major preoccupation for the rest of his life, scenes from the life of Napoleon Bonaparte. During the Franco-Prussian War of 1870–71, Meissonier was initially attached to the French general staff, but returned to the besieged capital to serve as a lieutenant-colonel in the National Guard artillery. Despite the crucial impact which the war had upon other artists such as his pupil, Edouard Detaille, Meissonier derived little inspiration from it and he continued to paint historical scenes, of which *1814: Campagne de France* is one of the most famous.

At the end of his life Meissonier is quoted as having said '*L'Angleterre n'a guère qu'un peintre militaire, c'est une femme*'.[1] This must have delighted Elizabeth Butler because, during the second half of the nineteenth century, he was generally considered to be the greatest of all battle painters and it is evident from her autobiography that she held his work in the highest esteem. His works were seen as the standard by which any British as well as French military artist was to be judged; for instance, *The Tablet* of 5 August 1876,

in reviewing *Balaclava* said that '. . . every blade of grass has been dealt with by a Meissonier-like touch.'

In defending the unconventional gait of the officer's horse in *The Roll Call*, Butler cited Meissonier in her letter to *The Times* of 6 May 1874; the French artist's 'realism', his industry and perfectionism for complete accuracy in even the smallest details, was legendary. The particular painting which Butler referred to, one that she could be sure that her critics would know, was *1814: Campagne de France*, showing Napoleon leading his defeated army during the allied invasion of France.

1814: Campagne de France, which appeared at the Paris Salon in 1864 after years of preparation, was a picture which Butler seems to have especially admired. Many of her works, such as *Missing* (fig 3), *Balaclava* (Cat 25), *The Return from Inkerman* (Cat 26), *The remnants of an Army* (Cat 31) and *Halt on a forced march* (Cat 57) repeat the central motif of this work; the weary survivors, battered but unbowed, who trudge along a rutted road in the aftermath of a great action with an air of grim resolution.

1. 'England really has only one military painter – a woman'. It is Wilfrid Meynell who mentions this encomium; ' . . . Meissonier, almost on his death-bed, offered homage to her name.' (*op cit*, p 31), but the exact source of the quotation has not been traced. Eileen Gormanston, writing in the 1950s, ascribes the remark to Alphonse de Neuville, (*op cit*, p 52), but this is unlikely. Meynell would have been better acquainted with Butler's French antecedents and it was Meissonier's great reputation which lent weight to the remark.

Fig 17. HENRI FELIX EMMANUEL PHILIPPOTEAUX (1815–84)
La charge des cuirassiers français à Waterloo

Oil on canvas 99 × 155 1874, photograph only

Insc: *F.Philippoteaux 1874*

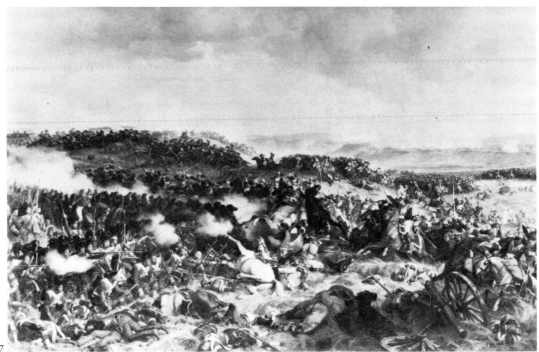

Fig 17

The charge of the French cuirassiers at Waterloo
was exhibited at the Royal Academy in 1875, the
same year as Elizabeth Thompson put *The 28th
Regiment at Quatre Bras* on show there. Both
paintings show a square of British infantry receiv-
ing the charge of French cavalry, with the cavalry
reeling back from a volley of musketry. However,
Philippoteaux treated the subject in the convent-
ional manner, taking a slightly elevated viewpoint
from which to observe a wide vista of the battle-
field. The immediate foreground is copiously lit-
tered with bodies and debris, indicating a long and
hard-fought battle; the lines of fighting men stretch
right into the distance, and the central scene is a
dramatic and tumultuous conflict, painted with a
wealth of detail. In comparison, Thompson's close
view of the square of the 28th (North Gloucester-
shire) Regiment was innovatory, and although it
avoided showing the whole conflict, it was never-
theless as dramatic as the panoramic view. In
concentrating on a few men, she captured the
essence of combat, in the way that it was experi-
enced by soldiers on the field, and by depicting their
individuality from such a near viewpoint she gave
the spectator a sense of that experience, something
which was totally new in British battle painting. It
was not surprising, therefore, that as well as being
admired by the art critics, Thompson's work
delighted the Army who gave her every assistance.

Exhib: R.A.1875 (613); British Empire
Exhibition, Wembley 1924

134. ALPHONSE DE NEUVILLE (1835–85)

Général de Division interrogeant un Garde National Mobile soutenant un Lieutenant blessé à tête, Armée de la Loire, Dec 1870 called L'Officier de mobiles blessé

Oil on canvas 69 × 87 1879

Insc: *A de Neuville/1879*

Prov: Presented to le Musée de l'Armée by
James N B Hill, Boston, USA, in 1966

Musée de L'Armée, Paris

Alphonse de Neuville launched his career with the
work *5th battalion of chasseurs at the battery of*

164

Gervais (*le 5ième batallion de chasseurs à la batterie Gervais*) at the Paris Salon in 1856, and he continued to turn out scenes from the Crimean War and 1859 Italian campaign until 1870. When hostilities broke out with the Prussians on 15 July of that year, de Neuville was attached to the staff of General Callier and he subsequently took part in the fighting around Paris. The war provided him with a stimulus that changed his career; he began to paint a pessimistic vision of tragedy and death. Although essentially romantic in its depiction of heroic soldiers broken by fate, the mood of France in the aftermath of the war encouraged de Neuville's predilection for the sensational and macabre and his work was immensely popular. Butler would have been aware of this novel emphasis and, even if she did not owe a direct debt to the French artist's work, it seems probable that this atmosphere of despair was a formative influence upon her early work.

Although he also painted scenes of fierce combat, *L'Officer de mobiles blessé* is typical of de Neuville's Franco-Prussian War images, seen from the soldiers' perspective. A *Garde National Mobile*, (in time of peace a civilian with little military training in his part-time defence role), leads a wounded officer away from the battlefield. The casual attitude of the general who stops the men, despite the condition of the wounded officer, emphasizes their heroism and there is an implied criticism of the high command.

De Neuville's work was widely admired in the British art world in the 1870s. In reviews of exhibitions at Goupil's and the French Gallery in London as well as of the Paris Salon, it was seen as epitomising the new 'realist' school of French military painting. *Bivouac devant le Bourget* (Goupil's, 1879), *Bataille de Villersexel* (French Gallery, 1876) and *Intercepted Despatches* (French Gallery, 1879), the type of picture on which de Neuville's British reputation depended, have more action and bloodshed than Butler's pictures. But the two artists certainly shared a concern with the condition of the ordinary soldier in war. In her article, 'Our Living Artists: Alphonse de Neuville', Butler's sister, Alice Meynell paid eloquent tribute to what she perceived to be the essential humanity of de Neuville's work.[1]

1. *The Magazine of Art* 1881, pp 354–8

134

Fig 18

Fig. 18 ALPHONSE DE NEUVILLE (1835–85)
The Defence of Rorke's Drift

Oil on canvas, approx 92 × 61 1879,
 photograph only

Insc: *A de Neuville/1879*

The Royal Regiment of Wales

De Neuville painted two copies of *The Defence of Rorke's Drift*; the larger canvas is in Sydney Art Gallery, Australia. This version is smaller and more freely painted than Butler's picture of the same subject (Cat 33). A comparison between the two works shows, not surprisingly, that they contain many of the same features such as the centrality of the officers; the wounded man in the centre foreground, supported by a kneeling comrade; raised rifle butts; the soldier with his head thrown back at

the moment of death and the burning hospital building. Both are extremely dramatic, but Butler's painting, viewing the scene from a slightly closer point, with the facial expressions of the antagonists clearly visible, directly involves the spectator in the action. De Neuville's picture is more conventional; the actual fighting is obscured by the backs of the soldiers, but he succeeded in introducing most of the principal combatants; nearly all the figures are identifiable.

The picture was well received when it appeared at the Fine Art Society in March 1880, for 'the evening of the deplorable day of Isandhlwana', 22 January 1879, was still vivid in people's minds.

Although it was Butler's intention to have her painting of Rorke's Drift ready for the Royal Academy in May 1880, she did not succeed. By the time it appeared at the 1881 exhibition the subject had lost much of its topicality.

Exhib: Fine Art Society 1880

166

8. Late Victorian Battle Painting

Elizabeth Thompson's extraordinary success in the mid-1870s encouraged a number of British artists to enter the lists as battle painters. She was not the only painter working in this field at the time, but the exceptional acclaim which she received at the outset of her career heralded a revival in military paintings. Of her immediate contemporaries only Ernest Crofts (1847–1911) had begun to exhibit pictures of war before *The Roll Call* apppeared, although he too only displayed his first painting at the Royal Academy in 1874 (*A retreat: episode in the German-French war*, No 1366). Among those who exploited the market established by Thompson were Richard Caton Woodville (1856–1927), whose first Academic work, *Before Leuthen, Dec 3rd, 1757*, appeared in 1879; Robert Gibb (1845–1932), who switched to military themes in 1878 with *Comrades* and *The Retreat from Moscow*, and William Barnes Wollen (1857–1936) whose second Royal Academy picture, *The rescue of Private J Andrews by Captain Garnet Wolseley ... at the storming of the Motee Mahal, Lucknow*, was shown in 1881. By the 1880s, these painters were successfully challenging Elizabeth Butler's leadership in the field.

In choosing battle painting as her *métier*, Elizabeth was following a European academic tradition, which for years had placed 'history painting' at the top of all the artistic genres. It was thought to require the highest skills in its depiction of the human form, the linking of a multiplicity of figures within certain defined rules of composition and the presentation of dramatic spectacle. For the first time in British painting, Elizabeth Thompson introduced a successful combination of the serious representation of events from past military history with the awareness of individuals as presented in contemporary genre scenes. In the 1870s, the vogue for social realism in British art was manifested in the careful if sometimes inaccurate attention to detail in battle painting, although it was not generally tempered with the humanitarian concern of Butler's pictures. The unsentimental realism of French military artists such as Jean Louis Ernest Meissonier and Edouard Detaille also had a profound influence upon the character of British battle painting (see above, pp 160–6). Equally, there were other influences affecting its development in the last quarter of the nineteenth century, arising from British involvement in a series of colonial wars.

Since the founding of *The Illustrated London News* in 1842, the public was accustomed to seeing pictures of contemporary conflicts published in a matter of weeks after the event. The first major British campaign to be

reported in this way was the Crimean War, but the lively sketches of their special artist, Joseph Archer Crowe (1825–96), lost much of their immediacy when translated into newspaper illustrations by the professional engravers. By the 1870s, however, the work of the best 'specials', such as Melton Prior (1845–1910) for *The Illustrated London News* and the Academy-trained artist, Frederick Villiers (1852–1922) in *The Graphic*, had reached a much higher standard, covering all aspects of the campaigns in which they often took an active part. Their work remained journalistic, but it encouraged the public to expect a more realistic depiction of war. Moreover, several of the battle painters exhibiting at the Royal Academy and other venues were also known for their contributions to the illustrated press. Richard Caton Woodville provided imaginative 'reconstructions' of contemporary actions for *The Illustrated London News* when sketches from the correspondent at the front failed to arrive in time for publication. Charles Edwin Fripp (1854–1906), whose picture *The last stand at Isandlhula* (now called *The Battle of Isandhlwana*, Cat 138) is one of the best known images of the Zulu War, worked as a 'special' for *The Graphic* and its daily edition from from 1879 to 1900. Another exhibitor at the Royal Academy, Godfrey Douglas Giles (1857–1923), depicted the First Sudan War of 1884–85 in which he had served as an officer in the Indian Army (see Cat 139) and went on to represent *The Graphic* in the Boer War, 1899–1902.

A consequence of this novel development in war reporting was that, in some instances the term 'battle picture' was used, not to refer to historical paintings, but rather to the images of war in the illustrated press. For example, an article entitled 'Battle Pictures' in *The Magazine of Art* in 1896 by the war correspondent, Charles Williams, was entirely devoted to the printed work of the 'special artists'.

Although battle painting was recognised as a serious category of art far removed from the instant journalism of ' . . . those newly invented curses to armies'[1], it was not generally popular among the art-loving public. The reception given to *The Roll Call* and Thompson's succeeding pictures was unusual, although subsequently there were some other highly popular works, notably Robert Gibb's *The Thin Red Line* of 1881 (Cat 136). The number of artists who also worked as 'specials' may be seen as an indication that it was difficult to earn a livelihood from this form of painting. In contrast to the admiration such pictures received in France, the status of the genre in Britain was reflected in the scant attention given to it in the journals that extensively reviewed Academy exhibitions, a paragraph at most in the second or third notice, although during the Boer War there was a brief upsurge in the numbers and prestige of battle paintings. Even among collectors there was little demand for large-scale battle paintings. As Richard Caton Woodville regretfully observed;

1. Field Marshal Lord Wolseley *The Story of a Soldier's Life* 2 Vols, Archibald Constable & Co Ltd, London, 1903

It is a curious thing how little the English public care for military pictures; there are hardly any in our public or private galleries. And as for the Army, they would much rather hang the latest Gaiety actress in their mess than the finest episode of their regimental history.[2]

2. Richard Caton Woodville *Random Recollections* Eveleigh Nash, London, 1914, p 79. See also; Pat Hodgson *The War Illustrators* Osprey, London, 1977; R J Wilkinson-Latham *From our special correspondent. Victorian war correspondents and their campaigns* Hodder and Stoughton, London, 1979.

Late Victorian Battle Painting

This section is exhibited at the National Army Museum only

135. ERNEST CROFTS (1847–1911)
Wellington's march from Quatre Bras to Waterloo

Oil on canvas 113.6 × 226 1876

Insc: *E.Crofts 76*

Prov: J N Mappin Bequest

Mappin Art Gallery, Sheffield

Ernest Crofts was Elizabeth Thompson's chief rival in the 1870s. His first Royal Academy exhibit, *A retreat: episode in the German-French War*, appeared in 1874, the year of *The Roll Call*. Like *Missing* (fig 3), Thompson's exhibit of the previous year, it was indebted to the realist tradition of French military art (see above, pp 160–6). Crofts had studied at Düsseldorf, as did his younger rival, Richard Caton Woodville, under Hünten, a pupil of the renowned early nineteenth-century French battle painter, Horace Vernet. He was commonly seen as a follower of Edouard Detaille, at least in style, although Crofts lacked the French artist's crispness, and his choice of historic subjects, after the initial venture with a contemporary scene, was more in keeping with Detaille's master, Jean Louis Ernest Meissonier.

The painting depicts Wellington's withdrawal on 17 June 1815, the day before Waterloo, when the Prussian retreat to Wavre had left the Anglo-Dutch army dangerously exposed. Unlike Thompson's treatment of the same campaign, *The 28th Regiment at Quatre Bras*, shown at the Royal Academy in 1875, the focus of the picture is on the British commander rather than his men. Crofts chose to depict a scene in advance of a great battle, where, with the exception of the downcast French prisoners of war, the soldiers' attitudes reflect their confidence as well as their respect for the great man. There are many similarities between this painting and Meissonier's largest canvas, *1807: Friedland*, in which the *12ième Régiment de Cuirassiers* salute their Emperor as they gallop into

135

action during the closing stages of the battle. This was exhibited at the Paris Salon in 1875 after six years in the studio and it seems that Crofts must have known it, for he reinterpreted the scene from a British perspective.

This is the second of three Waterloo scenes which Crofts painted in the late 1870s. The first was *On the morning of Waterloo*, (R.A.1876, No 1253, also in the Mappin Art Gallery), and the final work, *On the evening of the Battle of Waterloo*, appeared at the Royal Academy in 1879 (No 613, Walker Art Gallery, Liverpool). The following year Crofts was elected an Associate of the Royal Academy. His female rival was not so fortunate when she stood for election in 1881, even though at the time Butler's works were far more acclaimed than his.

Exhib: R.A. 1878 (609)

Ref: *The Art Journal* 1878, p 178

136. ROBERT GIBB (1845–1932)
The Thin Red Line

Oil on canvas 106.7 × 212.7 1881

Insc: *Robert Gibb-/81*

John Dewar & Sons, Limited, Distillers

In 1878, the Scottish painter, Robert Gibb turned from depicting romantic literary subjects to battle scenes with his painting *Comrades*. This shows a Highland soldier coming to the aid of a stricken friend in the snow, a work certainly influenced by *The Roll Call*, as well as by French military painting. *Comrades* had originated from Gibb's own sketch for *The Retreat from Moscow* (R.S.A.1879), an example of the way in which French depictions of long-suffering soldiers provided British painters with a formula which they used in tackling the ordeal of the British rank and file in the Crimea.

The Thin Red Line, Gibb's most famous work and one of the best known battle pictures of the late nineteenth century, depicts the crucial stand of the 93rd (Sutherland) Highlanders at the battle of Balaclava on 25 October 1854, the action immortalised by William Howard Russell's phrase 'that thin red streak topped with a line of steel.' The painter related, however, that it was the description of the battle in A W Kinglake's *The Invasion of the Crimea* rather than Russell's famous account which inspired him. To begin with, he could not think how to make a successful composition of the straight line of troops which the subject demanded. But while walking one day by the River Wye, the solution came to him; to guide the line across the rise and fall of an undulating piece of ground.[1] Gibb then set to work in his customary way, studying uniforms, weapons and accessories and consulting veterans. One of these told him that it had been a moment of great anxiety, when '. . . Sir Colin Campbell, riding down the front of the line, said, "Now men, you must die where you stand"; and Sergeant Scott, who was near the colours nothing daunted, replied "Ay, ay, Sir Colin, if need be we will do that".'

The unwavering line preparing to receive a cavalry charge echoed Butler's resolute square in *The 28th Regiment at Quatre Bras* (fig 5). As in

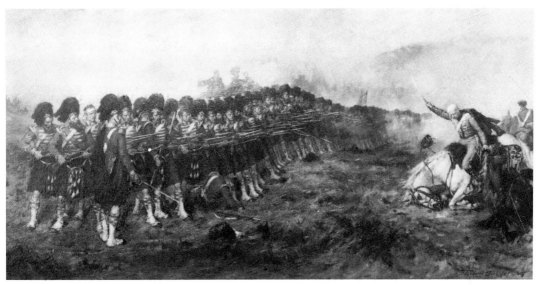

136

171

that picture, attention is focused on the faces of the British soldiers and the oncoming horsemen are largely left to the viewer's imagination – with one exception, the tragic figure of a Russian hussar officer struck down within yards of the line. Gibb's Highlanders differ in one respect at least from the soldiers of Butler's 28th Regiment; all are uniformly calm and determined, the epitome of courage. Gibb was the leading exponent of Scottish battle painting in the late nineteenth century, and his work, as exemplified by this picture and its successor, *Alma: Forward the 42nd* (R.A.1879, Glasgow City Art Gallery), was a celebration of the sterling military qualities of his fellow countrymen. The grim restraint of his soldiers had more in common with Butler's work than the fulsome heroics of Richard Caton Woodville. Gibb's *The Thin Red Line* was still influential in 1904 when William Barnes Wollen exhibited his Waterloo picture, '*The Line will advance*!' at the Royal Academy.

Exhib: R.S.A.1881; R.A.1882 (301)

Refs: *The Art Journal* 1881, p 123; *The Magazine of Art* 1881, p 263; *The Art Journal* 1882, p 210

1. W Matthews Gilbert 'Robert Gibb, R.S.A.' *The Art Journal* 1897, pp 25–8

137. RICHARD CATON WOODVILLE (1856–1926)
Maiwand: saving the guns

Oil on canvas 133 × 199 1882

Insc: *R.Caton Woodville/1882*

Prov: Purchased at the Liverpool Autumn Exhibition 1882

Walker Art Gallery, Liverpool (on loan to 29 Commando Regiment RA, Plymouth)

Richard Caton Woodville's career flourished just at that time in the early 1880s when Elizabeth Butler's career began to languish. Although he painted historical subjects from earlier wars, he specialised in topical, violent and dramatic battle scenes from contemporary campaigns. With public interest centred on a series of British colonial wars which were seldom brilliant affairs, his imaginative dramatisations of glorious victories or noble, hard-fought defeats, all treated in a realistic graphic style, catered perfectly for the jingoist appetite of the period.

Maiwand: saving the guns commemorates the same incident in the Second Afghan War as Butler's *Rescue of wounded, Afghanistan* (Cat 90), but by the time she exhibited her version in 1905,

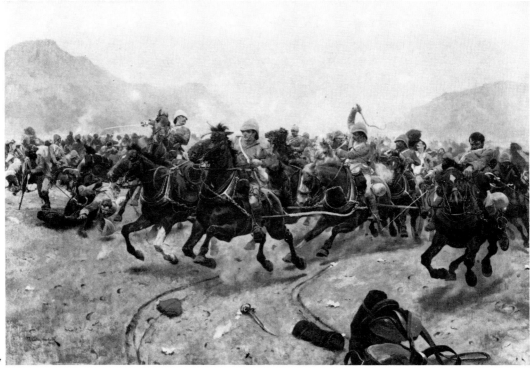

137

interest in the subject had faded. Caton Woodville's picture, exhibited at the Royal Academy within two years of the battle, was admired, despite the fact that it commemorated a defeat. 'The spirit, or rather the fire and energy, the vivid conception, the skill in representing men and horses in every conceivable attitude ... ' were such as to make Butler's *"Floreat Etona!"*, in the same exhibition, seem dull in comparison.

Exhib: R.A.1882 (576);
Liverpool Autumn Exhibition 1882; Guild-hall 1915 (247)

Refs: *The Architect* 13 May 1882; *The Art Journal* 1882, p 211; H Blackburn *Academy Notes* Chatto and Windus, London 1882, p 52; *The Illustrated London News* 13 May 1882

138. CHARLES EDWIN FRIPP (1854–1906)
The last stand at Isandlhula now called The Battle of Isandhlwana

Oil on canvas 144 × 225 1885

Insc: *Charles Fripp*

Prov: Presented by the 21st Special Air Service Regiment (The Artists Rifles)

National Army Museum 6011-82

The action at Isandhlwana was one of the worst disasters suffered by the British army in the second half of the nineteenth century. On 22 January 1879 six companies of the 24th (2nd Warwickshire) Regiment were overwhelmed by an immense Zulu army. They fought bravely, but all except 55 of the 1700 men were slaughtered. The successful defence, the same evening, of the mission station at Rorke's Drift several miles away was the subject of paintings by Elizabeth Butler (Cat 33) and Alphonse de Neuville (fig 18).

Charles Fripp, the son of the landscape painter George Alfred Fripp, studied art at the Royal Academy in Munich. He then embarked on a long career as a special artist for *The Graphic*, although the Zulu War was only his second assignment. In composition, his portrayal of the campaign may be seen as a tragic version of Butler's *The 28th Regiment at Quatre Bras* (fig 5). It shows the closing stages of the battle with the remaining force forming a tiny square against the Zulu attack, while in the background, individual redcoated figures are lost in a sea of native warriors. The contrast between the attitudes of the British infantry and the Zulus suggests a civilised superiority in the former,

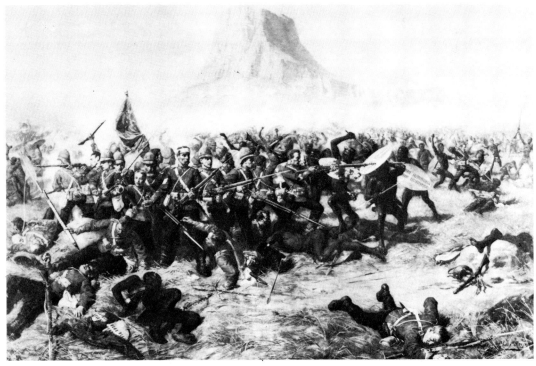

138

despite their being outnumbered by 'savage' hordes. The scene is one of violence as well as heroism, but despite this and the accuracy with which the site of the battle, overshadowed by the distinctive hill of Isandhlwana, was painted, the picture made little impact at the Royal Academy in 1885. The subject had hardly been a glorious defeat and it was no longer topical. The stoicism of the central figures and the fatherly way in which the wounded sergeant steadies the young drummer boy were also possibly too implausible for the Academy audience, given the known circumstances of the action. The reviewers preferred Godfrey Douglas Giles's less formally structured painting, *The battle of Tamaai, Soudan Campaign, 1884* (National Army Museum 6311–5).

Exhib: R.A.1885 (1065)

Refs: *The Art Journal* 1885, p 258; *The Athenaeum* 20 June 1885

139. GODFREY DOUGLAS GILES (1857–1923)
An incident at the Battle of Tamaai, Eastern Soudan, March 13, 1884

Oil on canvas 105 × 183 1885

Insc: *G Douglas Giles/1885*

The York and Lancaster Regiment, on loan to the National Army Museum 7009-19

At the battle of Tamai on 13 March 1884, the British almost suffered a humiliating defeat at the hands of a Dervish army which had been menacing the Red Sea port of Suakim. Despite its superior firepower, a British brigade square broke and the Gatling guns of the Naval Brigade were overrun. Only the arrival of reinforcements saved the day after a desperate hand-to-hand struggle. The events were accurately depicted by Godfrey Douglas Giles in two paintings executed in 1885; the first, *The battle of Tamaai, Soudan Campaign, 1884*, exhibited at the Royal Academy in 1885 (No 1068, National Army Museum 6311–5) and this work, shown there two years later. The first canvas depicted the Dervishes issuing from a deep ravine in which they had concealed themselves, at the moment of the British advance and the second, the action by the York and Lancaster Regiment, which suffered particularly heavy losses.

As a lieutenant in the Bombay Staff Corps Giles had witnessed the battle. The subject was topical and the first picture of the action, despite its scattered composition and massed tones and colours, was applauded by reviewers as showing the true face of battle, whereas both Elizabeth Butler's picture, "*After the Battle*" (Cat 41) and Charles Fripp's *The Battle of Isandhlwana* (Cat 138), both shown at the Royal Academy in the same year, 1885, were not so well received.

Giles retired from the Army in May 1884 and trained with Carolus Duran in Paris, but he only displayed three other pictures at the Royal Acad-

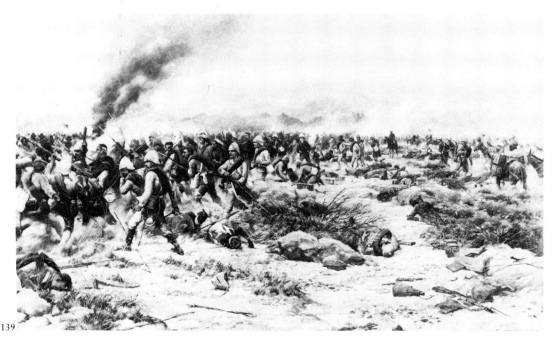

139

emy, including another of the same Sudan campaign. He was not in the forefront of battle painters, but he did accompany the Kimberley Relief Column as a representative of *The Graphic*, during the Boer War of 1899–1902.

Exhib: R.A.1887 (486)

Refs: (1st Tamai painting) *The Art Journal* 1885, p 258; *The Athenaeum* 20 June 1885

140. WILLIAM BARNES WOLLEN (1857–1936)
The last stand of the 44th at Gundamuck, 1842

Oil on canvas 68 × 124 1898

Insc: *W.B.Wollen/1898*

Royal Anglian Regiment, on loan to the National Army Museum 6006-116

The painting recalls an incident in the closing stages of the First Afghan War, during the disastrous retreat from Kabul in January 1842, when the last 80 men of the 44th (East Essex) Regiment were surrounded by Afghans at Gandamuk in the pass of Jugdulluk. Of the force which left Kabul, only Dr Brydon, an assistant surgeon in the Bengal Army reached the British lines at Jellalabad (see also Butler's *The remnants of an army*, Cat 31), although some stragglers and prisoners returned later.

William Barnes Wollen had a long career, regularly exhibiting battle scenes at the Royal Academy from 1879 until 1922. This small canvas represents another variant of Butler's original composition of 1875, the close-up view of the British square in *The 28th Regiment at Quatre Bras* (fig 5), although the desperate plight of this small group is emphasized by the variety of their expressions, the jumbled angles of the weapons and the litter of bodies in the surrounding rocks, set against the inhospitable, snow-covered landscape beyond.

Exhib: R.A.1898 (146)

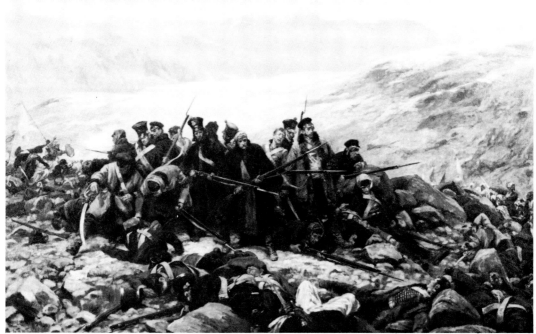

140

Appendix I
The Depiction of Uniform

by Boris Mollo, Deputy Director, National Army Museum

While Lady Butler placed much emphasis on the accuracy of her historic works, a detailed examination of the uniforms depicted indicates that her sources of information were limited and that she often misinterpreted proportions, particularly of headdress.

In the case of works relating to the Peninsular War and Waterloo Campaign, she was painting 60 or 70 years after the events and could not rely on eye-witnesses to check her accuracy. It seems probable that, for Napoleonic uniforms, she relied on one particular source, Colonel Charles Hamilton Smith's *Costume of the Army of the British Empire*, a series of prints published in parts between 1812 and 1815.[1] However, this work was based on regulations for new uniform introduced from 1812 and was not, therefore, relevant to the uniform worn during the early part of the Peninsular War. Moreover, with certain noted exceptions, Hamilton Smith depicted orders of dress as worn at home on ceremonial occasions and by that time, a number of adaptations had been made to uniform on service abroad.

As a result, the two Peninsular War paintings, *Halt on a forced march: Peninsular War* (Cat 57, depicting the retreat to Corunna in the winter of 1808–9) and *"Steady the drums and fifes!"* (Cat 61, the battle of Albuera, 1811) are the most inaccurate of the artist's paintings, in that the uniforms taken from Hamilton Smith, in particular the high-fronted 'Waterloo' shakos of the infantry, had not yet been introduced. In *Halt on a forced march*, she shows, sitting on the limber, a figure in a black shako with white cockade and blue jacket. The only British uniform like this was that introduced in 1812 for the Light Dragoons. It caused great consternation when it was issued in the latter part of the Peninsular War because of its similarity to the uniform of the French Army.[2] This painting also brings out another frequent fault in that the headdress of both the light dragoon and of the Royal Horse Artilleryman alongside are too small. Viewed on their own (the artist might well have seen examples in the Museum of the Royal United Service Institution in Whitehall), they may have looked like this to her, but when worn, their size became apparent. The drawings of the Dighton brothers, Denis, Robert and Richard, the leading British military artists of the Napoleonic era, are often thought to exaggerate the size of headdress, but in use, cocked hats and shakos appeared so large as to give an almost caricatured appearance.

In *"Steady the drums and fifes!"*, both the drummers and the main body of the regiment are shown in white breeches and black gaiters which was home

1. C Hamilton Smith *Costume of the Army of the British Empire according to the last Regulation* Colnaghi & Co, London, 1812–15
2. C R B Barrett *History of the XIII Hussars* William Blackwood and Sons, Edinburgh, 1911, Vol 1, p 168

ceremonial order. Contemporary pictures of warfare in the Peninsula show that they were replaced by white or grey trousers.[3]

When Lady Butler dealt with subjects from the Waterloo campaign, *The 28th Regiment at Quatre Bras* (fig 5) and *Scotland for Ever!* (Cat 36) she was on somewhat safer ground in using Hamilton Smith as a reference, but again errors occurred. In *The 28th Regiment at Quatre Bras*, the 28th Foot are shown in the Waterloo shako. The illustrations in J Booth's book, *The Battle of Waterloo*, published in 1816, are based on the drawings of George Jones who accompanied the army to the Netherlands.[4] His picture of the 28th at Quatre Bras shows them in an earlier pattern shako which differed both in shape and in the design of the shako plate. Even when the Waterloo shako was worn, contemporary sources show that it usually had a foul weather cover which hid the plate, cords and plume.[5] On the French side, a Polish Lancer is shown on the left of the painting. After 1814, most of Napoleon's Polish Legion was disbanded and returned home. The only Polish Lancers still with Napoleon's army were the Lancers of the Guard, who were not engaged at Quatre Bras.[6]

The artist appears to have used the Hamilton Smith plate, *A Private of the 2nd or Royal North British Dragoons (Greys)* as the source for *Scotland for ever!*,[7] but again, she followed the print too closely in showing the full dress shabraque (saddle cloth) of dark blue edged in yellow lace, when contemporary pictures show that, on campaign, a grey blanket was worn instead. The details of the jacket are also incorrect. Dragoons of the time wore a continuous strip of gold or yellow lace, according to rank, two inches wide with a central blue train (stripe), on the front of the jacket and collar.[8] Elizabeth Butler's version is narrower, does not have the blue train and, in many cases, is not continuous from jacket to collar. Officers wore twisted gold shoulder cords, not epaulettes, and the soldiers wore blue shoulder straps edged in yellow, rather than all-yellow straps.

Dawn of Waterloo (Cat 60), may be compared with a contemporary painting by James Howe of a similar scene.[9] The errors in lacing and shoulder straps are repeated. The forage caps worn by several soldiers are shown as blue with a red band. The Howe painting shows the band to be of a yellow zig-zag pattern (known as 'Vandyke') still worn by the regiment to this day.

When painting Crimean scenes, Lady Butler was able to use soldiers who had actually served in the war as models, and this is reflected in the greater accuracy of the scenes. The occasional errors which occur tend to be in points of detail or proportion. For example, in *Balaclava* (Cat 25) the 17th Lancers are shown correctly in the blue jacket and grey trousers which had been issued to them and the 13th Light Dragoons on a trial basis. However, the light dragoon holding a horse to right of centre has a scarlet collar identifying him as a 4th Light Dragoon

3. T St Clair *A Series of Views of the Principal Occurrences of the Campaigns in Spain and Portugal* Colnaghi & Co, London, 1812–15

4. *The Battle of Waterloo . . . Ligny and Quatre Bras by a Near Observer* J Booth, London, 1816–17, Pl 5 (after George Jones)

5. M J Barthorp *The Armies of Britain* National Army Museum, London, 1980, pp 128–9

6. Henri Lachouque and Anne S K Brown *The Anatomy of Glory* Lund Humphries, London, 1961, p 478

7. Hamilton Smith, *op cit*, Pl 34

8. John Mollo *Waterloo Uniforms, British Cavalry* Historical Research Unit, London, 1973, pp 31–7

9. John and Boris Mollo *Uniforms and Equipment of the Light Brigade* Historical Research Unit, London, 1968, p 18

who wore the conventional blue overalls, not grey as shown by the artist. At the Alma, Captain Lindsay and other officers of the Scots Guards wore their rolled cloaks over their shoulders and white haversacks neither of which are shown in Lady Butler's version, *The Colours* (Cat 64). In *The Return from Inkerman* (Cat 26), the mounted officer wears a staff officer's cocked hat of comparable size to that worn in the artist's time and presumably by her husband, whereas in the Crimea, as clearly seen in the photographs of Roger Fenton, they were half as tall again.[10]

Some basic errors occur even in her later works. For example in *Rescue of wounded, Afghanistan* (Cat 90), she shows the artillerymen in blue jackets. She may have been influenced by her experience of Egypt and the Sudan, where the home service dress of red or blue frock was worn in the early stages of the campaign, and it would have been a reasonable assumption on her part that this would also have applied in Afghanistan two years earlier. However, khaki uniforms, having originated in India, were in more general use there at an earlier date than elsewhere. In Afghanistan, where khaki drill was not available, the white summer uniform was worn after having been dyed locally with mud or tea leaves.[11] This is confirmed by the photographs of the campaign taken by James Burke.

In her paintings of the Great War, it is clear that Lady Butler based her depictions of uniform on the studies of the 7th Division which she made in the New Forest in September and October 1914, prior to their departure for the front. For instance, she always showed infantrymen wearing the 1908 pattern webbing, even though during the war many troops of Kitchener's Army were issued with old-style leather equipment. The absence of steel helmets, with the exception of some seen in *Back to his land* of 1919 (Cat 112), is also indicative of her use of early studies.

Although mistakes do occur in Lady Butler's paintings, she was a pioneer in attempting to make the details as accurate as possible. The study of period military costume was then in its infancy and the artist cannot be condemned for not making use of the many sources available now, but which were not known or recognised in her time. Equally, her pictures, particularly those of the Napoleonic Wars, should not be regarded as accurate reference material for uniform.

10. H and A Gernsheim *Roger Fenton, Photographer of the Crimean War* Secker and Warburg, London, 1954
11. T Herbert 'Uniforms and Medals' (in the 2nd Afghan War) in *Soldiers of the Queen* Vol 6, No 1, p 17

Appendix II
Chronology

1846	3 November, born at Villa Claremont, outside Lausanne, Switzerland
1847	11 October, sister Alice born. Childhood in Italy, with visits to Kent and Surrey
1861	Spring, Thompson family moves to London but spends several months at Hastings
1862	Receives lessons in oil painting from W Standish; briefly joins elementary class of Female School of Art, South Kensington; visits Millais's studio
1865	Travels in Germany and Belgium; 3 November, visits battlefield of Waterloo
1866–70	Student at the Female School of Art, South Kensington, with one term at Giuseppe Bellucci's Academy in Florence, summer 1869
1867	First exhibits at the Society of Women Artists and the Dudley Gallery
1868	March, Ruskin visits Thompson house – criticises and praises her work
1870	Exhibits *The Magnificat* in Rome; visits Paris Salon on the return to London; final term at Female School of Art
1872	Sketches the Army during autumn manoeuvres in the New Forest; *Soldiers Watering Horses* shown at the Dudley Gallery, leads to commission for *The Roll Call*
1873	*Missing* accepted by R.A.; sketches the Cameron Highlanders at Parkhurst; September, pilgrimage to Paray-le-Monial; takes studio at 76 Fulham Road, London and on 13 December begins work on *The Roll Call*
1874	May, *The Roll Call* shown at R.A. – immediate success; July, makes studies of Royal Engineers at Chatham; December, visits Paris to see French military painters
1875	*The 28th Regiment at Quatre Bras* well received at R.A.; visits Newcastle to see *Quatre Bras* on show; September-October, in Castagnolo, Tuscany for the vintage
1876	*Balaclava* at Fine Art Society; August–October, returns to Castagnolo and visits Florence, Sienna and Padua
1877	April *The Return from Inkerman* at Fine Art Society; 11 June, marries Major William Butler, 69th Regiment; honeymoon in west of Ireland
1878	Travels in the Pyrenees, then through France, Switzerland, Germany and Holland
1879	*The remnants of an army* and *"Listed for the Connaught Rangers"* at R.A.; fails to be elected as an Associate of the Royal Academy; Elizabeth, eldest (surviving) child born; (William Butler in Durban as

	AA & QMG, supplying Lord Chelmsford's force engaged in Zululand)
1880	Defers *Scotland for Ever!* to paint Royal Commission; Patrick born; (William Butler promoted to lt-col, 21 April)
1881	Living at Devonport (William Butler, AA & QMG, Western District) *The defence of Rorke's Drift* at R.A.; *Scotland for Ever!* at Egyptian Hall, Piccadilly
1882	*"Floreat Etona!"* less well received at R.A.; (William Butler serves in Wolseley's Egyptian campaign; promoted to colonel on 18 November)
1884	(William Butler organising boats for Gordon Relief Expedition)
1885	*"After the Battle"* at R.A.; November, travels to Cairo
1886	January, travels up the Nile in 'Fostât'; at Wadi Halfa until March
1886–8	Living near Dinan, Brittany. Begins *To the front*. Becomes Lady Butler, when husband is awarded KCB.
1887	*A Desert Grave* at R.A. – now lost.
1888	Living at Delgany, Co.Wicklow. (Sir William Butler heads enquiry into the administration of the Ordnance Department; report is suppressed by War Office)
1889	*To the front* at R.A.
1890	*Evicted* at R.A.; March, travels to Alexandria (Sir William in command of garrison); June, returns to Delgany; November, back to Alexandria, cruise on Lower Nile in 'The Rose'
1891	April, tour of Palestine; June, returns to Ireland via Verona to visit battlefield of Arcola (1796); November, returns to Alexandria
1892	*Halt on a forced march* at R.A.; June, returns to Ireland and back to Alexandria via Genoa in autumn. (Sir William becomes major-general on 7 December)
1893	*The Camel Corps* at R.A. June, in Ireland, then in November moves to Aldershot (Sir William in command of 2nd Infantry Brigade)
1895	*Dawn of Waterloo* at R.A.
1896	January, trip to southern Italy; stays at the Empress Eugenie's villa near Monte Carlo on the return journey. February, living at Dover Castle (Sir William in command of South Eastern District)
1897	*"Steady the drums and fifes!"* at R.A.
1898	*On the morrow of Talavera* at R.A. (Sir William appointed Acting High Commissioner, South Africa and in command at the Cape, with local rank of lt-gen)
1899	*The Colours* at R.A. February, sails for the Cape, but returns to England late August (on Sir William's resignation). September, at Devonport, (Sir William in command of Western District)
1900	Aldershot (Sir William given concurrent command of Aldershot District during Sir Redvers Buller's absence in South Africa; promoted lt-gen, 9 October)
1902	*The 10th Bengal Lancers tent-pegging* at R.A.
1903	*Within sound of the guns* at R.A.; publishes *Letters from the Holy Land*
1905	*Rescue of wounded, Afghanistan* at R.A. (Sir William retires from the Army and heads enquiry into 'War Stores Scandal'); October, living at Bansha Castle, Co.Tipperary; holiday in Co. Mayo
1908	*Homeward in the afterglow: a Cistercian shepherd in medieval England* at R.A.
1909	Publishes *From Sketch-Book and Diary*

1910	7 June, Sir William dies; buried at Killadrigh cemetery, near Bansha
1911	*Rivals: Bengal Lancers tent-pegging* at R.A.; Easter, in Rome for son Richard's ordination (who became Father Urban); 22 April, audience with Pope Pius X
1912	Exhibition of watercolours at the Leicester Galleries
1914	September-October, staying near New Forest to see son Patrick before he embarks for the front with 7th Division
1915	'Waterloo Centenary Exhibition' at Leicester Galleries
1917	*The Dorset Yeoman at Agagia, 26th Feb 1916* at R.A.; 'Some glimpses of the Great War' exhibition at the Leicester Galleries
1919	'Some Records of the World War' exhibition at the Leicester Galleries
1920	*"In the retreat from Mons: the royal horse guards"* at R.A.
1922	Publishes *An Autobiography*; Bansha taken over by Irish Republicans, moves to Gormanston Castle, Co.Meath
1929	*A Detachment of Cavalry in Flanders*, last known oil painting is executed
1933	2 October, dies at Gormanston; buried at Stamullen graveyard nearby

SELECT
BIBLIOGRAPHY

Lady Butler

John Oldcastle (Wilfrid Meynell) 'Our Living Artists: Elizabeth Butler (*née* Thompson)' *The Magazine of Art*, 1879

Wilfrid Meynell 'The Life and Work of Lady Butler' *The Art Annual*, 1898

Elizabeth Butler *Letters from the Holy Land* Adam and Charles Black, London, 1903

Elizabeth Butler *From Sketch-Book and Diary* Adam and Charles Black, Burns and Oates, London, 1909

Elizabeth Butler *An Autobiography* Constable & Co Ltd, London, 1922

Sir William Butler

Lt-General the Rt Hon Sir W F Butler *Sir William Butler. An Autobiography* Constable & Co Ltd, London, 1911

Edward McCourt *Remember Butler. The Story of Sir William Butler* Routledge & Kegan Paul, London, 1967

Unpublished Material

MS Letters from the painter to her mother or sister are in the collection of Hermia Eden, Catherine Eden and Elizabeth Hawkins at Greatham, Sussex.

The Fine Art Society MS Minute Book is in the possession of the Fine Art Society, Bond Street, London.

The Victorian Army

Brian Bond *Victorian Military Campaigns* Hutchinson, London, 1967

Alan Ramsay Skelley *The Victorian Army at Home* McGill, Queen's University Press, Montreal and Croom Helm, London, 1977

Edward M Spiers *The Army and Society 1815–1914* Longman, London, 1980

Edward M Spiers 'The British Army 1856–1914: recent writing reviewed' *Journal of the Society of Army Historical Research* Vol LXIII 1985, pp 194–207

INDEX